FACES

PHOTOGRAPHY AND THE ART OF PORTRAITURE

FACES

PHOTOGRAPHY AND THE ART OF PORTRAITURE

PAUL FUQUA AND STEVEN BIVER

ELSEVIER

AMSTERDAM • BOSTON • HEIDELBERG • LONDON
NEW YORK • OXFORD • PARIS • SAN DIEGO
SAN FRANCISCO • SINGAPORE • SYDNEY • TOKYO

Focal Press is an imprint of Elsevier

Focal
Press

Focal Press is an imprint of Elsevier
30 Corporate Drive, Suite 400, Burlington, MA 01803, USA
Linacre House, Jordan Hill, Oxford OX2 8DP, UK

Notices
Knowledge and best practice in this field are constantly changing. As new research and experience broaden our understanding, changes in research methods, professional practices, or medical treatment may become necessary.
Practitioners and researchers must always rely on their own experience and knowledge in evaluating and using any information, methods, compounds, or experiments described herein. In using such information or methods they should be mindful of their own safety and the safety of others, including parties for whom they have a professional responsibility.

To the fullest extent of the law, neither the Publisher nor the authors, contributors, or editors, assume any liability for any injury and/or damage to persons or property as a matter of products liability, negligence or otherwise, or from any use or operation of any methods, products, instructions, or ideas contained in the material herein.

Library of Congress Cataloging-in-Publication Data
Application submitted

British Library Cataloguing-in-Publication Data
A catalogue record for this book is available from the British Library.

ISBN: 978-0-240-81168-0

For information on all Focal Press publications
visit our website at www.elsevierdirect.com

09 10 11 12 13 5 4 3 2 1

Printed in China

Typeset by: diacriTech, Chennai, India

GALLERY

SELECTED WORKS BY
CONTEMPORARY MASTERS

By way of introduction, we present these examples of the work of some current masters whom we admire. This gallery of photographs by Nadav Kander, Joyce Tenneson, Sandro Miller, George Holz, Brent Stirton, and Dan Winters showcases both the studio and photojournalistic styles of portraiture. We hope you will find this collection of portraits inspiring.

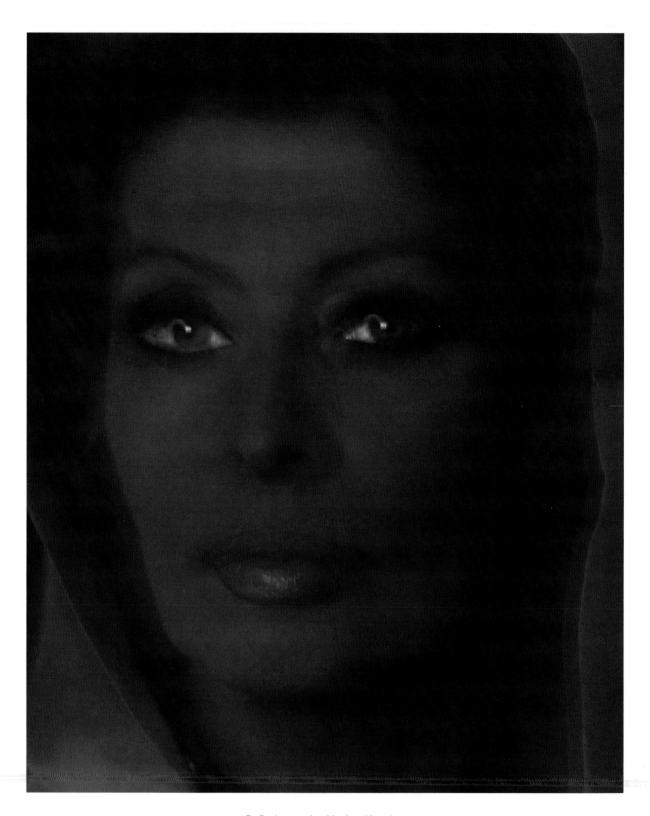

Sofia Loren by Nadav Kander

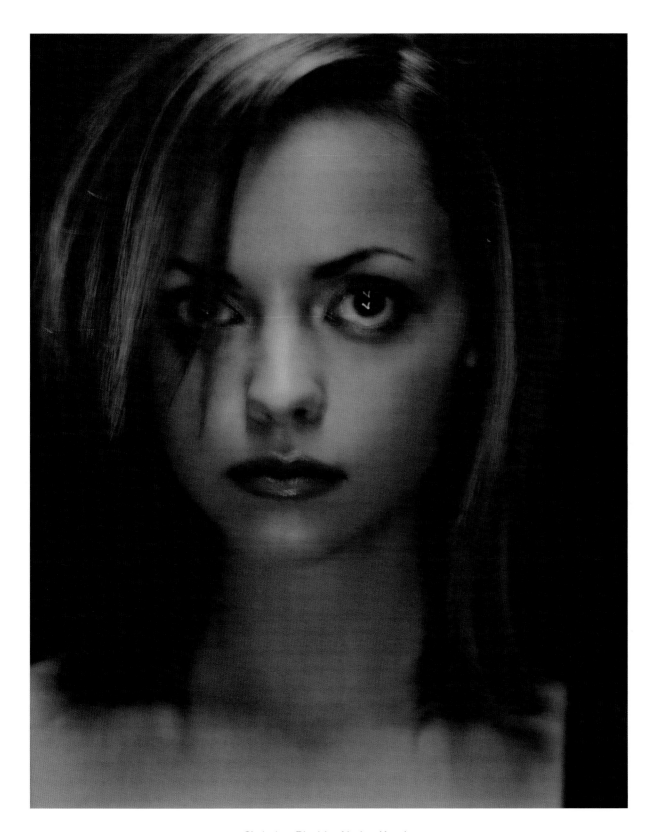

Christina Ricci by Nadav Kander

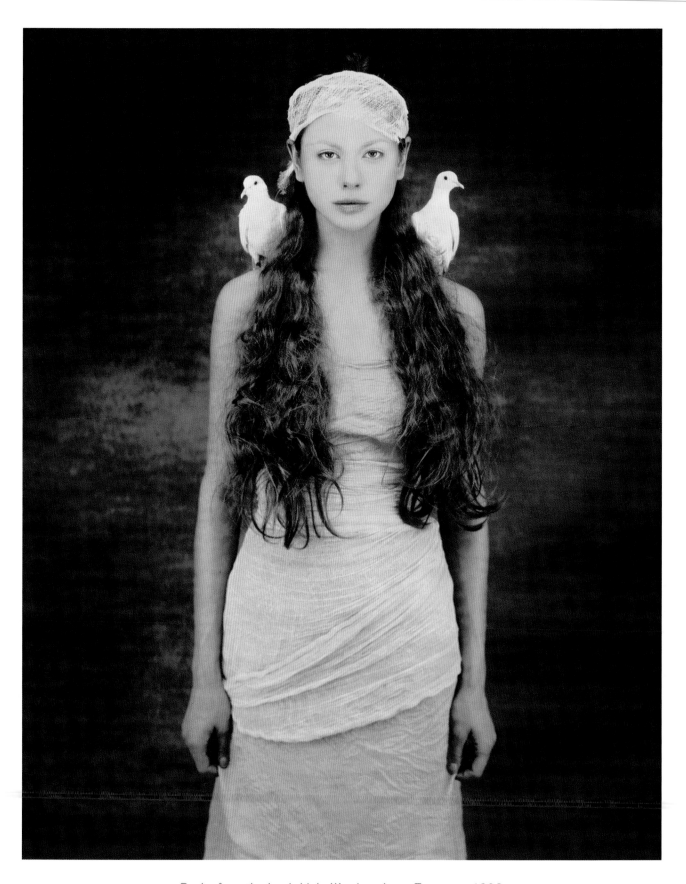

Dasha from the book *Light Warriors*, Joyce Tenneson 1998

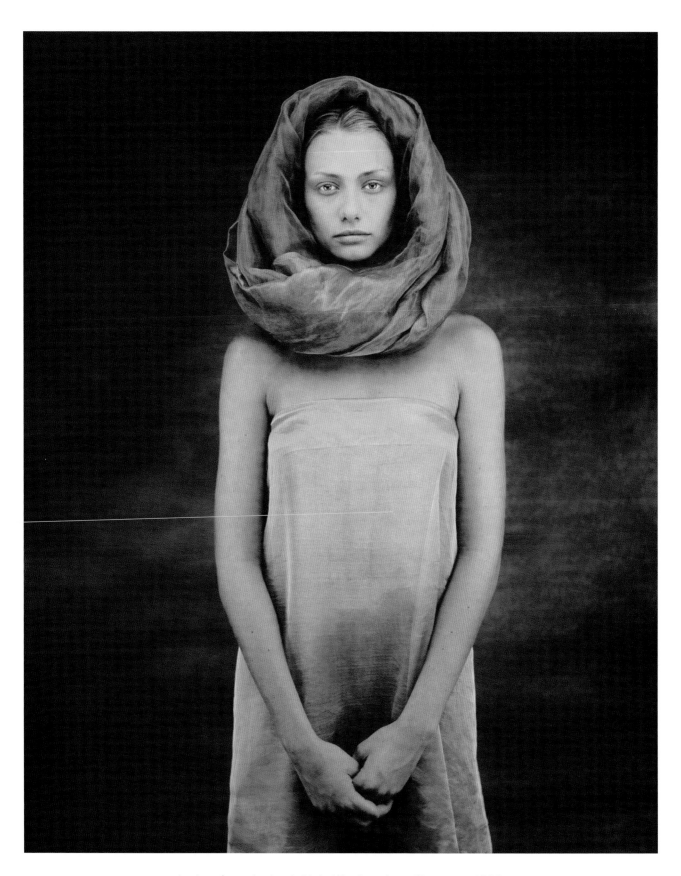

Larissa from the book *Light Warriors*, Joyce Tenneson 1998

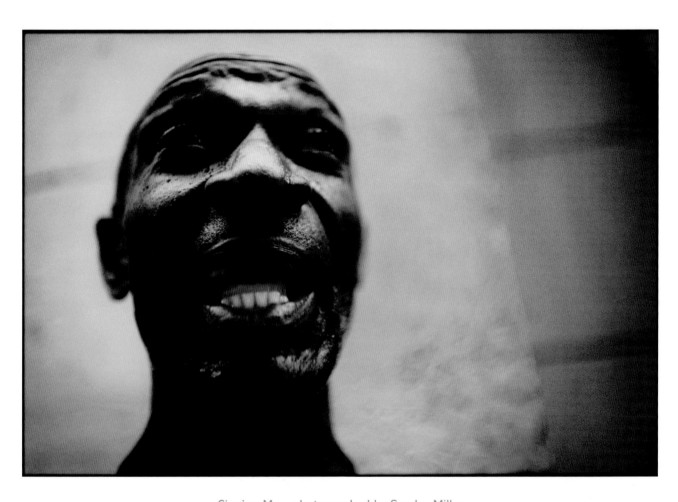

Singing Man, photographed by Sandro Miller

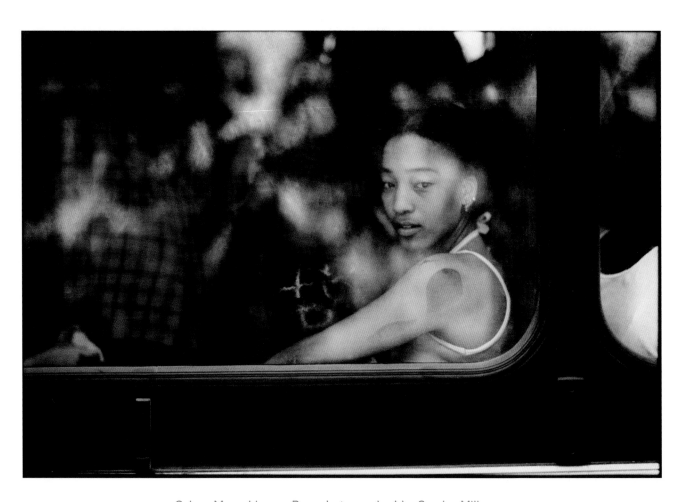

Cuban Mona Lisa on Bus, photographed by Sandro Miller

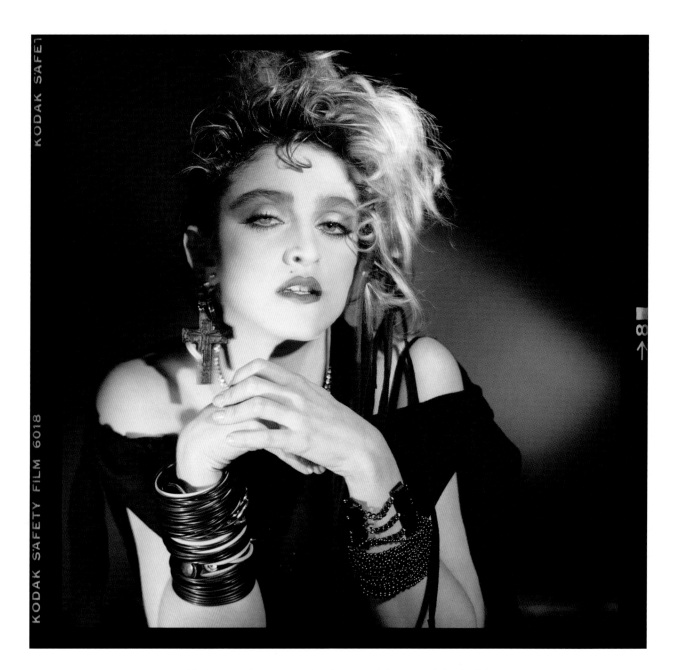

Madonna, photograph by George Holz, copyright 1984

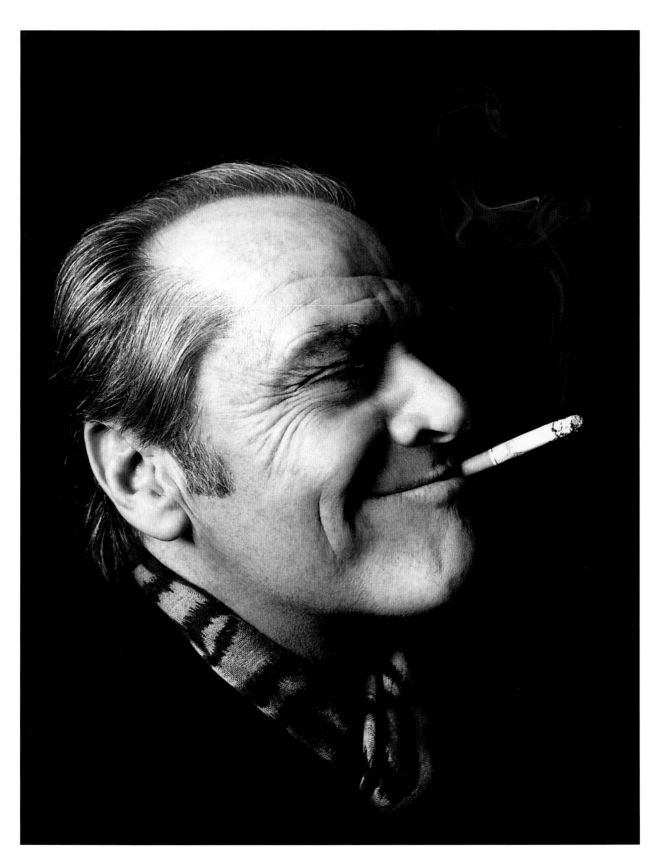

Jack Nicholson, photograph by George Holz, copyright 1997

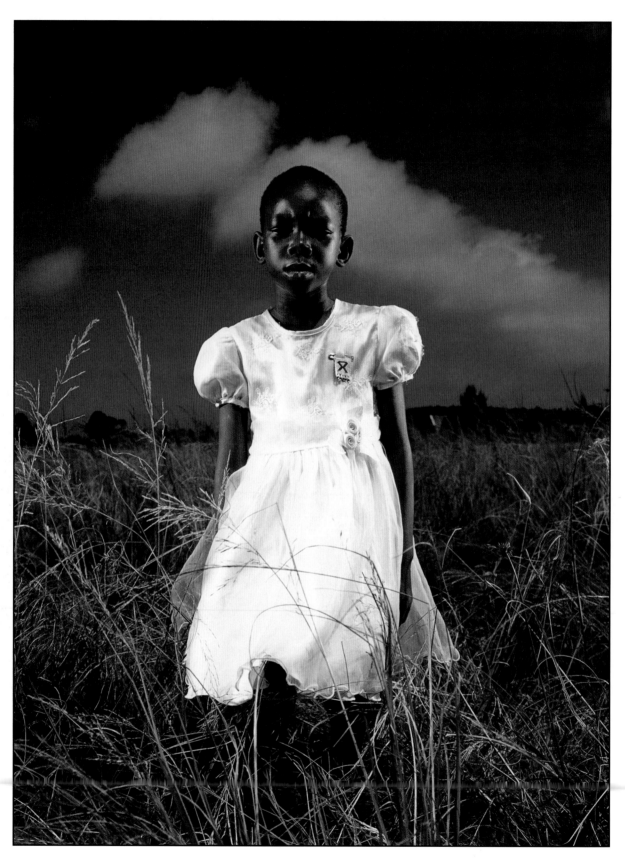

Photograph by Brent Stirton
Richards Bay, South Africa—May 2004: A young AIDS orphan stands alone in a field after
a church service, she lives alone with her grandmother, who is elderly and without an income.

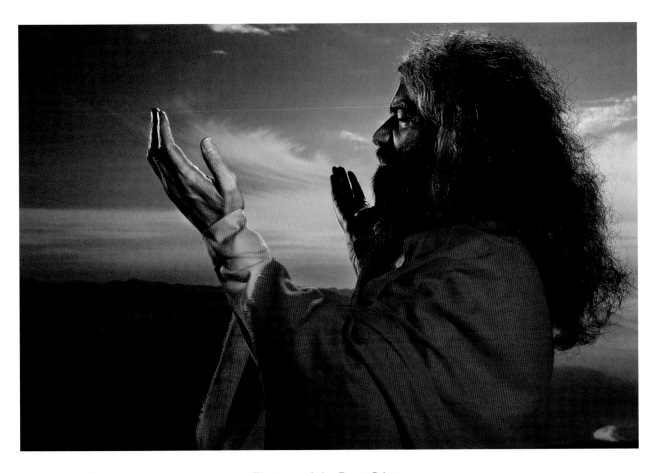

Photograph by Brent Stirton
Rishikesh, India—December 2006: The head guru of the Gurukul school of Parmarth Niketan in Rishikesh, India.
He is seen praying in the mountains behind the school.

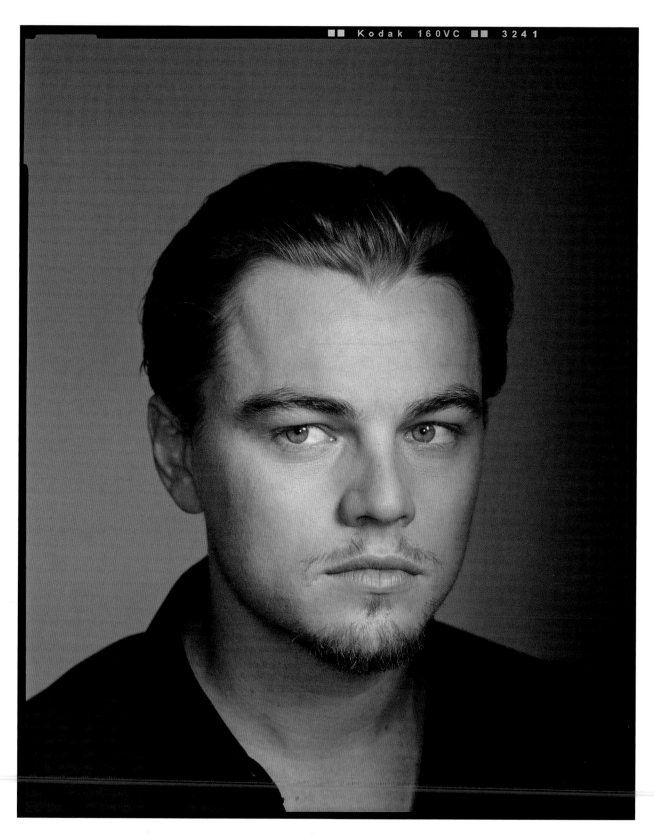

Leonardo DiCaprio, Los Angeles, California, November 2, 2002, The *New York Times Magazine*, photographed by Dan Winters

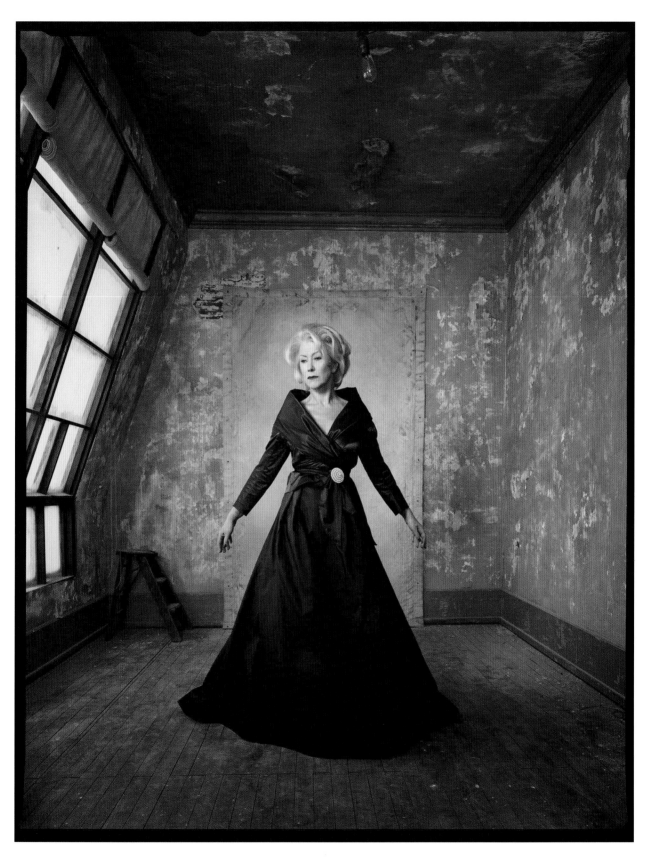

Helen Mirren, Los Angeles, California, January 11, 2007, The *New York Times Magazine,*
photographed by Dan Winters

www.nadavkander.com

www.tenneson.com

www.sandrofilm.com

www.georgeholz.com

www.brentstirton.com

www.danwintersphoto.com

Konichi wa—once again and always.

—*PQF*

I would like to thank my wonderful wife, Gina, and my kids Jade, Nigel, and Tessa for all their support and contribution to this book.

—*Steven Biver*

CONTENTS

Gallery v
 Selected works by contemporary masters.

Dedications xix
 Whom do we appreciate?

Introduction xxiii
 Opening thoughts about portrait making.

Acknowledgments xxvi
 And whom do we appreciate, once again—but differently.

How to Use This Book xxvii
 The importance of picking your way through the portraits in this book the same
 way you would through a bowl of delicious fruit.

Portraits From the Past 1
 A collection of 36 portraits—some happy, some terrible—
 made from the beginning of photography through the 1960s.

Making Portraits 15
 A collection of 48 portraits and detailed explanations of
 how we made them. Most are accompanied by full-perspective
 diagrams.

Street Shooting 115
 A series of suggestions and tips that have helped us during the
 many years we've spent making street portraits.

Getting Ready: A Guide to Preproduction 127
 Suggestions on how to prepare for portrait sessions both big
 and small.

Modifying Light 133
 Information about the many devices we use to modify or control
 light while making portraits.

And Finally 149
 Some parting words on what the "art and craft" of portraiture means to us.

Appendix—Tools and Techniques 153
 A look at four tips and techniques that we have found helpful: compositing,
 black-and-white conversions, reading histograms, and working with lighting ratios.

Index 161

INTRODUCTION

L et us confess. My coauthor Steve and I are addicts. Actually, "face junkies" is probably a better way of describing the two of us. We've never met a face we didn't find at least slightly interesting. And there have been lots of them that have caused us to grab our cameras and start shooting. Sometimes the results have been good; sometimes not so good. But whatever the outcome, we've had a lot of fun in the process.

And that's where this book comes in. We've written it for two reasons. First, of course, we hope that by looking at the pictures in it and reading our notes on how they were made, you'll learn things that will help you make the sorts of portraits you would like to make. But just as important, we hope that—in at least some small way—this book will also nurture and add to your enjoyment of portrait making.

PORTRAITS: WHAT ARE THEY?

At this point, seeing that I have used the word several times, let me define what Steve and I mean by the word "portrait" and explain how we use it in the following pages. As used in this book, a **portrait** is any picture of people (or other animals, if you want to push things) that at least partially identifies them in one way or the other. Most of the time, it does this by showing their face.

Obviously, this definition is an extremely broad one. And we mean it to be. It's also a definition that leads to the mindset that has governed our shooting over the years. And that's that a "good" portrait is one that we—or, if someone else is paying the bill, they—like. Nothing else really matters.

Still another way of defining portraits is to look at what they do. Perhaps the simplest example of such an approach rests on the core cultural concept of **identity**. It is the reason that untold millions of portraits have been, and will continue to be, shot. Look, for example, at Laura Bullion's portrait on page 6.

Bullion was a notorious outlaw who rode with train and bank robber Butch Cassidy's "Hole in the Wall" gang. The portrait of her we show is an official mug shot made by an unknown photographer who worked for the National Detective Agency. The purpose of this portrait was (like the countless similar mug shots made worldwide) to identify Bullion and thus aid in her arrest.

Yet other portraits are made to **publicize** groups and individuals. That is the case with the publicity portrait of Harry Houdini in chains on page 13 and the composite portrait we recently assembled for the Fuse Ensemble on page 153. In both cases, the motive behind these portraits was the same: publicity that would help to boost reputations and build audiences.

Social reformers have also used portraiture to come to the aid of many worthwhile causes. The portrait of a North Carolina "mill girl" on page 10 is such a picture. Lewis W. Hine—the great American photographer and social reformer—made it around the turn of the twentieth century. It's part of a

horrifying series he shot showing the widespread abuse of child labor in the United States and a chilling example of such "social reform" portraiture.

So far we've discussed portraits that in one way or the other give answers—that provide information. More often than not, this is the case. What does he or she look like? What kind of people are they? Who are their friends? What do they do? Where do they fit in society? These are all questions that portraits can, and often do, help to answer. There is, however, another kind of portrait: one that **asks more questions of its viewers than it answers**. Yonus's portrait in spread 42 is such an image. There's a visual tension in the image that's caused by an unknown, unshown something. Those who view this image will never be sure what it was.

MANIPULATING PHOTOGRAPHS

As I mentioned earlier, Steve and I evaluate the success or failure of the portraits we make by how much we (or our clients) like them. It also leads us to the oft-debated subject of how portrait shooters arrive at their final images. Or, to put it another way: how large a role should digital editing play in portrait making?

As far as we're concerned, this question is about as important as "How many angels can sit on the head of a pin?"—a hotly debated issue in centuries long gone by. For us, what matters is the final image, not how we got to it. Let's face it: photography involves the creation of a **representation** of a reality, not a duplicate of it. In the grand old days when film was king, we altered our pictures—our representations of reality—via the manipulation of chemicals, paper types and grades, processing times and procedures, lens and film selections, and other such things. Today, we make most of these adjustments (and many others) both faster and more effectively through the use of image editing software.

And adjust we do. As far as we're concerned, pressing the shutter release is only the first step in portrait making. The images that our camera's sensors capture are where the fun begins, not where it ends. As Ansel Adams so beautifully phrased it years ago, "The negative is the score, the print is the performance."

Some of the adjusting we do routinely to enhance our "performances" falls into the category of **retouching**. Removing unsightly blemishes from otherwise perfect cheeks and killing the glow of bright red eyes are typical of such everyday retouching chores. Misjudged exposures and unattractive color balances are also routinely corrected during postproduction. Tasks such as these are now—thanks to the brilliance of untold scores of software engineers—more or less "automatic" image editing functions. Others, however, are far more complex.

For example, the New Standard's CD cover shown on spread 8 and Fuse Ensemble's publicity shot on page 153 presented far greater challenges. We composited, or assembled, both of these "group" portraits from different individual images. This is a very useful technique when you need to make a group portrait but can't get everybody who has to be in it at the same place at the same time.

The saturated, richly textured, somewhat hyperrealistic look of Nigel's portrait in spread 30 shows yet another way in which we sometimes modify (hopefully for the better) the representational reality our cameras capture.

Moving even farther from reality, we come to Harry's portrait in spread 37. I took the original image and wasn't satisfied with the way it came out. It didn't portray the effects of the stress and strains under which he had lived powerfully enough. Our solution in this instance was for Steve to use his image editing software to move Harry's image more toward the abstract.

As you have seen by now, Steve and I take a rather broad—and sometimes disputed—approach to what a "good" portrait is, and to what is—and what is not—permissible in the making of one. As we see things, if you (or your client) are happy, then be happy, because you've succeeded. You've made a good portrait.

If, on the other hand, you're not satisfied with the results of your labors, don't get angry. Instead, go back and try again. And, equally important, relish the fun, and enjoy yourself during the process. Approached in this way, the art and craft of portraiture can provide you a lifetime of both challenge and joy.

ACKNOWLEDGMENTS

"I can no other answer make, but, thanks, and thanks."

—WILLIAM SHAKESPEARE

We owe a very large debt to all the many people who have helped us with this book. In particular, we would like to thank our incomparable editors, Cara Anderson and Danielle Monroe, along with the rest of the Focal Press staff. Without them, we could never have brought this project to fruition.

We would also like to warmly thank Nadav Kander, Joyce Tenneson, Dan Winters, Sandro Miller, George Holz, and Brent Stirton for their extraordinary kindness in allowing us to include examples of their work in this book.

Among the many others who helped us were Jerry Smith and Gary Garrison of Penn Camera, Jeff Whatley and Howard Hull of National Geographic Imaging, and representatives of the Lensbaby Company and Gary Fong, Inc.

Our friend and accomplished artist Matt McMullen produced the diagrammatic art that accompanies the majority of our teaching portraits. We would also like to thank Michael Jones, our longtime assistant, for all his efforts.

In addition, we also owe a very large debt of gratitude to staffs of both the Copyright and the Prints and Photographs Division of the Library of Congress and to Holly Reed and the rest of the staff of the Still Pictures Division of the National Archives, who time and again went out of their way to help us find the exact historic images we needed.

To the many individuals who allowed us to take their pictures, we also say a truly heartfelt "Thank you." We know that in many instances you must have thought we were completely crazy, and we do appreciate your patience and cooperation with us.

And finally, we would like to thank our longtime colleague, Fil Hunter, for the many conversations about and experiences with photography that we have shared together over so many years.

HOW TO USE THIS BOOK

We would like this to be a book that helps you learn some things that will help you take portraits you like—portraits of which you are justifiably proud. We'd also like to help you enjoy the time you spend doing it. To accomplish these intertwined goals, we've assembled what, for lack of a better name, one might call a "teaching gallery between book covers." The first three sections in it are:

The Selected Works of Contemporary Masters, such as Nadav Kander and Joyce Tenneson

Each of the six contributors to this section was kind enough to provide us with two images. These, they feel, exemplify their approach to portraiture. Taken together, the photographs in this gallery present a sampling of how some of the most sought-after photographers working today go about portrait making.

Portraits from the Past

This section presents images made from the earliest days of photography to the near present. The collection provides a chance for you to study the work of those portraitists—some, such as Ansel Adams and Edward S. Curtis, who are well known and some whose names are now lost forever—whose body of work, both technically and stylistically, has helped to bring the art and craft of portraiture to where they stand today.

Making Portraits

This third section consists of both "studio" and "street" portraits shot by the coauthors of this book. These images are shown in a two-page format consisting of the portrait on one page and an explanation of how we made it on the other.

A DIFFERENT ARRANGEMENT

You will soon notice that we have not arranged the "Making Portraits" section in any particular stylistic or teaching order, and we suggest strongly that you don't try to follow one while making your way through it. In other words, don't begin with the first spread and methodically work through the others to the end. And don't begin by looking at all the portraits in which we used one light and finish up with those we shot using four. Following such paths to enlightenment numbs the mind very quickly.

Instead, we suggest that you work your way through this section in a random manner, guided solely by what looks interesting to you at any particular time. One day, for example, a complex three-light studio shot may grab your eye. The next day, a simple natural-light street portrait may prove the most appealing to you.

Regardless of which portrait you select, don't be in too much of a hurry with your study of it. Any work of art, be it a Greek statue or a Navajo necklace, takes time to soak in—takes time to percolate back and forth between your conscious and unconscious minds.

So don't rush. Instead, slow down and try to absorb the image. Ask yourself such questions as what it is that draws you to it. What is it that makes this image "work" for you? Look carefully at how we posed and lit its subject. Read the accompanying notes, and if there is an associated diagram, take the time to go over it.

Finally, if you have the time and opportunity, try to shoot a portrait similar to ours. Note, however, that when you are doing this, we don't mean that you should necessarily try to duplicate our picture exactly. If that's what you want to do, fine. However, it's also fine if you extract what you like from our example and then modify it to produce a product different from ours but satisfactory to you.

The important thing—whenever you shoot—is to produce a portrait with which you are satisfied, and to enjoy yourself while doing it. If you, and others like you, do these two things, we will be more than just a little happy that we wrote this book.

Please note that, although many photographers feel that the correct way to present instruction on lighting and posing is through the use of formulas, we disagree. Rather than advocating this approach, we feel that students are far better served through the process of exploration. Thus, we do not include separate chapters dedicated to such topics as "The Four Basic Types of Lighting" or "The Rules of Posing."

Instead, we feel strongly that the best way of garnering this knowledge is through the above-mentioned approach of selection followed by thoughtful study. To further that, we have included examples that address many of the classic poses and lighting styles. In addition, we have included many examples that take little or no note of such "standard" approaches and techniques, but rather set out in new directions to photography and the art of portraiture.

AND THEN...

The final part of this book contains sections devoted to "Street Shooting," "Getting Ready" for a portrait shoot, "Modifying Light," "Final Thoughts" on portraiture, and an appendix that explains some useful "Tools and Techniques." Each of these sections is designed to help familiarize readers with some of the many different "nuts and bolts" aspects of portrait shooting.

PORTRAITS FROM THE PAST

PORTRAITS FROM THE PAST

Photography, as we all know, is not real at all. It is an illusion of reality with which we create our own private world.

—Arnold Newman

INTRODUCTION

This section presents a collection of portraits from the past. They are a very mixed, diverse bunch. Some of these images come from the 1840s—the earliest days of photography. Others were shot as recently as the 1970s.

Acknowledged masters made some of these portraits. Others are the work of obscure photographers whose names are now lost to us forever. Some show persons familiar to us all. Others present the likenesses of those whose identities and accomplishments are long forgotten. Some are amusing; others speak to us of horror and tragedy.

But as mixed a group as this is, despite the variety of the group, the images in it share much in common. Looked at individually, each of these pictures shows us how different photographers—working at different times, with the different techniques and technologies available to them—have gone about the business of recording the likenesses of their fellow humans. Taken as a group, these portraits provide an overview of a particular slice of the human experience.

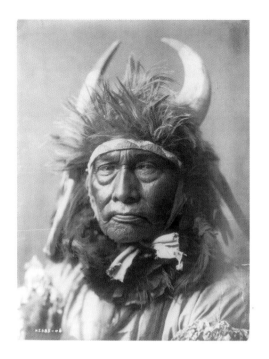

BULL CHIEF

EDWARD S. CURTIS (1868–1952)

This portrait of the Apsaroke or Northern Crow—Indian warrior, Bull Chief, was taken by Curtis as part of his effort to record "… the old time Indians, his dress, his ceremonies, his life and manners."[1]

(Courtesy of the National Archives, Washington, D.C.)

[1] Introduction to *The North American Indian*, Edward S. Curtis, 1907–1930.

PORTRAIT OF MISS K

ZAIDA BEN-YUSUF (1869–1933)

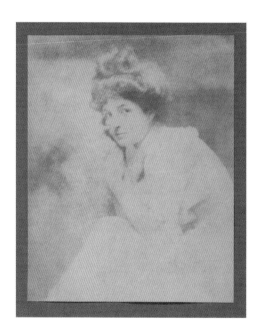

The nineteenth-century gum bichromate process produced extremely delicate and diffuse images. Some, such as this masterful "fine arts" half-length picture of the actress Florence Kahn, look almost as though they had been rendered in paint or pencil. This portrait was made in 1900 by the then widely popular Ben-Yusuf in her fashionable New York City studio.

(Courtesy of the Library of Congress, Prints and Photographs Division,
Washington, D.C.)

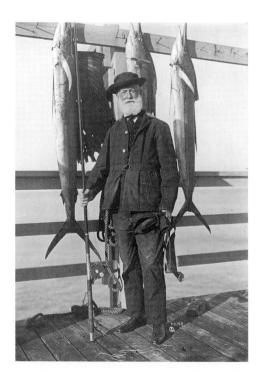

JOHN D. CRIMMINS STANDING IN FRONT OF FISH

PHOTOGRAPHER UNKNOWN

By 1912, when this photograph is thought to have been made, inexpensive and easy-to-use cameras were common enough that informal "snapshot" portraits—such as this fine example of a proud fisherman and his catch—began to be part of many family's albums.

(Courtesy of the Library of Congress, Prints and Photographs Division,
Washington, D.C.)

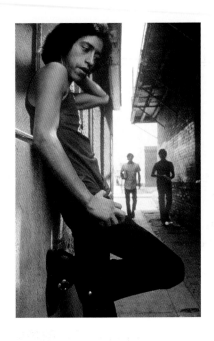

CHICANO TEENAGER IN EL PASO'S SECOND WARD. A CLASSIC BARRIO WHICH IS SLOWLY GIVING WAY TO URBAN RENEWAL.

DANNY LYON (1942–)

The worlds of portraiture and photojournalism can, and often do, collide. That is the case with this arresting picture shot in 1972 by the hard-hitting photographer, film maker, journalist, and author Danny Lyon.

But the truth is that it is of absolutely no importance into which stylistic "bin" we choose to toss an image such as this one. The fact remains that no matter how we choose or choose not to "classify" it, it is still a revealing and beautifully executed image of a young man in a world that is changing around him.

(Courtesy of the National Archives, Still Pictures Division, Washington, D.C.)

ABRAHAM LINCOLN

ALEXANDER GARDNER (1821–1882)

Made in February of 1865, this haunting image is thought to be the last photograph taken of Lincoln before his assassination. Sometimes referred to as Lincoln's "cracked-glass portrait," it is one of the most famous American portraits.

(Courtesy of the Library of Congress, Prints and Photographs Division, Washington, D.C.)

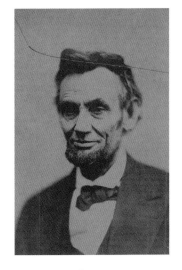

CANNIBAL TOM (80 YEARS OLD), THE LAST RELIC OF FIJI CANNIBALISM—FIJI ISLANDS

UNDERWOOD & UNDERWOOD, PUBLISHER; PHOTOGRAPHER UNKNOWN

This somewhat suspect portrait of a purported cannibal named Tom was made around 1905. It is a classic example of the thousands of different "exotic people in far away places" pictures sold by such mass-market publishers as Underwood & Underwood. Stereographic cards such as this one, which produce a three-dimensional look when seen through a special viewer, were particularly popular during the early 1900s.

(Courtesy of the Library of Congress, Prints and Photographs Division, Washington, D.C.)

4

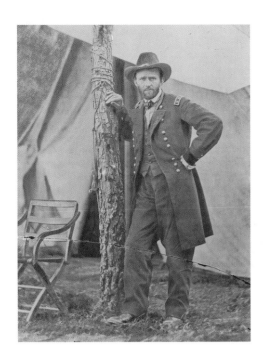

Gen. U. S. Grant at his Cold Harbor, Virginia, headquarters

Edgar Guy Fowx (1821–1870)

This print was made from a broken glass plate (wet collodion) negative. It shows Grant at his headquarters at Cold Harbor, Virginia, in June 1864.

The battle of Cold Harbor was a terrible Union defeat during which Grant's army suffered an estimated 12,000 casualties. In his memoirs, Grant was to write that Cold Harbor was the only attack he wished he had never ordered.

(Courtesy of the Library of Congress, Prints and Photographs Division, Washington, D.C.)

Martin Luther King press conference

Marion S. Trikosko

The distinguished photojournalist Marion Trikosko took this portrait of Dr. King. It demonstrates beautifully what a waste of time it is to worry about defining the term "portrait" too rigorously.

Some viewers may see this image as an example of photojournalism, or a "news picture"; others as a "portrait." But what difference does it make? The truth is that it is a fine example of both.

(Courtesy of the Library of Congress, Prints and Photographs Division, Washington, D.C.)

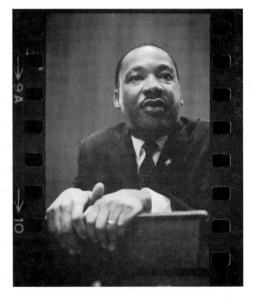

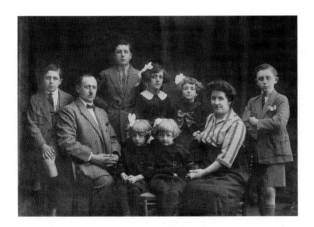

The Monti Family

Photographer unknown

By the 1920s, no middle-class family was satisfied unless they could display a formal family portrait. This was a picture that not only said *who* you were but also proclaimed proudly *what* you were—a portrait that by its very existence made it clear you had "arrived."

As is the case with this fine example taken in 1924 in Luxembourg, many of these "status" portraits were beautifully executed and remain as impressive today as they were when taken.

(Authors' collections)

5

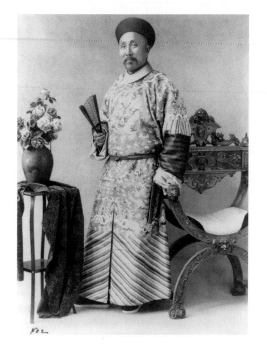

WU TING-FANG, CHINESE MINISTER
FRANCES BENJAMIN JOHNSTON (1864–1952)

Frances Benjamin Johnston, one of America's earliest female photographers, made this portrait around 1900. Its subject, Wu Ting-Fang, China's highly respected minister to the United States, was noted as a sophisticated and worldly diplomat. These are the qualities that Johnston's carefully posed and propped portrait so perfectly reflects.

(Courtesy of the Library of Congress, Prints and Photographs Division, Washington, D.C.)

FARGO AND DORIS CAUDILL, HOMESTEADERS, PIE TOWN, NEW MEXICO
RUSSELL LEE (1903–1986)

This informal portrait of the Caudills is one of the hundreds of often iconic pictures Lee took while working for the Farm Security Administration.

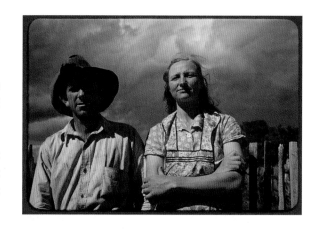

Made in 1940, this image is part of a series Lee shot documenting the hardships small farmers and migrant workers faced during the Great Depression and Dust Bowl years.

(Courtesy of the Library of Congress, Prints and Photographs Division, Washington, D.C.)

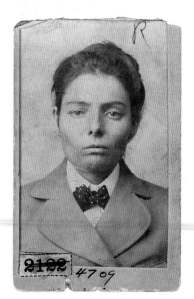

LAURA BULLION, OUTLAW
NATIONAL DETECTIVE AGENCY FILE PHOTO, 1893; PHOTOGRAPHER UNKNOWN

Portraiture became an important law enforcement tool in photography's early days. This mug shot, or criminal identification photo, shows the notorious female outlaw Laura Bullion.

Described by one lawman as "cool" and showing "absolutely no fear," Bullion was a member of Butch Cassidy's famed Wild Bunch gang of bank and train robbers.

(Courtesy of the National Archives, Still Pictures Division, Washington, D.C.)

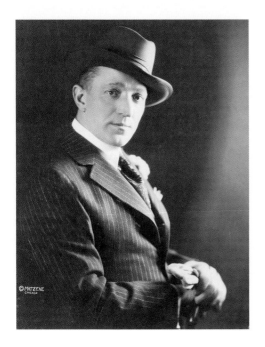

CHARLES DALMORÈS

MATZENE STUDIO, CHICAGO; PHOTOGRAPHER UNKNOWN

Made around 1916, this urbane and stylish portrait is of Charles Dalmorès, a famous international opera star. Produced in the fashionable Chicago studio of "Count" Jens Matzene, it is a fine example of the carefully posed—with few or any props or scenery—and dramatically lit image that would evolve into what later came to be known as the "Hollywood look."

(Courtesy of the Library of Congress, Prints and Photographs Division, Washington, D.C.)

KING FAROUK OF EGYPT AND HIS FAMILY

PHOTOGRAPHER UNKNOWN

King Farouk ruled Egypt from 1936 until he was overthrown by a revolution in 1952. This graceful and surprisingly informal portrait shows Farouk with his wife and young son.

It is a fine example of a "person in power" portrait. Such images strive to show both the sitter's human side and his or her authority. Rulers have often used such portraits to help win and maintain their subjects' loyalty.

(Courtesy of the Library of Congress, Prints and Photographs Division, Washington, D.C.)

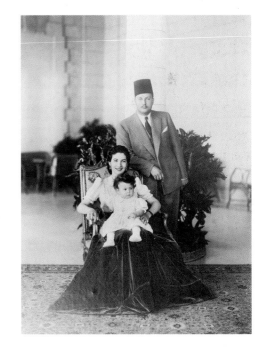

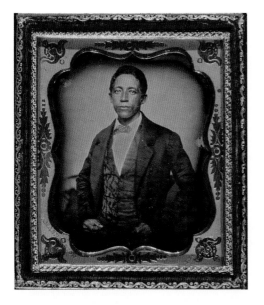

URIAS A. MCGILL

AUGUSTUS WASHINGTON (1820–1875)

New Jersey-born Augustus Washington was one of America's first African-American photographers. In 1853, he immigrated to Liberia. It was there that he made this daguerreotype of Urias McGill, a successful merchant and exporter.

(Courtesy of the Library of Congress, Prints and Photographs Division, Washington, D.C.)

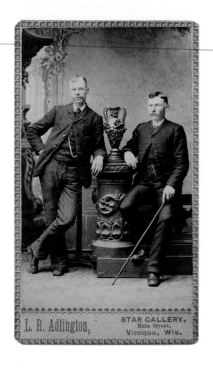

BOE BROTHERS
ADLINGTON STUDIO, VIROQUA, WISCONSIN; PHOTOGRAPHER UNKNOWN

Dressed in their finest clothes with their gold watch chains dangling from their vests for all to see, these two brothers were immortalized in this classically posed and propped carte de visite, or picture calling card, taken around the turn of the twentieth century.

Notice the richly painted baroque background, which was designed to convey a sense of "means"; this scene is typical of the era. So is the ornate pylon against which the brothers lean. Usually sold by the dozen, carte de visites were commonly exchanged among friends and family members.

(Allness family photographs, author's collections)

TOM KOBAYASHI, LANDSCAPE, MANZANAR RELOCATION CENTER, CALIFORNIA
ANSEL ADAMS (1902–1984)

Ansel Adams was one of America's greatest photographers. In 1943, he photographed the War Relocation Center at Manzanar, California, and the Japanese-Americans forced to live there during World War II. Shot against a background of cornfield and desert, this disturbing portrait is a stark reminder of the terrible injustice that Manzanar and the other camps like it represent.

(Courtesy of the Library of Congress, Prints and Photographs Division, Washington, D.C.)

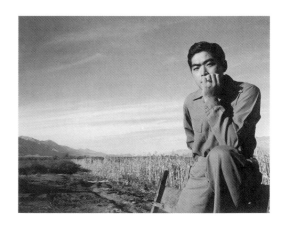

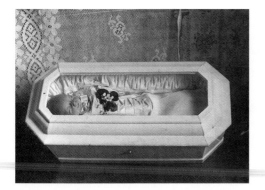

POST-MORTEM PORTRAIT OF AN UNKNOWN BABY
PHOTOGRAPHER UNKNOWN

The dead, especially children, were common subjects for early photographers. This gut-wrenching portrait was probably made in a small Wisconsin farm community in the 1890s.

Obviously great care was taken to make the picture as comforting as possible for its viewers—to make it appear that the baby was sleeping quietly rather than the awful truth so faithfully recorded. One can only hope that this sad memento provided some small measure of the consolation it was meant to.

(Allness family photographs, authors' collections)

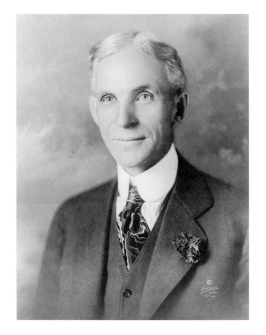

HENRY FORD
HARTSOOK STUDIO; FRED HARTSOOK (1876–1930)

This beautifully executed formal portrait of the American industrialist and founder of the Ford Motor Company, Henry Ford, was taken around 1919. Fred Hartsook, the probable photographer, owned several fashionable California portrait studios. He is often credited with helping to establish what later came to be known as the "Hollywood" look.

(Courtesy of the Library of Congress, Prints and Photographs Division, Washington, D.C.)

AMERICAN GOTHIC
GORDON PARKS (1912–2006)

Made by Gordon Parks in 1942 of a charwoman named Ella Watson, this riveting picture ranks among the twentieth century's most powerful portraits. It is well worth taking the time to compare it to Grant Wood's justly famous 1930 painting of the same name.

(Courtesy of the Library of Congress, Prints and Photographs Division, Washington, D.C.)

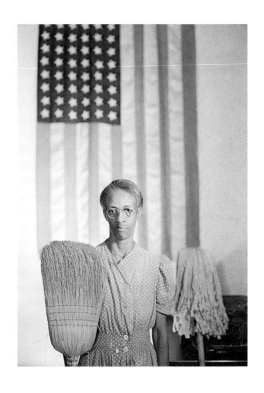

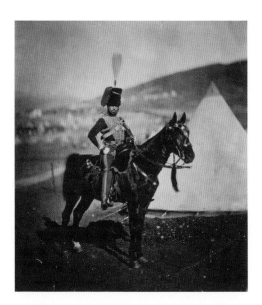

CORONET WILKIN, 11TH HUSSARS
RODGER FENTON (1819–1869)

This portrait of a British cavalry officer is one of the first pictures made as part of a systematic effort to use photography to document, and—some say to propagandize—a war. Produced using the collodion, or wet plate, process, it was shot by the British artist-turned-photographer Rodger Fenton during the Crimean War (1853–1856).

(Courtesy of the Library of Congress, Prints and Photographs Division, Washington, D.C.)

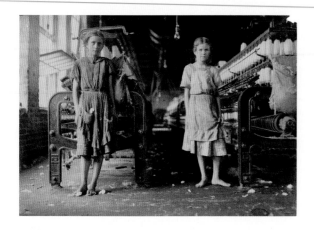

SPINNERS IN A COTTON MILL
LEWIS WICKES HINE (1874–1940)

Dedicated to social reform, Hine pictured these two young girls working as spinners in a cotton mill in 1911 while documenting child labor abuse for the National Child Labor Committee. Hine's portraits of young children working under often terrible conditions provided a much-needed boost to efforts aimed at passing effective child labor laws in America.

(Courtesy of the National Archives, Still Pictures Division, Washington, D.C.)

ON THE FREIGHTS
RONDAL PARTRIDGE (1917–)

In 1940, Europe was torn by war, a war that Rondal Partridge firmly believed America would soon join. But before that happened, and while he was working for the National Youth Administration, Partridge set out to document the conditions and challenges that America's youth faced at the tail end of the Great Depression.

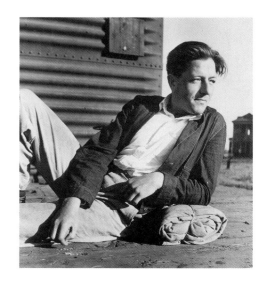

He shot this disturbing but beautifully executed portrait along the railroad tracks in Yuba County, California. It shows a young drifter who had spent much of his young life "on the freights" traveling from place to place looking for work.

(Courtesy of the Library of Congress, Prints and Photographs Division, Washington, D.C.)

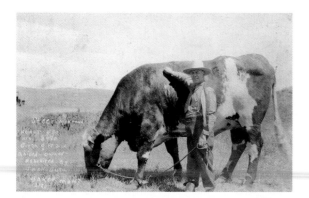

JACK GUTH AND HIS STEER
PHOTOGRAPHER UNKNOWN

Since their earliest days, we have used photographs as mementos of both ourselves and of our most prized possessions. Taken in 1920, this wonderful "environmental" portrait proudly records for posterity a Montana cattleman and his truly monumental steer.

(Allness family photographs, authors' collections)

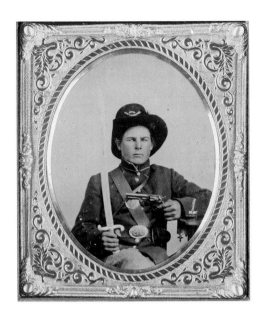

GEORGE KIMBRUE, PVT., 93RD INDIANA INFANTRY, U.S.A.

PHOTOGRAPHER UNKNOWN

Like countless thousands of soldiers, Pvt. Kimbrue sat for this tintype portrait in all his warrior finery sometime during the American Civil War.

Tintypes were popular among Civil War soldiers and their families because they were inexpensive, made quickly, and durable enough to be mailed home in letters. These qualities made them the ideal mementos for loved ones to share.

(Courtesy of the Library of Congress, Prints and Photographs Division, Washington, D.C.)

STARVING INMATE OF CAMP GUSEN, AUSTRIA

T4C. SAM GILBERT

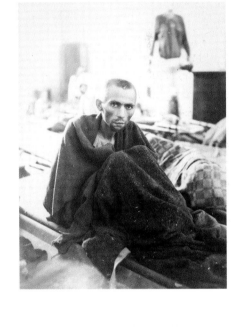

Taken in 1945 by an Army photographer immediately after U.S. troops liberated the notoriously brutal Gusen concentration camp, this mind-numbing portrait lives on as an icon for Nazi terror and atrocities.

Like all great portraits, the message so starkly proclaimed by this one is both timeless and universal.

(Courtesy of the National Archives, Still Pictures Division, Washington, D.C.)

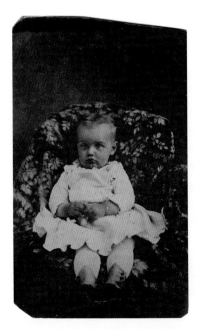

BABY IN BEST CLOTHES

PHOTOGRAPHER UNKNOWN

Since the first cameras arrived on the scene, children have been among portraitists' favorite subjects. Dressed in Baptism finery, this cherubic tyke was photographed using the tintype process by an unknown photographer sometime during the 1890s.

(Authors' collections)

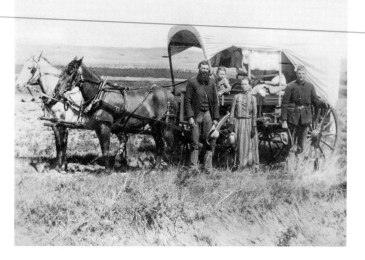

A PIONEER FAMILY BY THEIR WAGON

PHOTOGRAPHER UNKNOWN

Cameras followed the wagons during the Great Western Migration. This group portrait of a pioneer family standing by the covered wagon in which they lived and traveled during their search for a homestead is typical of the pictures made by photographers whose names are long lost to us.

This particular image was made in 1886 in the Loup Valley of Nebraska.

(Courtesy of the National Archives, Still Pictures Division, Washington, D.C.)

GUITAR PLAYER

PHOTOGRAPHER UNKNOWN

Little is known about this wonderful "a man and his music" portrait. It was probably taken by an itinerant photographer in the 1890s and shows a young man belonging to a Norwegian-American farm family living in Wisconsin.

(Allness family photographs, authors' collections)

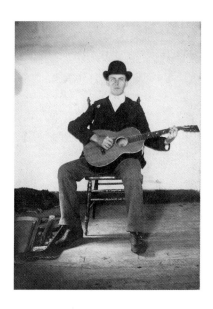

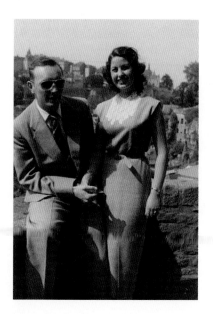

COUPLE ON AN OUTING

PHOTOGRAPHER UNKNOWN

The availability of good-quality, but relatively inexpensive, color film changed photography forever. For the first time in history, color photographs of friends and family were within the reach of a huge and ever-growing segment of the world's population.

This informal portrait from the 1950s of a stylishly dressed couple on an outing is typical of the hundreds of millions of similar color "people-pictures" produced since color film first became widely available.

(Authors' collections)

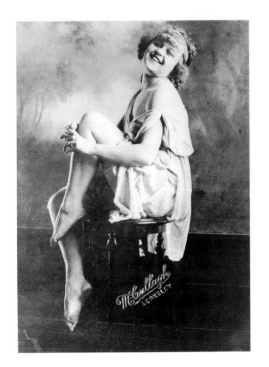

MISS DUBOISE FERGUSON, WHO HAS BEEN JUDGED TO BE PHYSICALLY PERFECT

KEYSTONE VIEW COMPANY; PHOTOGRAPHER UNKNOWN

Taken between 1909 and 1925, this glamour portrait is typical of the thousands of similar "pretty-girl" pictures that flooded the market around that time.

(Courtesy of the Library of Congress, Prints and Photographs Division, Washington, D.C.)

HARRY HOUDINI IN CHAINS

PHOTOGRAPHER UNKNOWN

Created around 1899, this somewhat humorous portrait of the great magician and escape artist Harry Houdini is a fine example of photography coming to the aid of publicity. The more widespread photographers became, the more magicians, actors, and other such performers came to appreciate how photographs could help to boost their reputations and build their audiences.

(Courtesy of the Library of Congress, Prints and Photographs Division, Washington, D.C.)

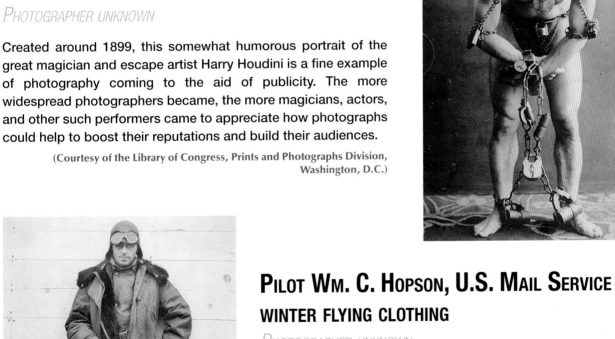

PILOT WM. C. HOPSON, U.S. MAIL SERVICE WINTER FLYING CLOTHING

PHOTOGRAPHER UNKNOWN

Scheduled airmail delivery service began in the United States in 1918. In its early years it was a rough business, to put it mildly. Flying in the open cockpit of a tiny plane in every kind of weather under all sorts of nasty conditions was not a task suited for the weak of heart. However, judging from his looks, the subject of this wonderful informal portrait taken at the Omaha airport in 1926 was well up to the task.

(Courtesy of the National Archives, Still Pictures Division, Washington, D.C.)

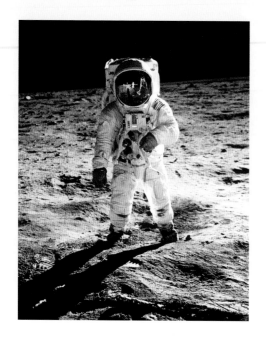

EDWIN ALDRIN, JR., WALKING ON THE MOON
NEIL A. ARMSTRONG (1930–)

Capturing one of history's most famous "firsts," this amazing portrait shows astronaut Buzz Aldrin walking on the moon's surface.

Look carefully at his helmet faceplate and you can see a reflection of his fellow astronaut Neil A. Armstrong taking the picture. This photograph was made during the July 1969 Apollo XI mission.

(Courtesy of NASA)

SGT. ALEXANDER KELLY, MEDAL OF HONOR WINNER
PHOTOGRAPHER UNKNOWN

This head-and-shoulders portrait of Sgt. Kelly, a Civil War Medal of Honor recipient, was displayed at the 1900 Paris Exposition. It was part of the picture collection assembled by noted African-American activist and scholar W. E. B. Du Bois to show the condition of African-Americans at the beginning of the twentieth century.

(Courtesy of the Library of Congress, Prints and Photographs Division, Washington, D.C.)

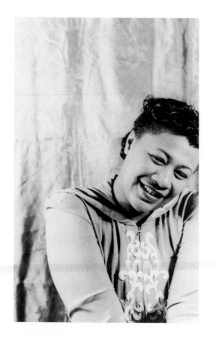

ELLA FITZGERALD
CARL VAN VECHTEN (1880–1964)

Early in his career, Van Vechten worked as both music and a dance critic for the *New York Times*. In the 1930s, he began making portraits of his large circle of friends in the arts.

Always interested in promoting black artists and writers, Van Vechten chose many of these icons as his subjects. This bust-length portrait of America's paramount jazz vocalist, Ella Fitzgerald, shot against a simple cloth background, is typical of his straightforward, no-frills approach to his art.

(Courtesy of the Library of Congress, Prints and Photographs Division, Washington, D.C.)

MAKING
PORTRAITS

MAKING PORTRAITS

A portrait is not a likeness. The moment an emotion or fact is transformed into a photograph it is no longer a fact but an opinion. There is no such thing as inaccuracy in a photograph. All photographs are accurate. None of them is the truth.

—RICHARD AVEDON

INTRODUCTION

The following portraits were made in different styles with different setups and equipment. Taken together, they provide a broad sample of what it's possible to do when one sets about the often daunting task of capturing someone's likeness with a camera.

As mentioned earlier, we have not arranged this collection of portrait spreads in any particular order. You'll not, for example, find all the portraits we shot with a two-light setup grouped together. We don't think this type of "classified" thinking is the right way to approach the study of something as subjective as portrait making.

Rather, to use a somewhat stretched analogy, we suggest that you view the following collection as a bowl of mixed fruits and that you sample them in whatever order is most appealing to you. One day, for example, you may feel like studying how we made a particular natural light image. The next day, however, it may well be one of our more complex, multiple-light portraits that most excites your curiosity.

Finally, as you make your way through this collection, please do not view the portraits it contains as examples of the "right, and only, way of doing things"—a way that you must slavishly imitate. Rather, think of the following images as examples from which you can learn techniques and approaches that will enable you to make portraits the way *you* want to—and to have some fun doing it.

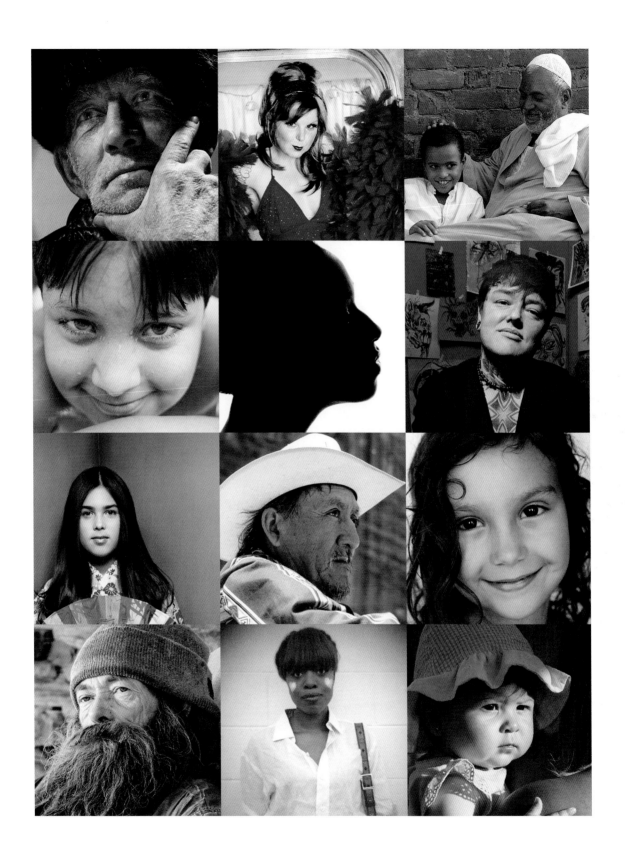

1

DOUG: A TWO-LIGHT CONFRONTATIONAL LOOK

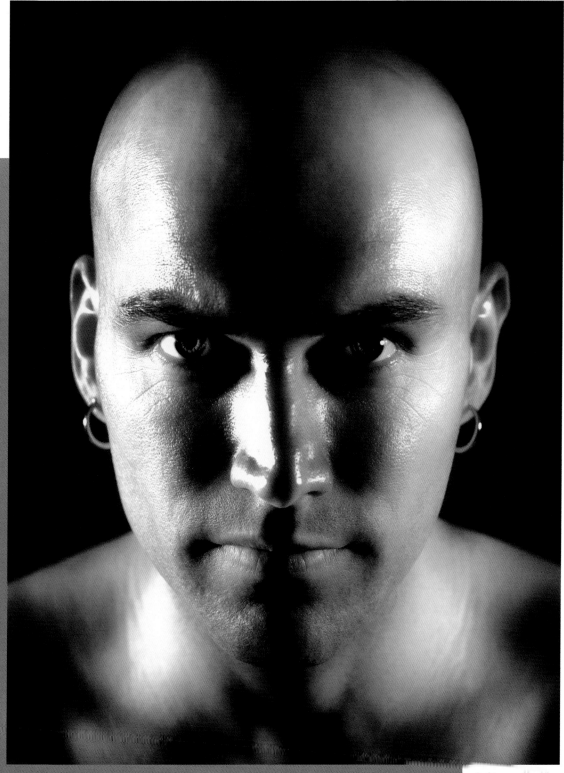

© Steven Biver

This was an interesting portrait to make. When Doug is around, you know it. He projects his personality. When he walks into a room, you know he's there. And that's exactly the aspect of Doug's character I wanted to capture. To do that, I decided to use a high-contrast and somewhat "confrontational" approach when making his portrait.

I used a very simple studio setup when shooting Doug. Besides my camera, the only other gear I used was a black background and two flash heads fitted with ten-inch reflectors. These I placed so that they were facing each other from about five feet on either side of Doug's head. Arranged in this way, they created the strong highlights and the deep shadows needed to give his portrait the high-contrast look I was after.

When the time came to take Doug's picture, I used a standard portrait lens set at *f*/8 and sat Doug about three feet in front of my camera. This lens/position combination let me fill the picture with his face. This, in turn, gave the picture the "massive" look I sought. In addition, I intensified this look by using a medium *f*-stop. This produced the depth of field needed to keep both the front and sides of Doug's face sharp, while at the same time letting the edges of his ears go slightly soft and throwing his shoulders well out of focus.

When it came time to press the shutter release, I asked Doug to lean forward and glare directly at the camera. This intense pose, on top of the high-contrast lighting, resulted in the portrait's overall edgy "confrontational" look—a look that captured at least some of what it is that makes Doug such an interesting person and portrait subject.

Finally, during postproduction, I altered Doug's portrait to sepia tones. This was a purely artistic decision. I choose to use sepia for the final portrait because I felt that the lack of any strong colors in the image as I shot it lent itself well to a monochromatic presentation.

2

LI'L DUTCH: A "RETRO," FOUR-LIGHT PORTRAIT

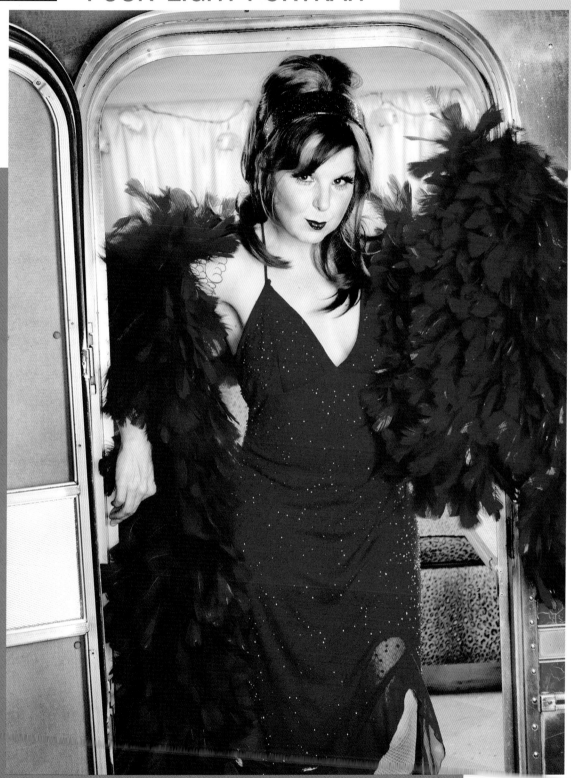

© Steven Biver

L i'l Dutch is a talented performer who has dedicated herself to the restoration of burlesque as an art form. For this portrait, I posed her in the doorway of her classic aluminum house trailer—a location that helped to give this portrait an interesting "retro" look.

I began arranging my lights by putting two small flash heads inside the trailer, one on either side of its door. I then taped a yellow gel filter to each and aimed them to bounce off of the ceiling at a 45-degree angle. Triggered by camera-activated radio slaves, these flashes flooded the trailer's interior with a rich and warm yellow light.

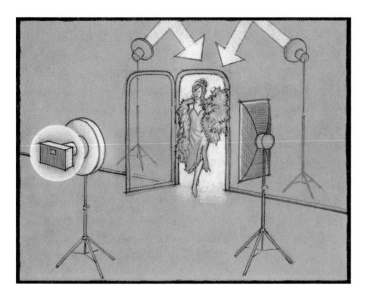

Next, I positioned my camera a dozen or so feet in front of the trailer's doorway where Li'l Dutch was standing and attached a ring light around its lens. This provided low-power fill light. In addition, the ring light also produced interesting secondary catch-lights that helped to enliven Li'l Dutch's eyes.

Finally, I put a four-foot vertical strip light slightly in front and to the right of my camera. Because I was using this as my key, or main light, I set it to provide about twice the illumination given off by the ring light.

For more information on lighting ratios, please see page 158.

3 TOM: A TWO-PORTABLE-STROBE AND AMBIENT LIGHT PORTRAIT

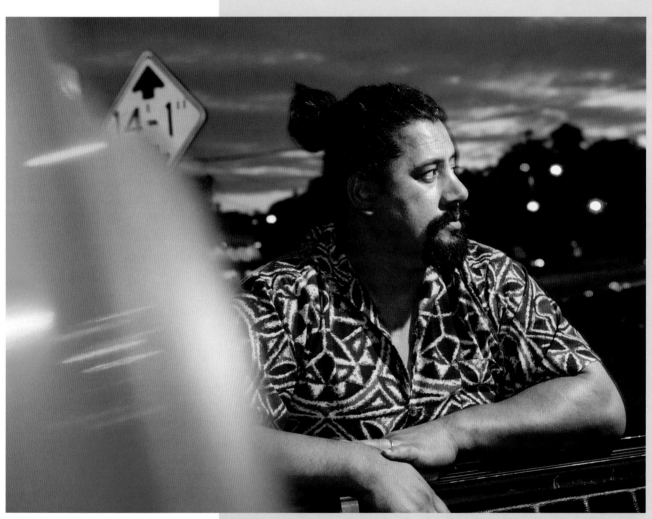

© Steven Biver

Tom has a uniquely powerful and commanding look about him. To best capture it, I decided to shoot him outside and in a somewhat unusual portrait setting—a strip mall's local parking lot. I also scheduled the shoot for early evening when there would still be a bit of summer light left in the sky. And prior to making his portrait, Tom and I agreed that he would style his hair in a traditional Maori manner and wear a boldly patterned shirt from his New Zealand homeland.

I used two small, electronically linked, portable flashes and the ambient light present from the sky and from the parking lot's lights for this shoot. My main, or key, light was a Nikon portable flash. After covering its head with amber gel to warm its light a bit, I mounted it on an eight-foot stand and positioned it at camera right and about six feet from Tom.

Next, I attached my other portable flash to my camera's hot shoe, fitted it with a spherical diffuser, and set it to fire at a low power. That done, it provided the small amount of fill needed

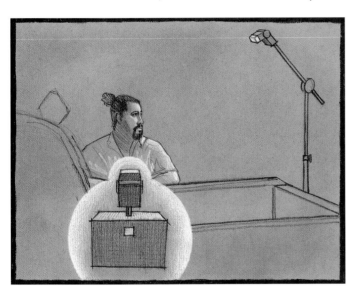

to lighten the shadows on Tom's left side. It also lit the side of the truck's cab nearest to me and produced the slightly "out-of-this-world" hotspots you see on it.

When it came time to shoot, I fitted my camera with a "normal" 50 mm lens, set my ISO at 125, my aperture at $f/5$, and my shutter speed at 1/4 second. These settings produced the slightly eerie "dragged-shutter" look I wanted for Tom's portrait. Notice, for example, the slight ghost image on the left side of his face and arm. It also let me capture the last rays of the evening sky, against which I partially silhouetted Tom's head.

See Mike's portrait on spread 35 for another example using this technique.

MAX: A SIMPLE-TO-MAKE SINGLE-LIGHT PORTRAIT

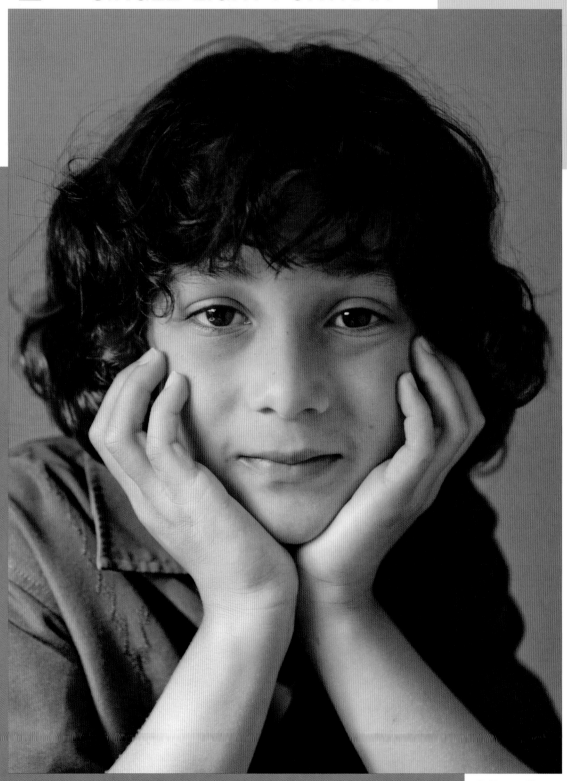

© Steven Biver

ax is a great kid. Clever, lively, and—as this portrait shows—interesting enough looking to catch the attention of any serious portrait shooter. Looking at this picture for the first time, anyone could be excused for thinking that I used an elaborate studio setup to create it. It certainly looks "professional" enough. But the fact is, nothing could be farther from the truth. That's because my setup consisted of nothing more than a worktable, an ordinary table lamp with a shade on it, and a piece of white foam board.

Putting the shoot together was simple. To start, I put a clear 150-watt bulb in the lamp and capped it with a plain white lampshade that acted as a diffuser. Next, I increased my camera's ISO setting until it gave me a shutter speed that was fast enough that I could handhold it.

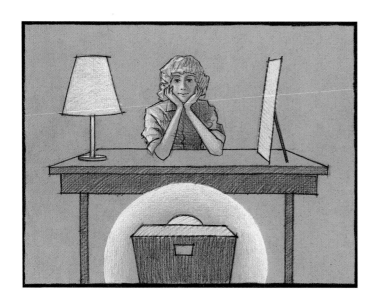

Posing Max was just as easy. First, I put my worktable far enough in front of the orange wall I was using as a background that Max's shadow would not fall on it. Next, I asked Max to sit in the middle of the table, rest his head in his hands and stare directly into my lens. I then put my lamp on the table about two feet in front of Max at camera left and moved it around until it lit the right side of his face in a way I liked.

That done, I used a piece of white foam board as a reflector to provide the fill light I needed to lighten some of the darker shadows on the left side of Max's face. When I had a look I was happy with, I propped the foam board in place and pressed my shutter release. And that's all there was to the making of this minimalist image—a "simple" portrait made using nothing but the simplest of gear.

5 SCOTT: A ONE-LIGHT FORMAL PORTRAIT IN A "REMBRANDT" STYLE

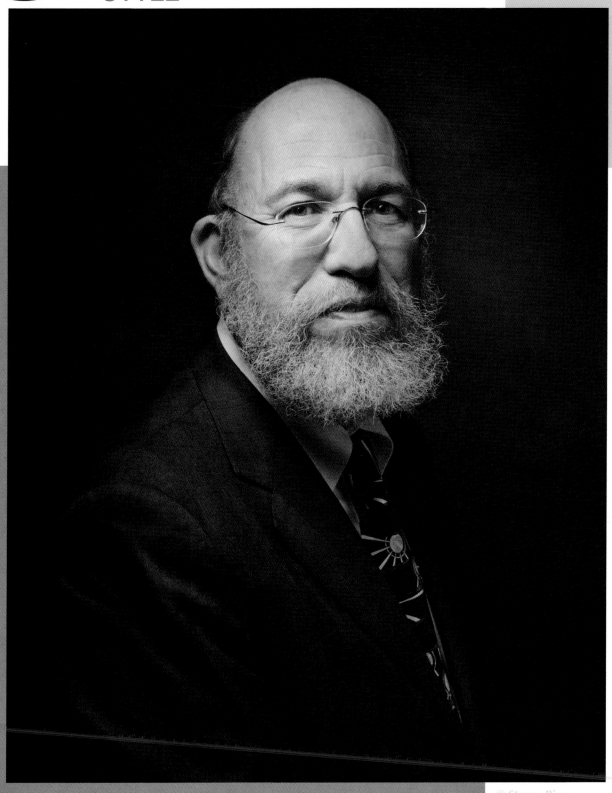

Scott is a man of learning—an expert on alternative energy. His advice is sought worldwide. He's also someone who projects a very decided presence. And these are the qualities I set out to capture when I made this photograph of him—an image that definitely leans towards the "formal" side of portraiture.

Because of the reserved, business-like look Scott wanted for his portrait, we agreed before the shoot that he would wear a dark suit and plain white shirt. We also picked a dark tie with a colorful solar design on it. This, we reasoned, would add an appropriate bit of "spot" color to the picture's overall muted tone.

The setup I used was basic. All it consisted of was the following:

• Brown, painted canvas, backdrop.

• Small (18-inch × 22-inch) soft box. This I suspended about two and a half feet above and at a 45-degree angle at camera left.

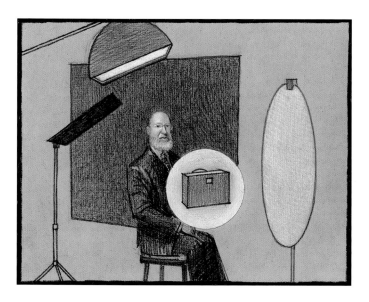

• Black flag placed where it would reduce the amount of extraneous light falling on his right shoulder.

• Reflector card. Light bouncing off it filled in some of the darker shadows on the left side of Scott's face.

This arrangement produced one of many possible variations of an approach that's sometimes described as the "Rembrandt" style of lighting. Named after the seventeenth-century Dutch artist Rembrandt van Rijn, this style results in portraits in which the subjects' faces are vibrantly lit and richly textured while their surroundings are usually darkly muted with few details visible. It's this contrast between subjects and their settings that's largely responsible for the impact that this classic approach so often generates.

6 JADE: A MIXED-LIGHT "FASHION"-STYLE PORTRAIT

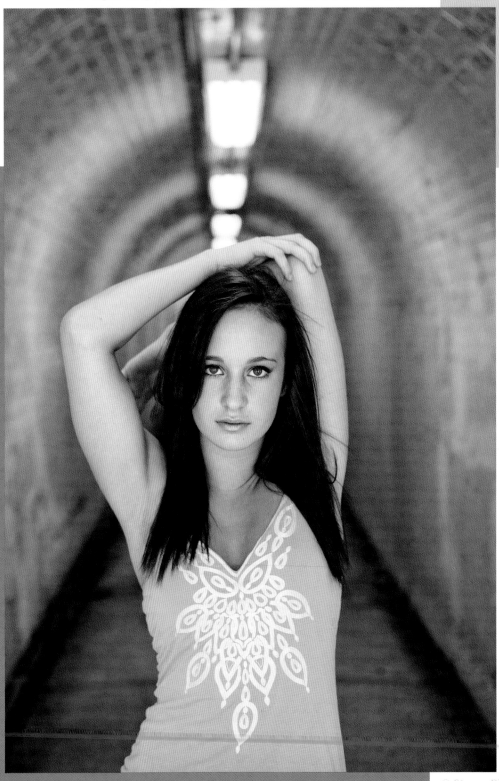

My goal with this portrait was to present Jade in a complimentary and eye-catching style. The way in which I chose to do it depended primarily on the two big "L"s of portraiture—location and lighting.

The location for the portrait that I had in mind for Jade had to clash with her striking, youthful beauty. Luckily, I found just the sort of place I was looking for—a cramped and truly filthy pedestrian tunnel under some railroad tracks. It provided the perfect "yang" to oppose Jade's "ying."

The lighting I used was a mixture of ambient light and flash from a small portable unit. The ambient light was a combination of mixed-color fluorescent fixtures and indirect sunlight that—

because of our location near its entrance and the bright, sunny day—bounced off the tunnel's ceiling, walls, and floor and onto Jade.

When I was ready to shoot, I rigged my flash to fire into a small silver-lined umbrella. This I set on low power and positioned to my right. The additional light this unit produced helped to give Jade's skin an attractive, youthful glow and added a little sparkle to her eyes.

Together, the ambient light present in the tunnel, and the flash I added to it, combined to produce the soft, free of hard shadows look I wanted for Jade. In addition, because I shot at 1/60 at f/3.5, thus throwing the tunnel around her well out of focus, Jade "jumps out" from her filthy, desolate setting to produce both an attractive and eye-catching image.

7 LARRY: A FULL-SUN, NATURAL-LIGHT PORTRAIT

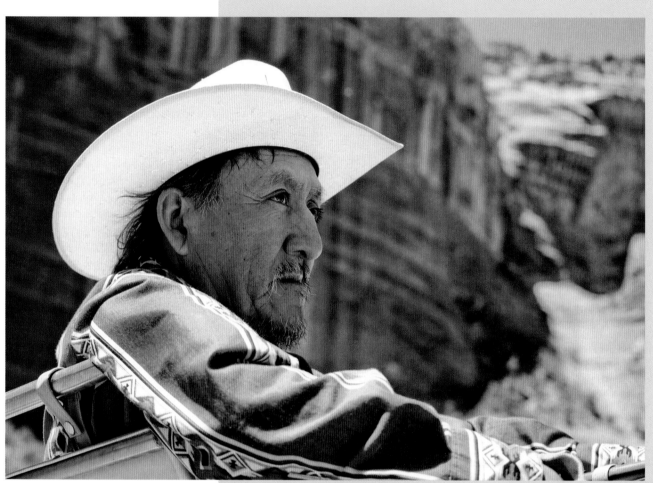

© Paul Fuqua

Just about every photography book warns against taking pictures of people in full sun. And they are right. To do so is perilous portraiture in its purist form. The midday sun almost always produces harsh, hard-edged shadows. To make matters even worse, it also "bleaches" or reduces the color saturation of the scene. However, despite all of this, there are those times when a picture's potential is so rich that I just have to go after it—bad light or not. This was one of those times. Larry, my subject, is a hard-working man, and that particular afternoon his already interesting face looked tired and strained from hours of navigating what are surely some of the most torturous roads in North America. And that stress was exactly what I wanted to capture in his portrait.

To record Larry's weary look the way I wanted to, I first positioned him so that a nearby cliff face rising high above the valley floor where we were provided a relatively dark background. I then framed the picture so that when I shot it from below his eye line, Larry's hat provided a natural top, or "roof," to the composition, while his right shoulder and arm made a bottom for it. This arrangement produced a "V on its side"–shaped composition that highlighted Larry's face inside its narrower end.

At that point, dumb luck came to my aid in a very big way. As chance would have it, Larry's straw cowboy hat was translucent, and that caused it to act as a diffuser. Thanks to that, and because the mid-day sun was almost directly over his head, Larry's face was bathed in nearly ideal soft portrait-making light. In addition, even more light was reflected onto Larry from his surroundings so that they acted as giant reflectors bouncing fill light up from the brilliantly lit desert floor and onto him.

And so it was that the combination of careful positioning and extraordinary luck let me come away from a burning desert day with a portrait of a hard-working man.

Please see page 135 for more information on diffusers.

8
THE NEW STANDARD:
A COMPOSITE PORTRAIT

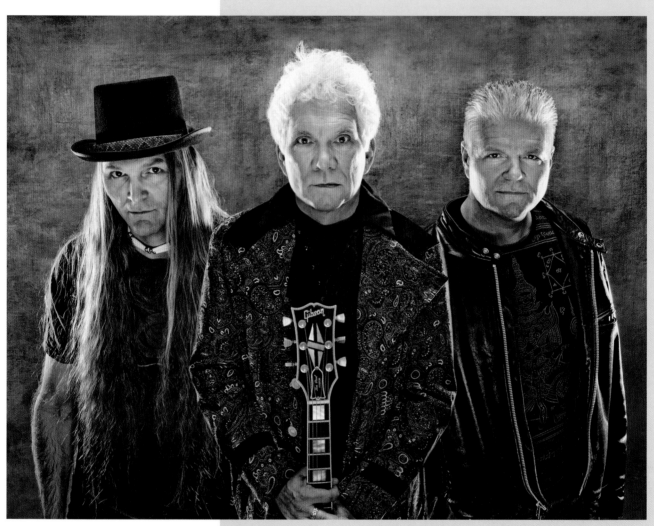

© Steven Biver

Shot as a music CD cover for the New Standard band, I wanted this to be an eye-catching, over-the-top portrait. I wanted to show the band in a way that would grab potential customers' attention the moment they saw the cover. To achieve the excitement needed for that, I decided to take what's often called a "hyperrealistic" approach to the making of this group portrait. That's to say, I chose to use the kind of intense and unusual lighting that would show the band's members in a striking and campy manner.

Along with using high-impact lighting, I also asked the band's members to bring a collection of different clothes to the shoot. From this wardrobe, I chose tones and patterns that would add to the hyper—"over the top" look I was after. Finally, I added a guitar as a prop to help tie the picture together.

Because of the lighting I wanted to use, and because I was not sure that all three band members would be available at the same time, I decided to shoot each separately. Later, during postproduction, I would combine the three individual images into one finished "group" portrait. This approach took some planning.

To make sure that each band member stood in the right place, I marked the floor where each should stand. In addition, because I wanted the faces of the band's three members to be in about the same general plane, I provided an "apple box," or small platform, on which the shortest could stand.

My setup for this picture used a mottled blue and gray painted canvas backdrop and four lights. After hanging the backdrop, I set a small (10-inch \times 32-inch) strip light horizontally in front of and under my camera. This lit my subjects' front and produced interesting catch lights in their eyes.

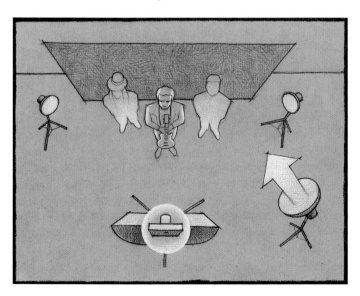

Next, I rigged a flash fitted with a 12-inch reflector on a stand so that it was behind and above where my subjects would stand. Light from it bounced off the ceiling adding fill light from above to the entire scene.

Finally, I set two flash heads fitted with 7-inch reflectors on 4-foot-high stands behind and on either side of where my subjects stood. These rimmed the band member's bodies and faces with light that not only illuminated them, but that also clearly differentiated them from each other in the final composited image.

For more information on compositing portraits, please see page 153.

9 TESSA: A THREE-LIGHT, BRIGHT, AND NATURAL LOOK

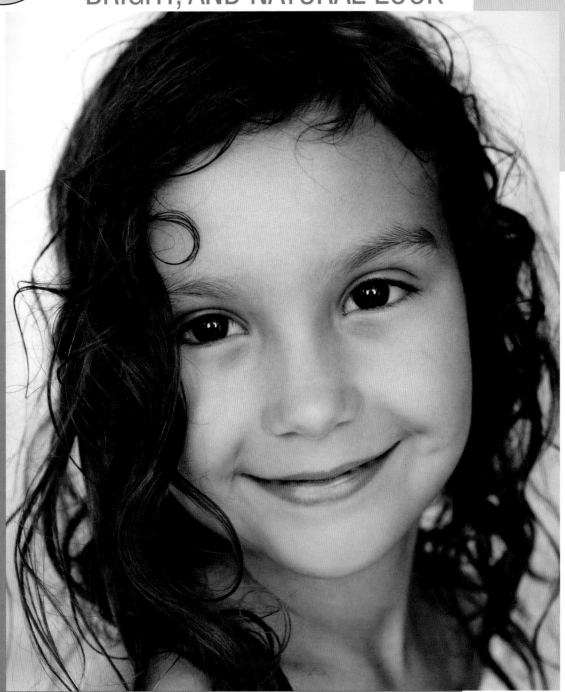

© Steven Biver

essa is a high-voltage package brimming with charm. Good-natured, and a ham to the core—to put it mildly, she is a "Here I am" kind of a kid. And that overflowing youthful energy is exactly what I sought to bring out when I made this portrait of her. To get the high-key, "up" look I wanted, I decided to picture Tessa against a bright, sky-like setting that I would create in my studio.

To get started, I hung a mottled blue and silver painted canvas backdrop. When photographed, it looked much like a bright, morning sky and helped to produce the soft, "natural light" look. Next, I set up a large (4-foot × 8-foot) silver reflector panel several feet behind my camera and lit it with two medium-sized soft boxes. I placed one of these at and in front of each corner of the panel and aimed it at it at a 45-degree angle to it. The light this arrangement produced had a soft and somewhat specular quality to it that helped to emphasize the flawless, iridescent nature of Tessa's youthful skin.

The final light I used was a flash head rigged to reflect from a white umbrella. This I put to the left of the camera and slightly behind Tessa. So positioned, it helped to illuminate the background. In addition, it also provided a little extra fill light on Tessa's right side.

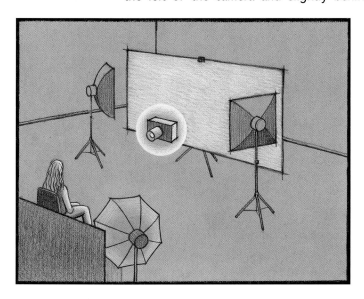

The proper depth of field was critical to the success of this image. I needed to work with a shallow one if I was to create the portrait I had in my mind. To do that, I used a 60 mm focal length on my lens, set its aperture at f/3.5, and focused carefully on Tessa's eyes. By doing this, I was able to keep the front of her face in sharp focus while at the same time letting her neck, shoulders, and much of her hair fall off out of focus. This—plus the slight line produced by the delicate shadow under her chin—helped to direct her portrait's viewers to Tessa's sharply defined face and all that it reveals about her boundless, youthful energy.

AX: A TWO-COLOR, GELLED LIGHTS PORTRAIT

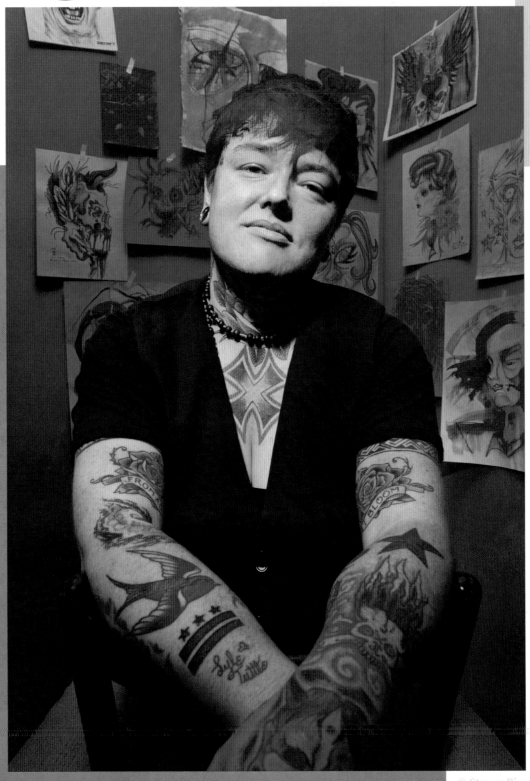

A x is a serious artist, educated as a geophysicist; since early childhood, she has been devoted to drawing and painting. Presently in what she calls her "skin period," Ax is now a much sought-after tattooist. The major challenge I faced in making her portrait was to find an interesting way in which to show both Ax and her art in the same image.

My first step was to tape several of Ax's paintings on the walls behind her. I then seated her, with her arms over a chair back, several feet in front of them. Next, I positioned a flash head with a 12-inch reflector to which I'd taped blue gel about three and a half feet above Ax's head. This I aimed at the studio ceiling. When fired, light from it bounced off the ceiling and flooded Ax and the wall behind her with an intense and highly saturated blue light.

I then placed a tight grid-spot that I'd covered with amber-colored gel at camera left, about three feet above Ax's head and aimed it down toward her body at a 45-degree angle. When fired, this spotlight—because of its intensity, position, and the angle at which it was aimed—lit Ax's head, face, and upper body with a concentrated amber light. This overpowered the blue light bounced from the ceiling above her and then faded off back to blue toward the picture's background and edges. The result is a bold, highly color-saturated, "Ax as the artist" portrait. In it, a brightly lit Ax "pops" out of a dark blue setting that shows her art on the wall behind her.

A note on using colored gels. Covering lights with colored gels can, and frequently does, produce dramatic, eye-catching results. Unfortunately, when using this technique, it can prove difficult to get the exact color effect you're after.

The only way to be sure of the color gels are going to produce is to test them on a subject before your final shoot. This is extra work—but it's the kind of work that often spells the difference between success and failure. You can, of course, also make minor color adjustments later during postproduction.

11 FATHER AND SON: A "RELATIONSHIP" STREET PORTRAIT SHOT WITH AMBIENT LIGHT

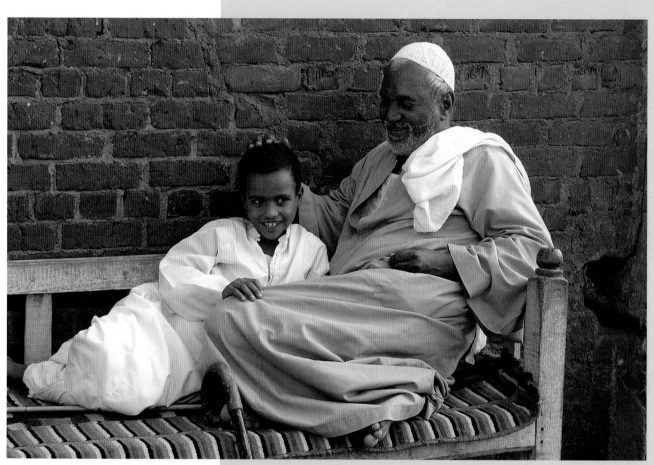

© Paul Fuqua

shot this portrait of a father and his son early one morning at a camel market near Cairo, Egypt. It's a classic example of a street portrait that shows more than just what people look like. It also captures the relationship between them.

You need to work quickly when the opportunity for a picture such as this one strikes. The magic of a moment is a fleeting thing. In an instant, what was the perfect scene can melt away. Unfortunately, it can also change into a nasty confrontation. This is particularly true when you are working in those parts of the world where strangers—especially Americans such as me—are often less than beloved. With that in mind, I usually shoot in RAW with my camera set on either the Programmed Automatic or the Aperture Priority modes. Purists sometimes frown upon this approach, but it works for me. Not only does it allow me to shoot fast, but it also almost always gives me exposures that I can live with.

Whenever possible, I prefer shooting with available light. It gives by far the most natural look—by far the best "feel" or authenticity—to street scenes. In the case of this picture, I was unusually fortunate. Beautiful, direct morning "desert" sunlight was streaming into the scene from the right. In addition, the sky provided just the right amount of ambient fill for the look I wanted.

Of course, no matter how much I prefer to shoot by ambient light alone, there are those times when I must pump some extra light to a scene. In such cases, I like to use an off-camera flash with some sort of small diffusion device attached to it. In addition, when working the street, I always wear light-colored shirts or jackets. In a pinch, these let me bounce my flash off of my body and onto my subjects. Crude lighting? Well, yes, but it can save a picture.

Handheld reflectors are available, and they can be a wonderful source of light in many shooting situations. However, I have found them to be too bulky and attention getting for most street shooting situations.

For more information on the many joys and tribulations of "street" shooting please see page 116.

PAUL: A HARD-EDGED, MAINLY DARK PORTRAIT

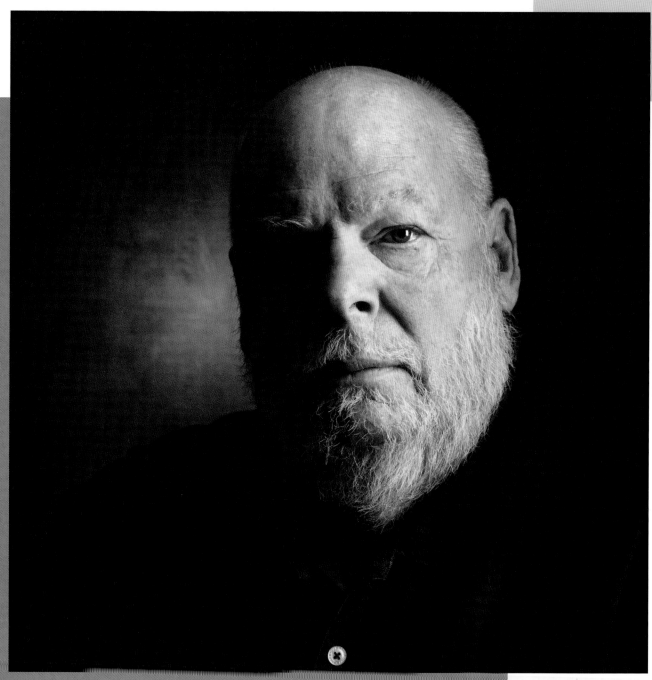

This is the second portrait I've taken of my coauthor, Paul (please see portrait on spread 31 for the first one). I shot the first using two diffused light sources—partial shade and direct sun shining through a diffusion screen. The resulting photograph was exactly what I wanted, a somewhat "soft," low-contrast image. This time, however, I was after something very different. This time I wanted a portrait of Paul with a hard-edged, mainly dark look.

I began this project by hanging the same mottled gray painted canvas backdrop I used when I shot my first portrait of Paul. Next, I placed a posing stool about seven feet in front of it. I then set up a table on which Paul could rest his arms and draped it with black velvet.

This draping was critical. Black velvet is an effective "light eater." If I had not draped the posing table with it, light bouncing off its surface would have added unwanted fill light to the scene, thus opening up, or lightening, some of the image's dark shadows. This, in turn, would have compromised the stark, high-contrast look I sought to create.

Next, I began arranging the lights I was going to use. The first was a large sized (3-foot × 4-foot) soft box. This was my main light and I put it close to Paul at camera right. I then placed a large (2-foot × 4-foot) vertical flag between it and Paul's head. This I feathered so that less light fell on the back of Paul's head than on the front.

This arrangement also helped to prevent unwanted extraneous light falling on the background.

I then placed a large (30-inch × 40-inch) sheet of black foam board at camera left and about a foot from Paul's head. This helped to block any extraneous light bouncing from nearby walls from adding unwanted fill light to the right side of his face. Finally, I finished my setup by attaching a small, tightly focused grid at camera left, aimed so that it projected a bright circle of light onto the backdrop behind him.

The product of my labors was what I wanted—a dramatic, richly textured, and high-contrast portrait of Paul.

CHILD IN THE SUN:
AN AMBIENT VIGNETTE

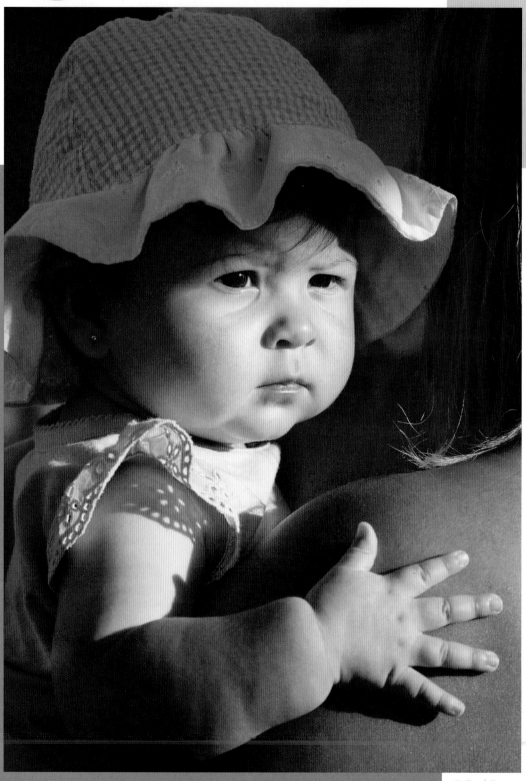

© Paul Fuqua

One of the great thrills of street shooting is having a wonderful picture suddenly materialize before your eyes. And that's exactly how this portrait came to be made. Camera in hand, I was prowling about a local county fair when I saw this little girl. She was fixated on a particularly noisy nearby carnival ride, and her little face showed that in a most charming way.

All the elements of a great street portrait were there, right in front of me, except for one—light. When I first spied them, the little one and her mother were standing in the deep shade cast by an overhead awning. There was nothing for me to do but hope that mom would step into the sun before her child lost interest and moved. And, remarkably, that's exactly what happened,

producing quite by chance the natural vignetting—and its resulting tonal differences—that give this portrait so much of its punch.

Of course, the time of day also helped. It was late in the afternoon and the sunlight had a beautiful, rich, warm tone to it. In addition, as it was low in the sky, the sun shaped some obvious and clearly formed shadows and highlights. These helped both to define and to give form to the little girl's body and to separate her visually from her background.

A charming child, a wonderful pose, and textbook perfect light—yes, we who love to roam the streets in search of "the" picture do get very lucky every now and then.

PRATIMA: A TWO-LIGHT RELAXED PORTRAIT

© Steven Biver

Pratima is a woman blessed with a simple, elegant beauty, and that is what I wanted to capture in her portrait. To do that, I decided to take a very basic "at-home," approach to photographing her.

We planned in advance to photograph her at a friend's house. Though I had been there only a few minutes, I could see that there were several places where I could get the kind of pose I was after from her. She also, as I asked, agreed to wear a simple, light-colored top for the shoot. It would, I thought, contrast well with her slightly darker complexion.

Once I decided to shoot into the hallway, I set up my main light in front of Pratima. It was a medium-sized (22-inch × 28-inch) soft box that I attached to a small stand and put about six feet in front of her, on the left of and close to my camera.

I then attached a flash fitted with small silver-lined umbrella attached to a small stand and put it on the right side of my camera, about ten feet in front of where Pratima stood. This provided fill light, as did ambient light filtering in from the windows in front of which she was standing.

When the time came to shoot, I asked Pratima to relax against the side of doorway where she was posing and look straight into my lens. The result was a "relaxed" informal portrait of an elegantly beautiful young woman.

LYNN: A FOUR-LIGHT PORTRAIT IN A "MOVIE-POSTER" STYLE

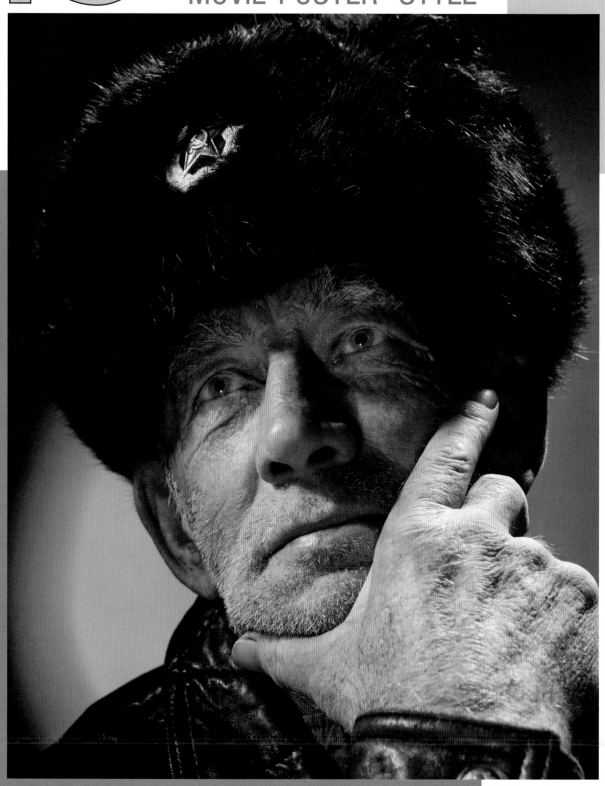

© Steven Biver

ynn has tough, hard-edged looks that are perfectly suited for a dramatically lit portrait. He's also blessed with the ability to effortlessly assume any pose or persona. With this in mind, I decided to shoot his portrait in the stark and contrasty style of vintage noir movie posters.

Before the shoot, Lynn and I met and agreed that he would wear a dark leather jacket and a Russian army officer's fur cap for his portrait sitting. These, I knew, would contrast starkly with Lynn's very light skin. In addition, because I wanted his face to appear a bit on the rough side, I asked him not to shave for two days before we shot.

The first thing I did to set up for this shoot was to hang a blue, seamless paper backdrop. This brought an element of color into the image. Next, I arranged the four lights I planned to use. These consisted of the following:

• **Optical spot.** I used this light to project a bright, clearly defined circle of light on the backdrop behind Lynn.

• **Large Fresnel.** This served as my key light. Mounted on an eight-foot stand, I placed it in front of Lynn, at camera left and about seven feet away from him. From this location, it projected a hard, shadow-making light across Lynn's face and body. I then put a long black flag in front of the Fresnel. This I used to help control the light from it spilling on the background.

• **Grid spot.** Mounted on an eight-foot stand, I put this light about three feet behind Lynn and to camera right. Light from it helped to illuminate the left side of Lynn's hat, head, and body.

As was the case with the Fresnel, I also used a flag in front of this light to help control where light from it went.

• **Small flash.** This I put on a three-foot stand and placed beside my camera to my left, about four feet in front of Lynn. It gave off light that filled shadow areas in his face and also produced specular catch lights.

When it came time to shoot, I sat Lynn on a stool, put a table in front of him on which he could rest his arms, worked out the final pose, and adjusted my lights.

During postproduction, I adjusted the image's contrast and color. This gave the finished portrait the slightly faded "retro" look I wanted.

16

YOUGESHWAR: A RING LIGHT PORTRAIT

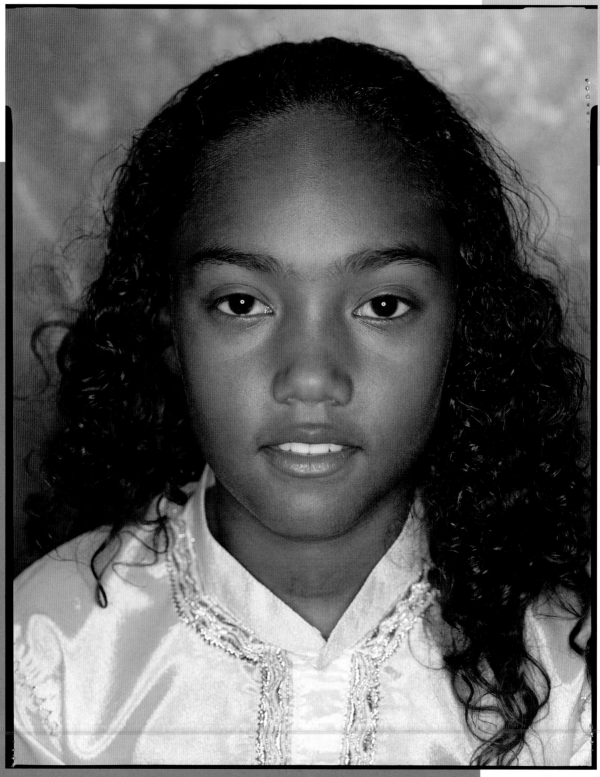

Yougeshwar is a very bright and pleasantly energetic young man. He's also blessed with the sort of joyful personality that makes him fun to be around. These were the traits that I was trying to capture in this portrait of him.

The setup I decided to use in the making of it was simple enough. The first thing I did was to paint a large (4-foot × 6-foot) sheet of plywood a bright, mottled orange. Once that was dry, I then finished the background by adding random streaks of gold paint to it.

On the day of the shoot, I suspended a large (3-foot × 4-foot) soft box about a foot in front of my newly painted backdrop and about five feet above Yougeshwar's head. Next, I attached a ring light to the front of the lens of the 4 × 5 view camera I was using. When positioned where I wanted it, this light was about three feet in front of Yougeshwar's face and a few inches above his eye level.

As you can see from his portrait, this combination of a ring light and an added top light fill produces an interesting, and to me, pleasing, pattern of highlights and darker tones on Yougeshwar's face, hair, and clothing. And, in addition—because of the huge amount of visual information a sheet of 4 × 5 film captures—the details and range of tones in Yougeshwar's portrait absolutely jump out at its viewers.

Along those same lines, an interesting feature of this portrait is the catch lights in Yougeshwar's eyes. They're circular—reflections of the ring light's shape, and a characteristic of images shot using one.

17

EDITH: A WINDOW-LIGHT PORTRAIT

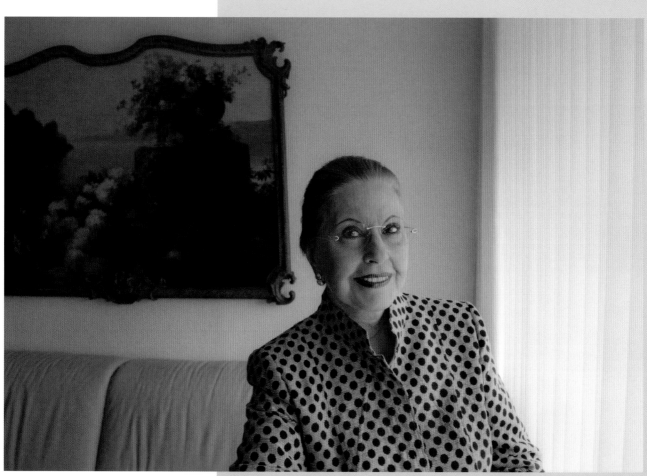

© Steven Biver

Edith is a charming and elegantly fashionable lady—a subject ideally suited for a "high-production" studio portrait. The problem with that, however, was that my only opportunity to photograph her was on a day when she was in her apartment and the only gear at hand was my camera. Fortunately, what *was* available was a tasteful room setting and a large window draped with sheer white curtains—everything, in other words—needed to shoot a classic window-light portrait.

I began by positioning Edith between a painting on her living room wall and a large window. This window, as I have said, was draped with sheer white curtains. These helped to diffuse and thus soften the light coming in through the window.

Because the day on which I made Edith's portrait was only partially sunny, this light was not quite as bright as I would have liked. With that in mind, I boosted my ISO to 200 and set my shutter to the relatively slow speed of 1/60 second and my aperture to $f/5$. Along with letting me work with nothing but available light, these settings produced the shallow depth of field needed to throw Edith's background slightly out of focus, thus producing the look I wanted for her surroundings.

The result of this simple but effective setup was a classic environmental portrait of a strikingly elegant lady in her beautiful home.

A note on using a horizontal format for portraits. We shot many of the portraits in this book using either square or vertical formats. We did this because we liked the results such framing produced. However, in those cases—such as with Edith's portrait—when we felt that it would help a portrait to connect its subject closely to his or her surrounding, we frequently chose the more visually expansive horizontal format.

18 DEREK: A PORTABLE-STROBE AND AMBIENT-LIGHT STREET PORTRAIT

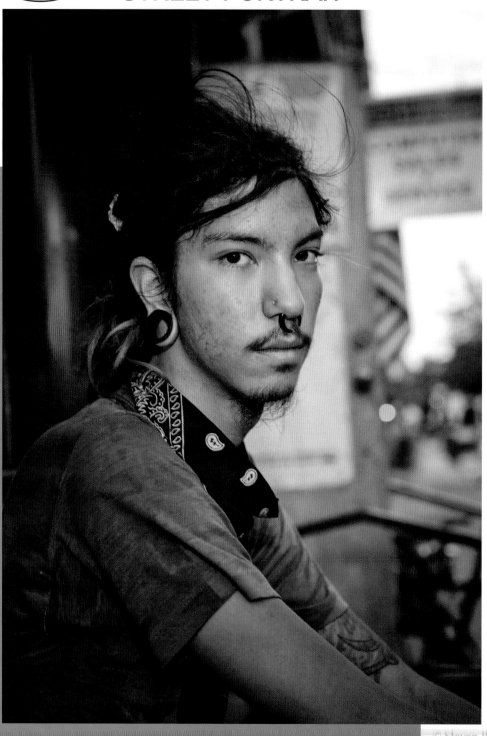

© Steven Biver

f you want to take engaging portraits, find engaging people. Those widely spouted words of portrait-making wisdom are what brought me to Derek.

I was driving when I saw Derek sitting on a stoop. He certainly looked interesting, and he didn't seem to be doing much of anything besides watching the world go by, so I stopped, introduced myself, and, with his permission, began shooting his portrait.

Because it was early evening and the light was fading fast, I decided to use a flash. Usually, I try to avoid doing this when I'm street shooting. That's because in most cases I think

adding light to a street portrait also adds an air of artificiality to it that I don't care for. To avoid this, I set my strobe on as low a power as I could. Hopefully, at this setting I would get enough light to bring Derek's features out nicely without causing his portrait to appear too artificially bright.

In addition, prior to shooting, I mounted the flash on a bracket that held it about a foot above my lens. So positioned, light from it did not reflect from the interior of Derek's eyes and thus produce that troublesome "red-eye" look that often results from shooting with an on-camera flash. However, my flash did reflect in Derek's eyes in such a way as to produce catch lights that added a pleasant bit of sparkle to his eyes.

19

ALEXIS: A THREE-LIGHT PORTRAIT IN PROFILE

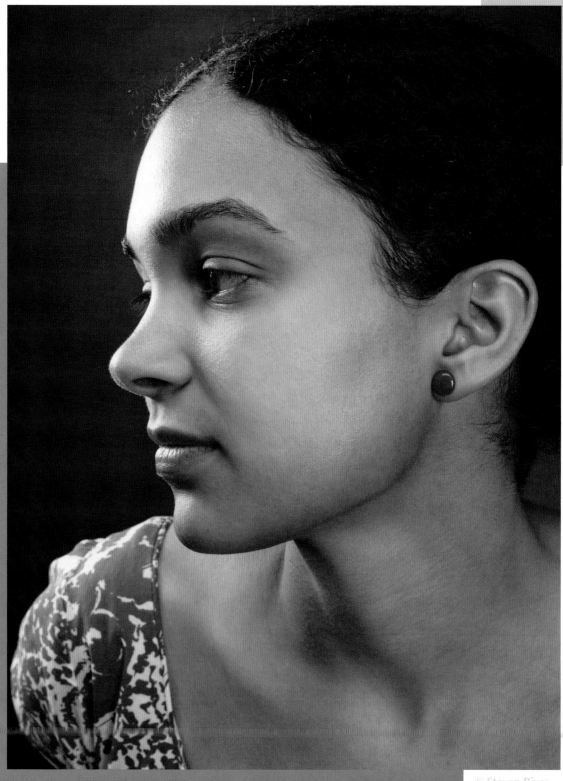

54

Alexis is blessed with the sort of beautiful, sculpted face that lends itself to a portrait that's shot in profile. In addition, her dark hair contrasts with her lighter skin tones in a very striking way. It was these two features that guided my approach to photographing her.

Because my original intention had been to make a color portrait of Alexis, I began by hanging a dark-red painted canvas backdrop. I then set up a small soft box (22-inch × 28-inch) behind and to the side of her at camera left. This produced the strong highlights you see on her forehead, nose, lips, and shoulders. These are vital to the portrait. Not only do they help to separate Alexis from the background's considerably darker tones but they also help to give critical shape and form to her features.

The second light I used was a small silver umbrella. I put it close to and on the right side of my camera. It provided specular fill light. This light—because of umbrella's silver foil lining—gave a lovely glowing silvery iridescence to Alexis' skin. This iridescence became even more evident when I converted the image from the color in which I originally shot it to the black and white of the final portrait.

Finally, I suspended a medium-sized soft box (2-foot × 3-foot) directly over Alexis' head, setting its intensity low enough that it illuminated the top of her head and shoulders without competing with light from the silver umbrella I had set up earlier. This overhead light also produced a shadow line along the bottom of Alexis' chin. This line is important. It helps to "frame" and thus accentuate her facial features—the most important element of nearly all portraits.

20

MARK: ONE LIGHT ON WHITE

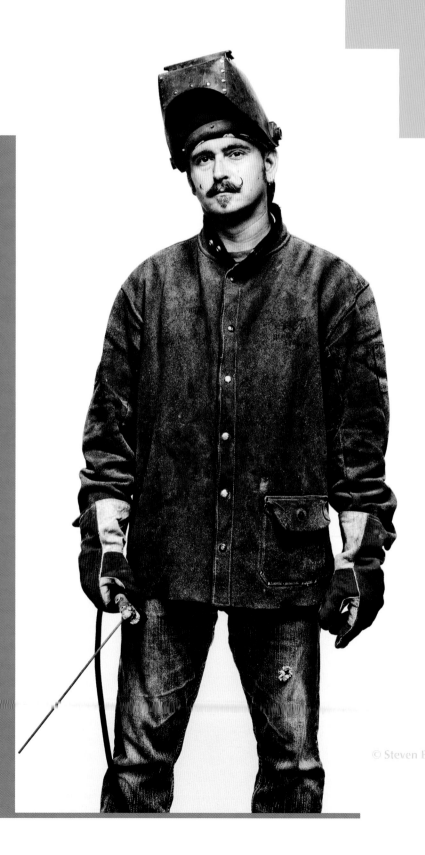

© Steven Biver

My goal with Mark, a master welder, was to make a classic "craftsman with his tools" portrait. There are two tried-and-true ways of creating such an image. One is to show workers in their actual work environments. The other is to picture them isolated from their workplaces but with some tool, or other item, that identifies their trade. I chose the latter—a less literal and more symbolic approach.

I began the session by standing Mark, dressed in his welding gear, about 4 feet in front of a plain white seamless paper backdrop. Next, I put a 4.5-foot-diameter white shoot-through umbrella with a flash head mounted in it several feet above and in front of his head. This setup

prevented Mark's body from casting any distracting shadows on the backdrop. It also added a slight, pleasing intensity gradation to the portrait by casting a bit more light on Mark's head and upper torso than on the lower part of his body.

In addition, because the backdrop was several feet farther from the light source than Mark was, it photographed slightly darker than he did. This minor tonal difference, in turn, prevented the background from appearing as a simple pure white—something I didn't want for this portrait.

Finally, during postproduction I tweaked the image digitally to increase its contrast range a bit. This added more texture to the final portrait. In addition, it also boosted both the brightness and the saturation of its colors.

NIGEL: A MINIMAL APPROACH

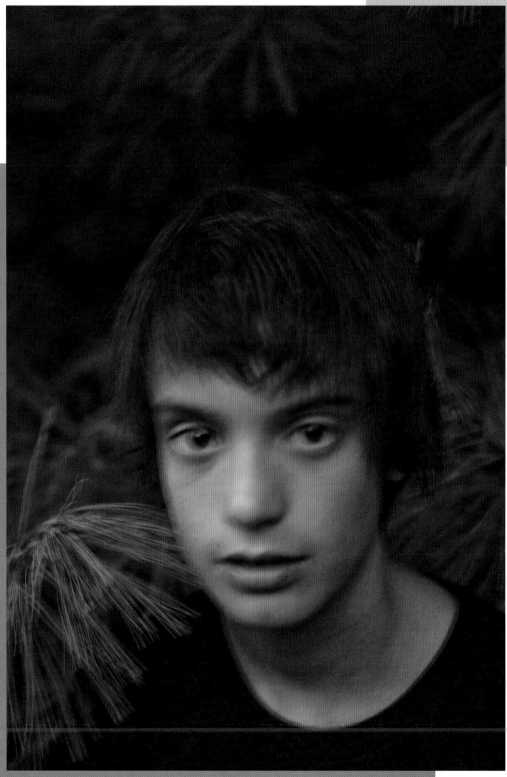

Most portraits are realistic—that is, representational. We make them to record for all time what Aunt Mary or Uncle Joe "really" looks like. We then tuck these images away in albums and scrapbooks or burn them by the millions to computer disks and flash drives, all so that in the years to come we can, in some small measure, recapture frozen glimpses of looks long gone.

And then there are portraits such as this one I recently made of Nigel. Its purpose is different. In no way was I driven by realism in taking it. I did not make this picture to accurately record for posterity exactly what a certain 12-year-old boy, who happens to be my son, looked like at a given place and during a specific micro moment in time.

Rather, my purpose in making this portrait was more abstract: more minimalist. Rather than trying to record a realistic image of a boy standing in a garden in at dusk, I sought to create a reaction from viewers that was produced by a picture from which I had removed everything I deemed unessential, thus reducing the final image to its core—its most telling visual elements. I decided to attempt this by shooting an overwhelmingly dark image—an image that I intentionally abstracted by shooting in the early evening without benefit of either a light or a tripod.

To accomplish this, I set my camera at a high ISO, chose an aperture that would result in a shallow depth of field and used long exposures ranging from 1/2 to 3 seconds. Working at such extremes is always a crapshoot. But, let's face it, that's one of the things that makes the art of portrait shooting so exhilarating.

Later, during postproduction, I added a blue overtone to the entire image. The final result of my efforts is a moody, slightly blurred and textured portrait of a boy staring into my lens. And, to paraphrase the noted minimalist painter Frank Stella, "What you see in it, is what you see."

LAURA: A TWO-LIGHT POISED LOOK

Laura is a poised and serene person. She is also someone who has developed her own distinctively personal "look." And those were exactly the qualities that I wanted to bring out when I made this portrait of her.

I used two lights set next to each other behind my camera and about six feet from Laura to make this picture. My main light was a large (4-foot × 6-foot) soft box, or as it is sometimes called, bank light. The other was a 4-foot-long strip light.

Because the soft box was large in relation to Laura, light from it "wrapped" her in a soft, frontal illumination. It then fell off behind, her producing a noticeably darker background. Thanks to the glowing, porcelain-like quality of Laura's complexion, light from the soft box also highlighted her face and caused it to stand out—and thus dominate—her portrait.

The strip light helped Laura's portrait in two ways. First, it added a bit of needed fill light on the right side of her face and shoulders. Second, its reflection produced pleasing catchlights that both enlivened and added sparkle to Laura's eyes.

Because of the contemplative appearance I wanted, I posed Laura in a classic three-quarter side-shoulder pose, using the back of her chair for support. I then asked her to stare directly at the camera with as little expression on her face as possible. This stability of this arrangement, and the resulting lack of visual tension it produced—plus the muted colors of Laura's cloths and surroundings—helped to give her portrait the look I was after.

I used a 4 × 5 camera positioned slightly above Laura's eyes to make this portrait. Because of the innate flexibility of the format, this position allowed me to shoot using the shallow depth of field needed to throw her left shoulder and the background out of focus while keeping her face perfectly sharp.

23 CAPTAIN JAY: A "CLOSE AND WIDE" PORTRAIT MADE WITH A POINT-AND-SHOOT CAMERA

© Paul Fuqua

I t was early evening when I took this picture of Captain Jay on a Virginia dock. My reason for making his portrait was purely creative. Captain Jay has a great face, he was in an interesting place, and the fast-falling sun was bathing the scene in that beautiful glow it often produces just before falling below the horizon. If there are such things as portraits just waiting to be taken, that evening Captain Jay's was one of them.

I wanted Captain Jay's face to dominate the picture I set out to make of him. However, I also wanted enough of his surroundings to show that anybody seeing his portrait would recognize the environment of which Captain Jay was a part. To accomplish this, I framed his portrait horizontally and then moved close enough that his face, which I positioned off-center, was clearly the most important part of my composition.

This kind of portrait shooting is sometimes called working "close and wide." In this case—because I don't have much of a zoom on the point-and-shoot camera I was using—I had to stand within three feet of Captain Jay's face to be able to frame it the way I wanted for his portrait.

Finally, I set my camera to shoot using its built-in "Portrait" mode and focused carefully on Captain Jay's eyes. This automatically forced the camera to use the shallow depth-of-field-producing aperture of $f/4.2$ and a focal length of just over 100 mm. The result was a nicely colored portrait in which the good captain's sharply focused face stands out clearly against the out-of-focus background of his waterman's world.

24 DENNIS: A HIGH-KEY, MIXED-LIGHT ENVIRONMENTAL PORTRAIT

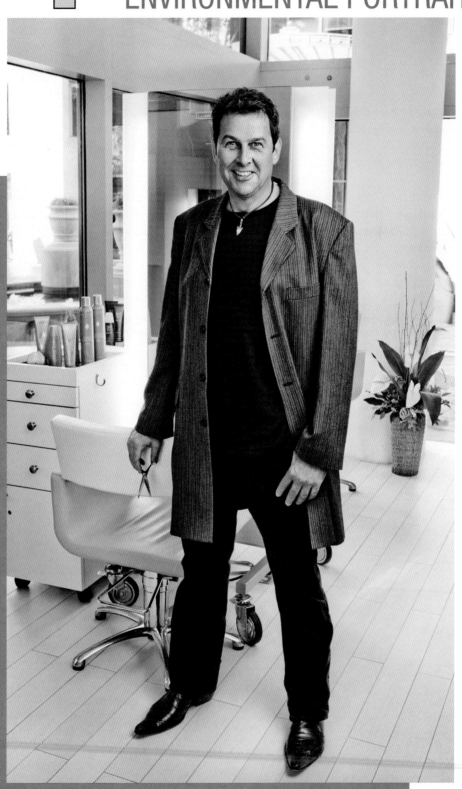

© Steven Biver

y friend Dennis is the owner of a very high-end architecturally striking beauty salon. And that is where he wanted his portrait made. With a basically white-all-over-everything interior and huge windows looking out onto a sunlight-flooded plaza, this was a project that cried out for a bright, high-key treatment.

With that in mind, I posed Dennis next to one of his workstations and close to a large, floor-to-ceiling window. I then set a small (10-inch × 32-inch) strip box at camera left and about three feet from the floor and aimed it up at his face. That in place, I then suspended a large (4.5-foot-diameter), octagonal soft box on a stand about eight feet from the floor at camera right. This was my main, or key, light.

Lights in place, I asked Dennis to hold a pair of scissors. They acted as a "clue" to his vocation. Finally, I put a floral decoration behind him and to his left to help delineate that edge of the scene.

Prior to the shoot we had agreed that he would wear dark clothes. As you can see from the finished portrait, these helped to emphasize and draw attention from his light-toned background.

The day on which we shot was exceptionally bright and sunny. As a result, a great deal of light poured through the window near which Dennis was standing and onto him and his mostly white surroundings. The challenge was to balance it correctly with the light the flashes gave off. Too much of either source would ruin the look I was after for this portrait. But that, after all, is exactly what trial exposures are for. And after a number of them, I captured the look I was after—that of an energetic, high-key kind of a guy in his mixed-light, high-key surroundings.

25

CAROLYN: A THREE-LIGHT PORTRAIT IN BLACK AND WHITE

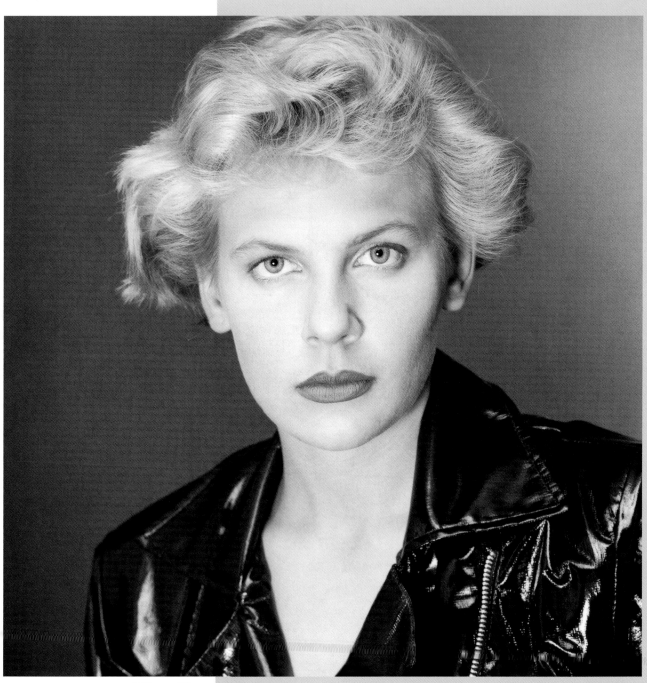

© Steven Biver

And just how does one shoot a portrait of a young woman with very white skin and very blond hair who is wearing a very black and shiny leather jacket? That was the question posed in the making of Carolyn's portrait. Fortunately, the answer that came to me was straightforward enough: "You shoot it on black-and-white film." And that's what I did.

Setting up for this shot was simple. My first step was to hang a gray, seamless backdrop. Next, I mounted a grid spot on a five-foot stand and aimed it so that it produced a circular spot of bright light with evenly feathered edges on the backdrop slightly above Carolyn's head and to camera right. This light also produced many of the bright highlights visible on Carolyn's jacket. (I excluded all but the outer edges of this bright spot from the final, square composition I choose for this portrait.)

The other light I used was another grid spot. I placed it alongside and to the left of my camera lens and about three feet from Carolyn's face. This was my key light, and I mounted it on a four-foot stand and aimed it toward her face. In this position, it flooded most of Carolyn's hair,

face, and chest with light. It also—because of its slightly off-center position—produced the mostly soft shadows visible down the left side of Carolyn's face and along her chin line. In addition, this light reflected in her eyes as bright catch lights. The third light I used was a large soft box with a low-power setting. This added the additional fill light to the top of her head that I needed to get the contrast balance I wanted.

It's also worth noting that because I shot this portrait using 120, medium-format film, the finished portrait shows a lovely, even gradation running from its lightest through its darkest tones. In addition, the barely noticeable grain pattern that also resulted from using film enhances the image by adding a slight hint of texture to Carolyn's features.

26

YAHYA: A BACKLIT "STREET" PORTRAIT MADE WITH ON-CAMERA FLASH

© Paul Fuqua

My coauthor Steve and I made many of the portraits in this book using highly sophisticated cameras and expensive studio lighting gear—but not this one. I shot it using a pocket-sized point-and-shoot camera and its tiny built-in flash. As far as I'm concerned, the result is a nice, informal street portrait of my friend Yahya enjoying a moment of life on the easy side.

From a purely technical point of view, there's not much to say about this picture. Today's point-and-shoot cameras truly are electronic marvels. Mine, for example, has a built-in Portrait mode that automatically selects the proper exposure, flash intensity, and color balance (some models also allow you adjust some or all of these settings manually). All that remains for me to do is compose the shot I want. Fortunately, however, that's where the fun begins.

Personally, I usually like to position myself close to, and a bit below, my subject's eyes. I then focus on them carefully and fire away until I have several images—each somewhat different from the others. That's what I did to make this portrait. Feel free to use this approach as a starting point for your own street shooting. But please don't stop there. Experiment, experiment, and then experiment some more! That's how you'll find your own "look"—how you'll create your own individual style.

And one last point—buy a small pocket-sized point-and-shoot camera, and never go anywhere without it. Do this, and you'll be amazed how many great street portraits you'll find yourself shooting.

For more on "street" shooting please see page 116.

27

THE FIVE FLEMMINGS: A ONE-LIGHT FAMILY PORTRAIT

© Steven Biver

The Flemmings are a warm and charming family. They're also a family for whom music is very important. And those were the qualities I set out to show when I made this portrait of them.

The lighting I used could not have been simpler. It consisted of nothing more than a single large (4-foot × 6-foot) soft box. This I placed to camera left and about ten feet in front of the Flemmings. I mounted this light as high as I could, which—due to the room's rather low ceiling—was only about eight feet high. This arrangement bathed the family in soft, evenly diffused, side light. In addition, it also produced the soft, but clearly defined, shadows that helped to sculpt and delineate the family's facial features.

Before the shoot I asked the Flemmings to dress in dark-toned clothing. Such attire matched the rather muted tones of the room they were in. But, even more important, such dark clothing markedly contrasted with the family's light-colored complexions. This, in turn, helped their faces to "pop out" from the finished portrait.

Posing five people of different ages and sizes—one of whom is a not-too-happy and very wiggly baby—always presents a challenge. In this case, I built my composition around two separate but visually intertwined groups. The first consisted of Mr. Flemming and one daughter. The other group was made up of Mrs. Flemming and the two remaining children. Once everybody was in place, I asked Mrs. Flemming to place her hand on her husband's shoulder. This helped to tie the two groups or sides of the composition together.

As I mentioned, music is important to this family, who had asked to be photographed by their grand piano. That was fine. However, once they were all posed in front of it, the instrument was hardly visible. Fortunately, however, there was a simple solution to the problem—open the piano's top. That done, the emphasis on the piano was far more obvious.

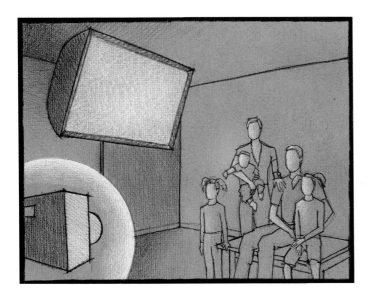

Opening the piano's top also added a strong diagonal line to the portrait. That proved to be an important plus. It helped fill—and to add some small measure dimensionality and texture to—what otherwise would have been a distracting blank area in the portrait's overall composition. The same is true of the pitcher on the mantle behind the Flemmings. It also adds a measure of interest to what otherwise would have been a visually bland area.

Finally, during post-production I vignetted the family by darkening the portrait's edges. This helped them stand out from their rather muted surroundings.

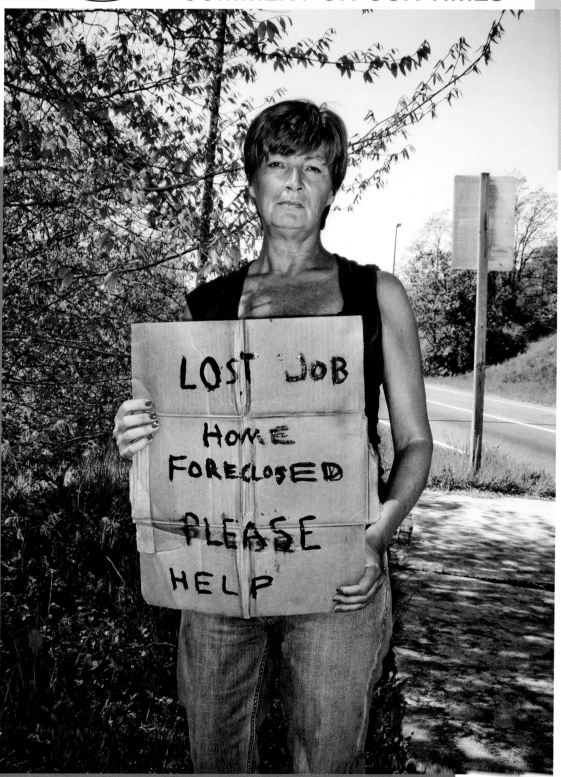

© Paul Fuqua

Kirin, like so many today, is in trouble—very serious trouble. She's been "downsized" out of her job and foreclosed out of her home. She's on the street and doesn't know when, or if, she'll ever get off it. For the time being, at least, Kirin just barely survives by begging at stoplights.

And that's why I made this portrait of her. She stands with her sign as a savage icon of, and comment on, where our great nation finds itself at the moment in history when my coauthor Steve and I are writing this book. Hopefully, portraits such as Kirin's can, in some small way, help to make known what the life of so many has become and thus motivate those who can to work toward the solutions needed.

Technically, this was a simple enough portrait to make. To get Kirin out of the harsh and shadow-producing noon sun, I had her stand in the open shade of a nearby tree and positioned her so that a bit of the road along which she was begging was visible. Finally, I asked her to hold her sign so that it was clearly readable.

My camera was a small point-and-shoot model that I set to Portrait mode. I also used its built-in flash to provide the small kiss of fill light needed to highlight Kirin and separate her tonally from the background against which she was standing.

Later, during postproduction, I used my image editing software to adjust the portrait's brightness, texture, and contrast until I was satisfied with them.

29

BJ: A PORTRAIT IN SILHOUETTE

© Steven Biver

This image is the product of my second attempt to capture BJ's look in a portrait. (Please see spread 47 for my first.) It wasn't unhappiness with my first try that drove me to make this photograph. Rather, it was the challenge of producing an image in silhouette style that successfully defined BJ's striking beauty that motivated me now.

As I had when making my first portrait of her, I sat BJ about two feet in front of a large (4-foot × 6-foot) soft box. This time, however, instead of having her face me as I had before, I asked BJ to rotate until the side of her face was toward my camera, which I then positioned several inches above her eye line.

Light from the soft box produced a bright, white background against which BJ's features silhouetted beautifully. In addition, because of its size in relation to BJ, some of the soft box's light also "wrapped" around her features nicely. This gave a lovely soft glow to parts of her face and neck. Light from the soft box also gently illuminated part of BJ's shoulder and chest in a pleasing, muted manner.

Later, during postproduction, I used the curves and burn tools in my image editing software to adjust the picture's tones until I was happy with the degree of silhouetting in my final image.

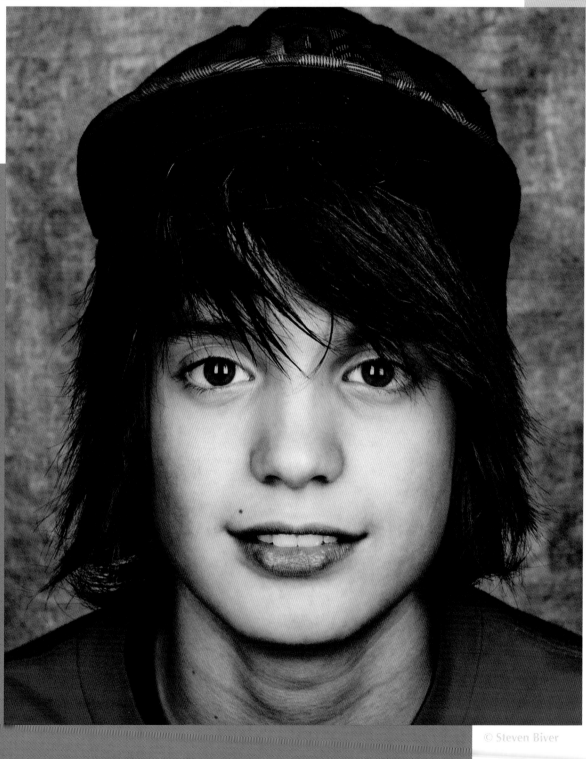

Sometimes a very simple approach also is a very good approach. That was, I think, the case with this portrait of Nigel. In making it, I used a simple setup to wash both him and the backdrop behind him in a sea of softly diffused top and frontal light.

My first step was to hang a mottled blue-and-gray canvas backdrop. That done, I hung a large (3-foot × 4-foot) soft box, set on low power, two feet over Nigel's head. This added fill light to his head, shoulders, and background.

Next, I put two small (10-inch × 32-inch) strip lights about three feet from and on either side of Nigel's face. These "strips" lit both sides of his face, his body, and the background evenly. This produced an almost shadowless image. In addition, these lights also reflected as the unusual double catchlights visible in his eyes.

When it was time to press the shutter release, I asked Nigel to lean forward a bit and stare directly into my lens. Finally, during postproduction, I used my image editing software to intensify the picture's contrast and texture slightly.

The result of my efforts is this somewhat hyper-realistic portrait of my son as a young man.

31 PAUL: TAKING THE STUDIO OUTSIDE

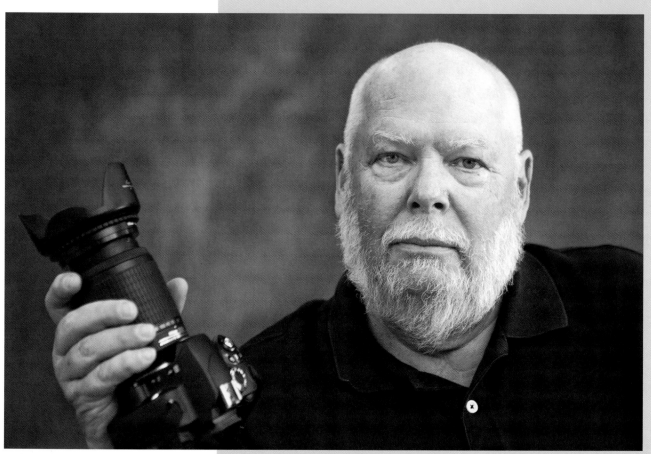

© Steven Biver

A good selection of studio strobes is a great asset for any portrait photographer. Unfortunately, however, it's also an expensive asset—as in thousands of dollars. This rather regrettable truth is enough to discourage many would-be portraitists. But it need not be. The fact that you don't have a studio packed full of high-tech and high-priced strobes at your disposal doesn't mean—as this image of me demonstrates—that you can't still create fine, completely professional-looking portraits.

To make this one, my coauthor Steve and I decided to use nothing but natural light. And the best way to do that, we figured, was to put together a simple outdoor "studio." We began by setting up two sturdy stands with a pole between them in the shadow of a large tree.

Next, we hung a painted canvas backdrop from them and placed a stool for me several feet in front of it. That arrangement put me far enough away from the backdrop that I wouldn't cast a shadow on it when it came time to shoot.

We finished our setup by putting together a simple 4-foot × 8-foot diffuser. That was easy enough to do. All we did was to nail a lightweight wooden frame together and then staple a large sheet of plastic diffusion material to it.

Once completed, we used clamps to suspend our homemade diffuser between two sturdy light stands. Then, when we were ready to shoot, we moved it around until we found the spot where light from the morning sun shone through it and onto me.

As you can see, the result of our efforts is a softly lit, studio-quality portrait of a bald old guy holding a camera against a medium gray background. And—thanks to our newly assembled outdoor studio—we didn't have to use an expensive studio setup to create it.

For an example of a low-key portrait of Paul see spread 12.

32

GARY: A "FRAMED" AMBIENT LIGHT PORTRAIT

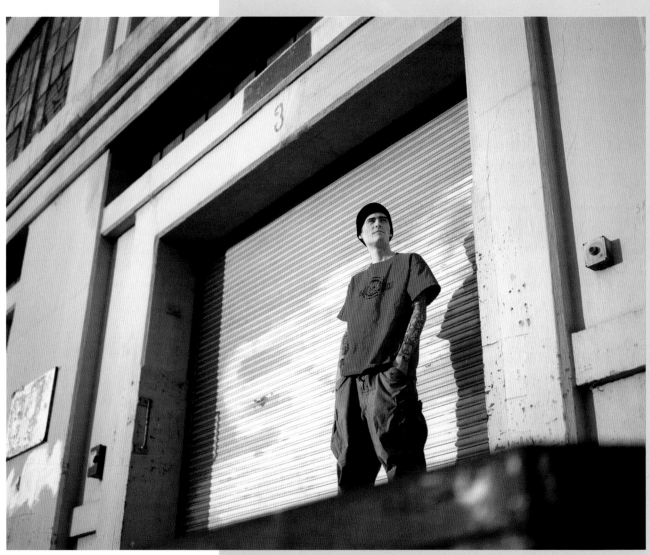

© Steven Biver

Most of the time we are used to seeing portraits in which the folks being pictured take up a good bit, if not most, of their picture. As one old timer so graphically put it to me, "A big head makes a good portrait." Well, often enough, that's the case. Think back about most of the portraits you've seen and you'll agree that in the majority of them, those who are being pictured take up most of their picture. Only rarely do we see portraits in which those being pictured seem small in relation to the rest of the image.

There are, however, exceptions to this generalization, and Gary's portrait is one of them. As you can see, Gary's body takes up only a small area of his portrait. Instead, I decided to make his "frame"—the stark lines of the building in front of which he stands—the dominant visual element of his portrait. And I chose this decidedly unusual composition for a very simple reason. I liked it.

In particular, I liked the way the low-raking late afternoon sun gave a warm, slightly pink glow to the scene. The lighting at that time of day also produced bold and interestingly shaped shadows that had an interesting, slight blue tinge to them that went together well with the red of Gary's shirt and the dark, reddish brown of the loading dock on which he stood.

With all of these considerations in mind, I decided to shoot Gary the way I did. Was this the right decision? Is the result a successful portrait? Is it really a portrait at all? The answers are yours to make.

MASTER SEARGENT GLEASON: A GRAPHIC PORTRAIT

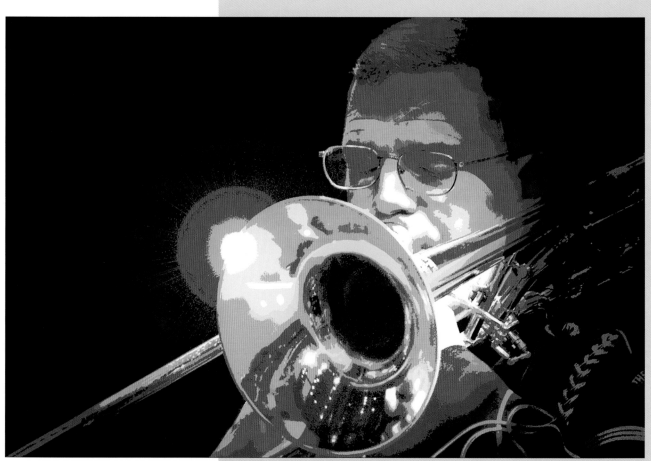

© Paul Fuqua

Fred Gleason was about to retire after a long and illustrious career in the United States Army Band when I made this image. I wanted to make a somewhat unusual portrait of him as a present. After several failed attempts, I finally settled on the idea of using a stylized, nonrealistic "graphic" look.

During one of his last performances, I positioned myself so that the slide of Fred's trombone produced a strong diagonal line from the bottom left of the composition up toward and into his face. In addition, by shooting from this position I was also able to frame the picture so that the trombone's bell was positioned below and in front of Fred's face. This composition gave what I think is an unusual and eye-catching look to the image.

During his performance, I made a dozen or so exposures. When it came time to select one, I picked an image in which Fred's eyes are partially shut. This, I felt, gave him an authentic "musician in the groove" look.

During postproduction, I used one of the filters in my image editing program to put a spot of bright light on the bell of Fred's trombone. I then used another filter to posterize the image. This reduced the number of colors in the photograph and caused them to "band" into several discreet color zones.

The resulting abrupt changes between these different colored zones resulted in Fred's portrait having a strong graphic look much like that produced by silk screening. That was what I wanted—and I'm pleased to say Fred was happy with his portrait.

A note on nonrealistic portraiture. There's nothing to say that every time you make a portrait, you have to produce a realistic representation of your subject. Quite the contrary: if you feel that you want to leave the world of pictorial reality behind and move on to some other form of expression, by all means do so.

As the old saying goes, "There's more than one way to slice a pie." And every now and then, the oddest way surprises us all by turning out to be the best way.

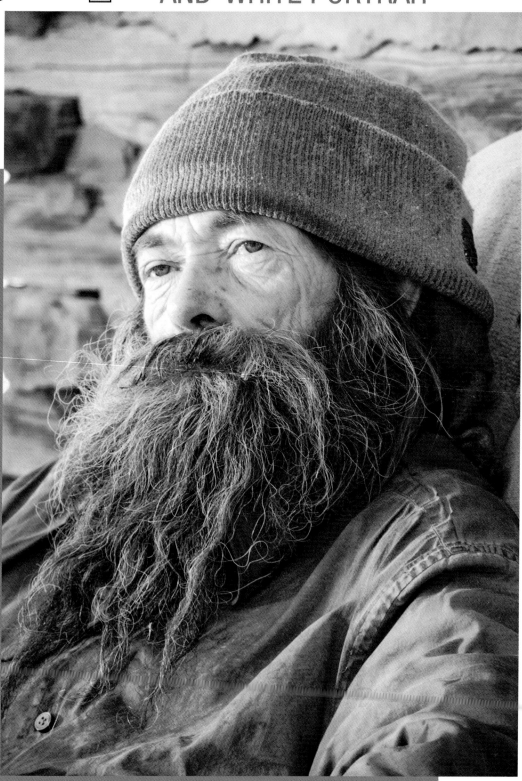

© Paul Fuqua

ran into Shorty in the harsh, high desert country of northern Arizona. He's a tough man who has lived a rough life, and that's exactly what I wanted to bring out in this portrait. To do that, I framed my shot tightly and positioned Shorty so that his beard would lead viewers up and directly into his piercing "been there, done that" stare.

The only light I used came from an early morning sun shining through, and being diffused by, a nearby tree grove. A shallow depth of field setting of *f*/5.6 kept Shorty separated from the cabin wall behind where he was seated.

As usual, I shot in color. This time the result was more than just a little disappointing. The soft, highly diffused morning light did not work for what I was trying to do. It produced a bland picture—an image that lacked any real punch and failed completely to capture the Shorty I was trying to show.

Fortunately, however, the solution to these portrait-killing shortcomings was simple. Using picture editing software, I converted the original color file to black and white and then increased the ensuing image's contrast.

The result is a stark and richly textured portrait that goes a long way toward capturing the complex persona of the Shorty I know.

For more information on the conversion of color images to black and white, please see page 155.

35

MIKE: A THREE-LIGHT, PLUS AMBIENT-LIGHT ENVIRONMENTAL PORTRAIT

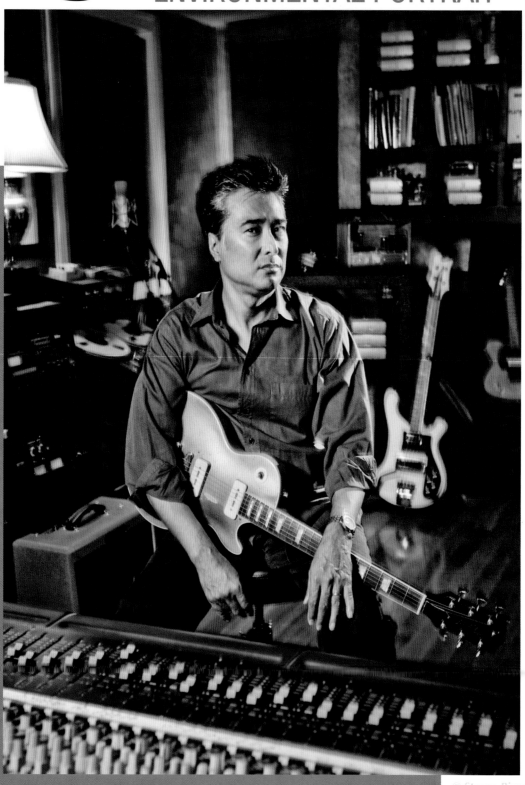

© Steven Biver

Not only is Mike a fine musician, but he's also an accomplished recording engineer and producer. With that in mind, it's easy to understand why we decided to make his portrait in his studio's control room.

The setup I used for this portrait involved three lights along with the ambient light inherent to the control room. The first light I set up was my key light. For this, I used a small (18-inch × 22-inch) soft box. This I attached to a stand that I put about eight feet in front and to camera left.

My second light was a grid spot. I mounted it on a six-foot stand and put it behind and about six feet from and to camera right of Mike's shoulder. This light produced the bright rim of light that you see running down the left side of Mike's face and body.

The third light I used was a grid spot. I mounted this on a three-foot stand that I set behind Mike and aimed at the wall. Placed there, it produced the area of bright light you see on the wall directly behind him.

When I was ready to shoot I set my ISO at 100, my aperture (for a shallow depth of field) at f/5.6, and my shutter speed at 1/4 second. I also set the modeling light shining on the background behind Mike to stay on continually. This added to the light that the ceiling lights and table lamp already produced.

When I was ready to shoot, I held my camera in my hands. And because the flash fired the instant I pressed the shutter release and Mike was close to my main—and most powerful—light, he remained relatively sharp in the image. And that's exactly what I wanted.

However, because:

• My camera's shutter remained open for the full 1/4-second exposure for which it was set *and*

• My hand shook a bit (which was what I wanted) while I handheld my camera *and*

• The ambient light in the control room lit it quite brightly

this setup produced the dark-toned and somewhat blurred (because of my shaky hand) background for Mike's portrait that I wanted.

As you may have already noticed, the look of Mike's portrait is quite similar to the look of my portrait of Tom on spread 3. Both are environmental portraits, and in both cases I produced the somewhat unusual-looking image by using a flash (one little, one big) and hand holding my camera at a slow shutter speed. With a bit of practice, you'll find that this is a versatile technique, and one that works well in both indoor and outdoor low light settings.

36
SUZI: A LOW-FIDELITY AESTHETIC PORTRAIT

© Steven Biver

S uzi has a charming look about her that absolutely cries out to be photographed. I met her on a street in Philadelphia, and she graciously agreed to let me make this quick street portrait.

To shoot it, I used an inexpensive, low-resolution analog or "toy" camera. Called the Diana F+, this little retro gem takes 120 medium-format film. Manufactured with a disregard for precision, an absence of anything even vaguely resembling "high-tech," and fitted with a simple, low-resolution lens, you can never be sure of a Diana's results until you see them.

All that being said, the Diana, and other such low-tech cameras, is a "toy" that—if you're willing to step back in time with your thinking to the days of preautomatic everything—can produce unpredictable, yet truly intriguing, images. As a result, low-resolution analog shooting has become widely popular, especially in many fine-art photography circles, and a growing number of sites on the Web are dedicated to it.

I'm not sure where cameras such as the Diana—and its delightfully erratic results—fit into the big picture of portrait making. But I do know that when I shoot with it, and similar cameras, I slow down, move out of the digital realm, and step back in to a slower and more considered way of shooting that used to be the only way of shooting. I'm not sure that this is necessarily "good" (whatever that means) in and of itself, but it sure can be fun. And in this case, it produced this out of the ordinary portrait of an intriguing-looking young woman.

HARRY: AN ABSTRACT PORTRAIT

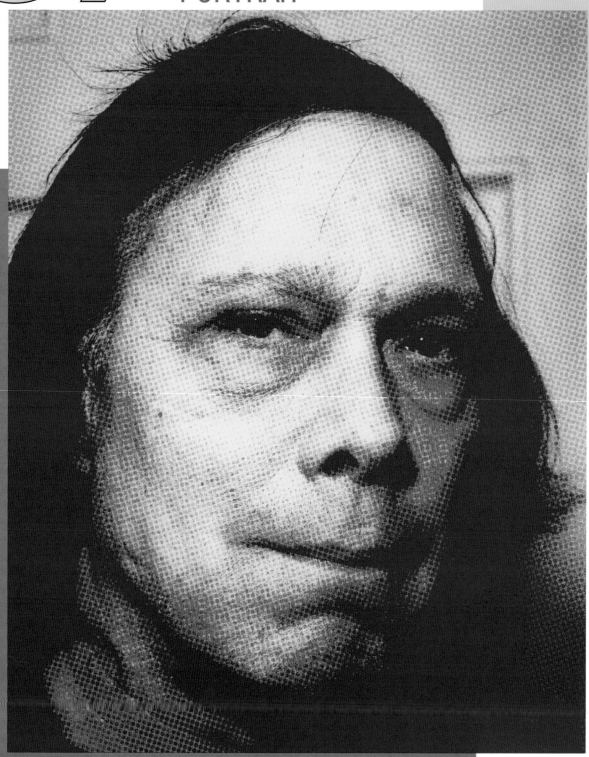

© Paul Fuqua

There's an old truism that if you want to learn the truth, then read fiction. The same sort of logic can hold true in portraiture. An abstract, nonrealistic portrait can sometimes reveal more about someone than a "real," or completely life-like, image. And that's why the portrait of my friend Harry looks the way it does.

Harry has suffered through some very rough times, and the strain they've caused was showing clearly the day he posed for his portrait. Look at it in its original form and you see the face of a very stressed, very anxious man. You see, in other words, the face of someone to whom life has been very rough for a very long time.

In that limited way, then, perhaps one can say that this first portrait is at least a partial success. However, to my way of thinking, it isn't nearly as successful as it could be. It's flat. It lacks the "punch" needed to tell Harry's story as forcefully as it could—and should. With that in mind, I left the world of the totally "real" and ventured, at least partially, into that of abstractionism.

Using the tools available in my image editing software, I replaced some of the colors in the first image with nonrealistic (to the extent that they were not actual) ones. These new colors are deeply saturated and they clash, producing a noticeable lack of chromatic harmony. In addition, I added a halftone dot pattern similar to that found in many comic book/ cartoon illustrations. The resulting visual tension or friction—along with my introduction of a distracting and visually disruptive dot pattern—produced a portrait that's a subjective and abstract visual metaphor of the "real" true-to-life Harry.

Is the abstract portrait of Harry better than the original? Does it help us understand more about him and the life he has led? The answers are up to you.

38

MATTEO: A TOP-LIT, ONE-LIGHT PORTRAIT

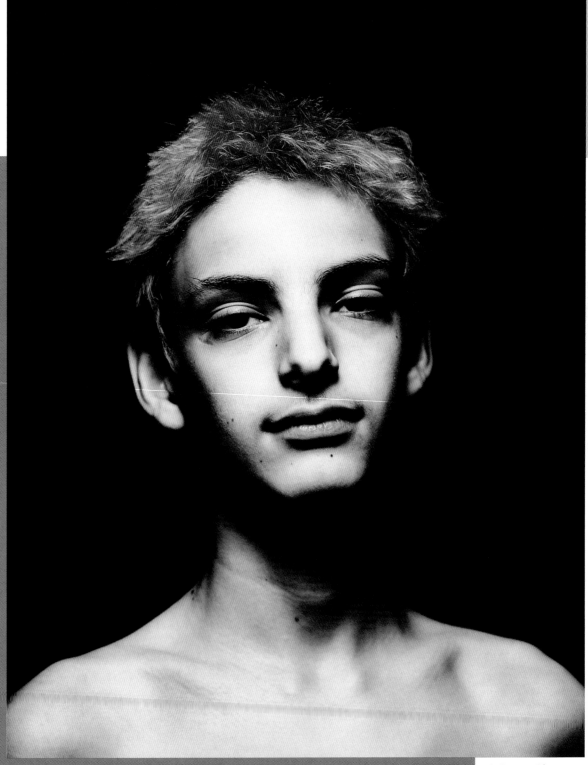

This picture is validation of a key fact of portrait making—simple is often good. And nothing could be simpler than the setup I used to make this photograph. It consisted of but one light and a black background. Yet the result was just what I wanted—an eye-catching portrait of an interesting young man.

To make his portrait, I first positioned Matteo about six feet in front of a black backdrop. Because I wanted the background to appear as dark as possible in the final print, I hung black velvet. In my experience, it photographs darker than any other commonly available material.

Next, I suspended a small (18-inch × 22-inch) soft box in such a way that it was centered several feet in front of and above Matteo's head. This arrangement bathed him in light and produced shadows that clearly delineated his finely sculpted facial features, yet did not overpower them.

When using this sort of lighting, it's important to experiment with different positions for your subjects. Take your time and ask them to move back and forth in relation to the light above them. Even small differences in where they are can produce very different looks. One area where this is particularly noticeable is the butterfly-shaped shadow (that's why this style is sometimes called "butterfly lighting") that this lighting produces under a subject's nose. Even small changes in position can cause big changes in both its shape and its size.

39

ANDY: A PORTRAIT MADE WITH BOTH AMBIENT AND REFLECTED LIGHT

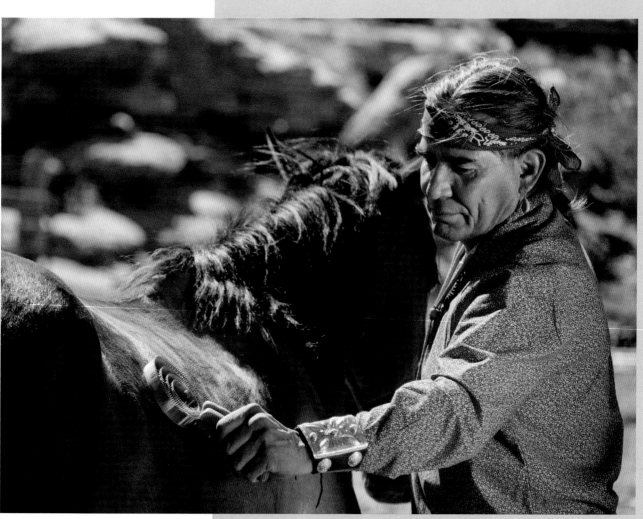

© Paul Fuqua

When working with natural light, it's not uncommon to find yourself in one of those annoying situations in which you have plenty of light, but not enough of it is coming from the right direction. That was the case when I made this portrait of my friend Andy combing his horse.

To compose the picture I had in mind, I was forced to shoot almost directly into the sun. That would have left Andy's face and eye-catching red shirt considerably darker than I wanted. The only way to avoid this was to add some fill light to the scene. I could, of course, have accomplished this with a flash, but I didn't have one with me.

Fortunately, however, I did have my folding gold-colored foil reflector on hand. It saved the day. A friend, standing to my right and about 15 feet from Andy, bathed both him and his horse in the rich, warm light such reflectors produce. This, combined with the scene's plentiful ambient sunlight, produced just the look I wanted for this informal "a man and his horse" portrait.

A note on reflectors. Reflected light can be a powerful photographic tool, often adding just the light you need, either ambient or artificial, just where you want it. Today's convenient and moderately priced folding reflectors are a great investment.

Available in a range of sizes, many of these come with different colored reflective surfaces. Some models are even provided with diffusion screens that can be swapped in place of the reflectors. This makes them a great multipurpose tool. Light-colored art and foam boards are also useful as reflectors. This is especially true in studio situations where their size and rigidity aren't an issue.

And finally, one dedicated ambient light street shooter I met never leaves home without a white bedsheet stuffed into his gear bag. This he pulls out whenever he needs a large reflector and there's nothing better at hand. A practical sort of man, he also claims his "security sheet" makes a great pillow on long flights.

DELILAH: A SINGLE "BEAUTY DISH" PORTRAIT

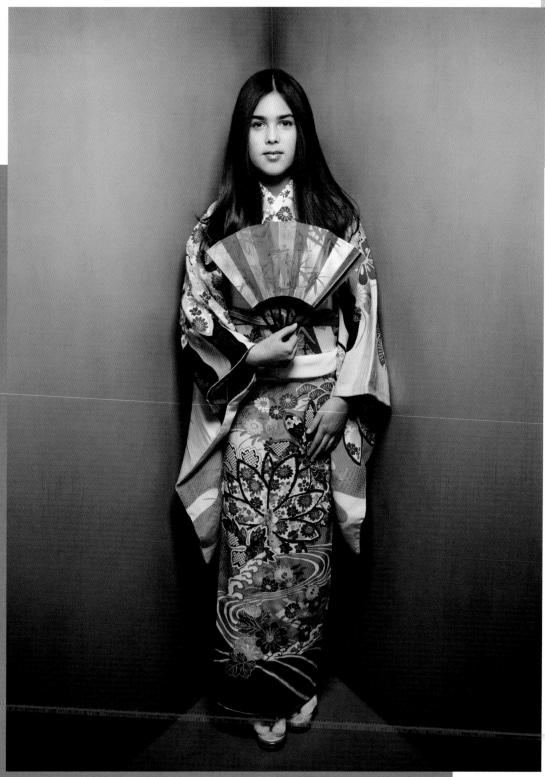

How best to photograph a lovely young girl dressed in her grandmother's gorgeous antique kimono? That was the puzzle that the making of this portrait posed.

The first part of my answer involved selecting a background that would add the most to Delilah's picture. Posing her against a plain, flat one would, I thought, be the wrong way to go. It would do nothing for the image. Instead, I decided to take a completely different approach. I asked Delilah to stand as far as she could to the back of a tight corner between two tall, converging walls. Earlier, I had painted these a bamboo green color and then "distressed" them with a thin overcoat of a slightly darker green.

This combination of Delilah's obviously pinched pose and the deeper, more saturated green tones of the walls surrounding her provided an interesting setting for her portrait. They also showcased the bold and brilliant colors of her kimono. In addition, the green surrounding Delilah also carried through beautifully with the green of the bamboo leaves on both her kimono and on the lovely antique fan she was holding.

The lighting for this portrait could not have been simpler. The only light used was a 22-inch-diameter beauty dish, or as it's sometimes called, "softlight." The one I used produces a light pattern that's concentrated in the center and then falls off evenly into darker tones at its edges. In addition, because the beauty dish I was using was equipped with both internal and external diffusers, the light from it was considerably softer than that given off by a standard reflector.

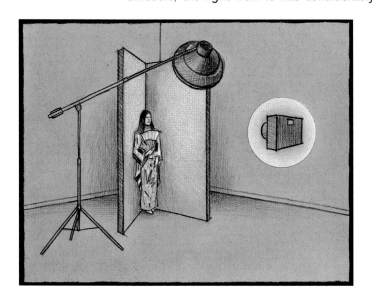

I suspended this light from a boom stand and put it about five feet in front of and two feet above Delilah's head.

Finally, I positioned my camera directly in front of her, and because I wanted the entire scene to be sharp, selected an aperture of f/16 and began shooting. The result is a portrait in which Delilah's face and the top third of her body are bathed in pleasingly soft but relatively bright light, while the rest of her body and surrounding walls fall off toward the floor into increasingly darker tones.

Later, during postproduction, I used image editing software to complete the portrait by darkening some of the picture's tones. This vignetted Delilah slightly and helped her to stand out from her surroundings.

41 SAM: AN INFORMAL NATURAL-LIGHT PORTRAIT IN BLACK AND WHITE

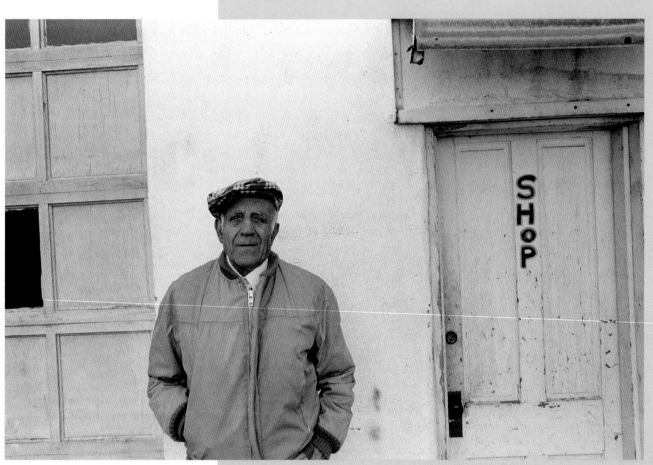

© Steven Biver

S am, hard-working father and grandfather, loved his family and cherished his friends near and far. He was passionate about cars, collected mementos, and enjoyed big Italian dinners.

I decided to make this portrait of him in front of the custom auto body shop that he owned for many years. Fortunately, it was partly cloudy on the day I took Sam's picture. This caused the scene to be bathed in partial shade—light that was perfect for the picture I had in mind. In addition, because I envisioned a slightly grainy look for Sam's portrait, I decided to shoot it on Tri-X black-and-white 35 mm film.

My composition is simple. The picture is divided into three vertical areas or "zones." These differ both in tone and texture. The darker and more textured ones are at either side of the image. They serve to define both its left and right boundaries.

A lighter and less-textured zone makes up the picture's middle. It was against this lighter background (against which his darker complexion and clothes would contrast sharply) and a bit off-center that I asked Sam to stand. Being the unassuming man he was, he quickly got into his normal, humble stance—giving me a true portrait of the Sam I knew.

YONUS: A THREE-LIGHT PORTRAIT

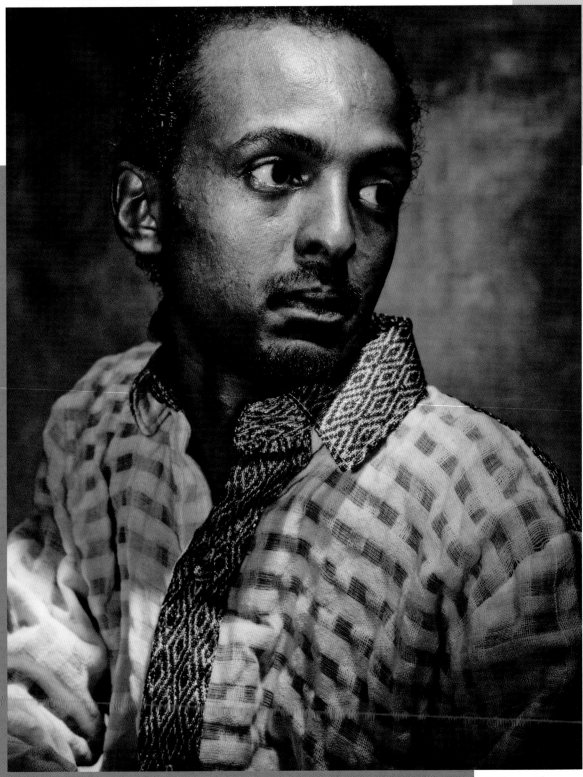

My friend Yonus has a remarkable face. He also has a somber and thoughtful nature. It was these things that I was trying to capture when I made this somewhat moody and to some extent hyperrealistic portrait of him.

I began my setup by hanging a mottled silver/blue painted backdrop. This I lit with a medium-sized (1-foot × 4-foot) strip box placed on a floor stand and aimed up at a 45-degree angle.

For my key light, I used a tight grid spot mounted on a seven-foot stand and positioned it camera right and in front of Yonus.

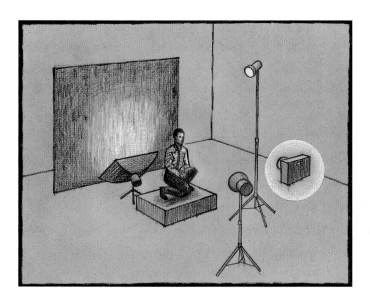

Next, I asked Yonus to pose by crouching on a small apple box or portable platform, with his arms on his thighs, his body turned to his right, and his head turned to his left in a three-quarter profile.

Finally, I placed a tight grid spot on a three-foot floor stand near me at camera left. I used this unit at a very low power to add the small amount of fill light needed to reduce the intensity of the shadows on his face. Importantly, it also helped to give his skin a slightly iridescent metallic glow.

Later, during postproduction, I desaturated the image slightly, opened up some of the shadows a bit, increased overall contrast, and added a small amount of noise. Combined, these steps gave the finished portrait a somewhat grainier and more textured look than it otherwise would have had.

43

HAYDEN: A CLOSE-UP, WIDE-ANGLE PORTRAIT OF A CHILD

© Steven Biver

Our dear children: how we love them! Check just about any study and you'll find it shows that we take more pictures of our children and grandchildren than almost anybody else. Needless to say, lots of them leave something to be desired in terms of portraiture.

There are, however, several simple things that can be done that will improve anybody's attempts at child photography. This portrait of my nephew Hayden demonstrates one of the more useful of them. Photographers often call it going close and wide, and it turned what otherwise could have easily ended up just another "kid-in-the-pool" shot into an appealing relaxed portrait.

The key to this approach is simple. Move in close to your subject's face while using a wide-angle lens and a small aperture setting. This lets you put a lot of his or her face in your composition while also showing something of their surroundings. In this particular portrait, I did this somewhat indirectly by including the blue float Hayden was playing with in the picture. In addition, I positioned him in a typical poolside pose, looking up with folded arms.

Nothing involved in making Hayden's portrait was complex or hard to do. Taken together, however, the use of a close-and-wide composition coupled with a somewhat "symbolic" poolside pose produced a simple, yet to my mind attractive and informal portrait of Hayden having some summer fun.

LELIA: A THREE-LIGHT "HALO" PORTRAIT

© Steven Biver

Lelia is a beautiful woman. She is one of those fortunate few who would look great almost any way you photographed her. For this particular portrait, I decided to use a warm, vignetted approach. That, I felt, would make the most of her striking eyes; dark hair; and lovely, light-colored complexion.

To begin, I selected a gold-colored cloth that was randomly flecked with patches of gray and brown as my backdrop. Next, I set a tight grid spot in front of and to the left of my camera. From there it projected a clearly defined yet softly edged circle of bright light onto the backdrop behind Lelia. Because she was seated several feet in front of the backdrop, none of this light spilled onto her.

Two small (10-inch × 32-inch) strip lights completed my setup. I placed one of these at each side of and about two feet in front of Lelia's head. Not only did these bath her face in a pleasingly even light, they also reflected as interesting linear catch lights in her eyes.

When it came time to press the shutter release, I set my portrait lens to a wide enough aperture to throw the background well out of focus and asked Lelia to turn until her shoulders were at a 45-degree angle to me and to stare directly at the camera.

The result is a classic "halo" portrait in which Lelia's head is vignetted or ringed by the circle of soft, golden light falling on the backdrop. In addition, the effect is amplified by the contrast between Lelia's dark hair and bright circle of light behind her. In addition, the manner in which the color of Lelia's eyes blends with that of the backdrop color also adds to the impact of her portrait.

POP: AN INSTANT CAMERA PORTRAIT

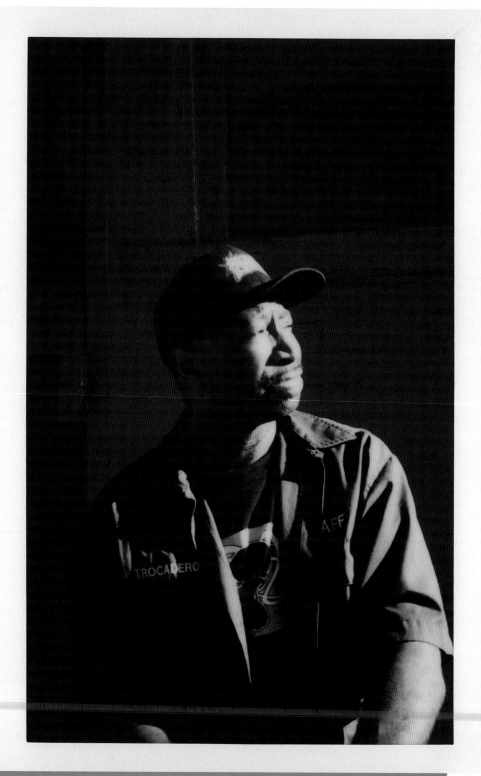

It's not often that one is lucky enough to get an opportunity to shoot a street portrait in a narrow, grungy alley behind an inner-city nightclub using wonderfully colored and positioned early evening sunlight. But that's what happened to me. I was winding down a long day of street/alley shooting when I stumbled upon Pop and this great portrait-making location.

As it turned out, Pop was providing security for the stage door entrance of a popular Philadelphia nightclub the evening I met him. The wall behind him was painted a deep burgundy red and the warm rays from the setting sun raked down the alley and onto Pop.

Making Pop's portrait could not have been easier, thanks to the location and ambient light. All I did was ask him to turn toward the sunny end of the alley, compose the picture so that he was where I wanted him in it, and press the shutter release.

As you may have noticed, Pop's portrait has a somewhat different look from the others in this book. The main reason for this is that I made it using a Fujifilm Instax 200 instant camera. Like the Polaroids of yesteryear, this newly released camera produces finished prints in a matter of minutes.

I like using the Instax for making street portraits for two reasons. First, the colors in its prints are richly saturated, and to me, very beautiful. Second, using an Instax allows me to give my subjects pictures of themselves just minutes after I shoot them. This pleases them no end, and it helps to build communication between us.

My only complaint about the Instax concerns its heft. The camera is somewhat big and heavy. Hopefully, the folks at Fujifilm will do something about this in future models.

46

MARK: AN AMBIENT-LIGHT EVENING STREET PORTRAIT

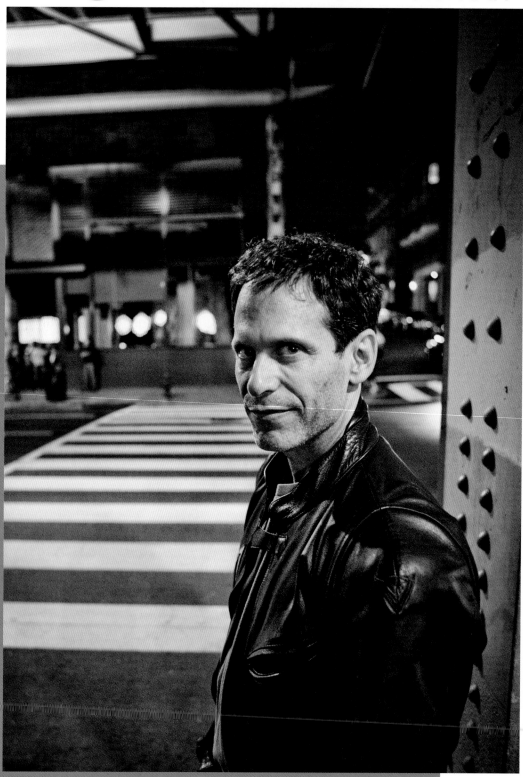

© Steven Biver

There are times when my old friend Mark can look pretty intense. And that's exactly the look I wanted to capture when I set about making this slightly gritty portrait of him. With that in mind, I decided that rather than working in a studio, I'd shoot Mark on location—and the seedier-looking, the edgier that location could be, the better.

After much scouting, I finally found a location that had just the "look" and the vibe I wanted. It was a dingy street corner under an elevated traffic freeway. Not only did the area have an overall grainy and grimy appearance, but the battered steel girders supporting the freeway above us also helped give it a brooding, noir movie-poster look.

To make things even more interesting, the area was lit by a random mix of lights—many of which gave off light of a different color temperature than those around them. This gave the surroundings a rather muted and ghoulish look.

Because I was shooting in a part of town where it would not have been a good idea to draw attention to the thousands of dollars worth of camera dangling around my neck, I decided not to use either a flash or tripod. That meant, of course, I would have to handhold my camera and shoot with nothing but the scene's ambient light. To do that, I boosted my camera ISO setting to 800, letting me shoot at f/2.8 at 1/8 second.

I also switched to manual focus. Over the years, I've found that it often provides more reliable results in low light than the Autofocus mode does.

When it came time to shoot, I positioned Mark where he would be illuminated by as much of the scene's ambient light as possible, steadied myself and my camera the best I could, and

began shooting. Fortunately, things went well. The location's garish top lighting produced exactly the look I wanted. Not only did it bathe Mark in light from head to toe, but it also produced interesting multiple highlights on both his hair and the shiny leather jacket he was wearing. In addition, this lighting also created a series of distinct shadows in Mark's eye sockets and across the rest of his face. Together, these helped to sculpt Mark's features dramatically and gave a powerful, edgy intensity to his camera-fixed stare.

Later, during postproduction, I selected the shot I liked best and worked with its color, grain, and contrast until I was satisfied. Luckily, the resulting image was what just I wanted—an intense portrait of my sometimes intense-looking friend.

47

BJ: A BACKLIT ONE-LIGHT PORTRAIT

© Steven Biver

My model, BJ, is a very pretty young woman. She has a lovely face and a beautiful complexion. The challenge in making this portrait was how to best show them off—how, in other words, to make the most of BJ's natural beauty. Early in my planning, I decided that my best bet was to go high-key—to show her against a white background and partially surrounded by a sea of soft white light.

Normally when I think "high-key" I also think "lots of lights"—but not this time. This time, I decided to get the look I wanted with just one light. To do that I began by positioning a large (4-foot × 6-foot) soft box, or as it is sometimes called, "bank light" about two feet behind BJ. This light served two purposes. Not only did it light her, but it also served as her background. Next, I placed a 30-inch × 40-inch white reflector or "bounce" card on each side of and about two feet in front of BJ's face.

The result of this simple setup was just what I wanted. The soft box flooded the scene with diffused light, some of which spilled or softly "wrapped" around and over parts of BJ's head, shoulders, and hand.

Other light from the soft box background reflected off of the two bounce cards in front of BJ and provided a soft fill that illuminated both her face and the front of her body.

The first shot I took looked good. I then spent the next hour or so experimenting with different poses and tinkering with bounce card positions. And then during postproduction, I did my usual retouching.

48

STEVEN BIVER:
A SELF-PORTRAIT IN
TWO STEPS

And why do we make self-portraits? I've no idea. But perhaps the following reason, offered by Andy Warhol—a brilliant artist not given to long-winded psychobabble—is as good as any: "I paint pictures of myself to remind myself that I'm still around."

"Why" is one thing. "How" is another, and much simpler, question to answer. The making of this self-portrait was a two-step process. First, I shot the image of my face with the help of my camera's trusty self-timer. Later, I shot the dark and roughly textured "frame" image for it among what remains of the historic Eastern State Penitentiary in Philadelphia.

The second step was to composite my own image into the security mirror that was a key part of the image I shot at the penitentiary. Together, the two high-contrast and strongly textured images combined to produce this clear but not easily "read" or understood portrait.

Is this a "good" portrait? Does it tell you anything particularly interesting or noteworthy about me? These are questions that only you can answer. But there's one thing of which I am sure—I had a lot of fun making it.

STREET
SHOOTING

STREET SHOOTING

The camera is an instrument that teaches people how to see without a camera.

—DOROTHEA LANGE

One of the great joys of portrait making is that you can do it just about anywhere at just about any time. Wherever you go and whenever you go there, all those around you are "fair game"—potential targets for your portrait-making lens. This wide-open, freewheeling style of portrait making is often called "street shooting," and it's something that I've done, and greatly enjoyed, for many years.

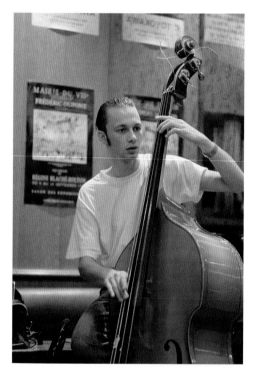

Figure 1. This classic café shot of a Paris jazz musician by my coauthor, Steven Biver, is a great example of the endless number of street portraits out there just waiting for us to take them.

Today, thanks largely to the ever-evolving digital revolution, street shooting has become something of an international rage. If you don't believe that, just take a look at Flickr or any of the other web sites dedicated to photography. There you'll find literally thousands of street portraits shot by photographers from around the world.

With this in mind, I happily pass on the following tips and techniques. All have been of help to me at one time or the other. All have made my work on the street easier. In no way, however, does that mean you should treat them as "rules" chiseled in stone and destined never to be broken. Far from it. That the following suggestions have helped to keep me out of trouble and to make me a more productive portrait shooter in no way means that you can't ignore any or all of them. All that really counts is that you, in one way or the other, end up taking pictures that you like and have as much fun as I have had in doing it. How you go about accomplishing those goals is up to you.

ALWAYS TAKE A CAMERA

"You never know when." That should be the motto of all street shooters. You never know when or where the perfect portrait subject is going to suddenly appear before you. The only way to be ready for such a blessed event is to take a camera with you each and every time you go out the door. Fortunately, the abundance of small yet high-quality and reasonably priced cameras available today makes that an easy enough thing to do.

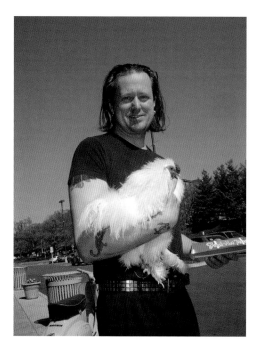

Figure 2. Fortunately, I had stuffed my trusty point-and-shoot camera into my pocket the morning I met this gentleman and his finely feathered companion.

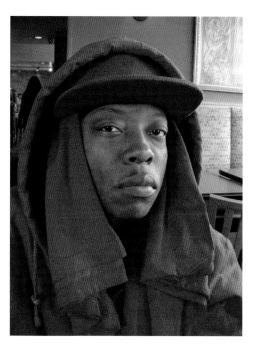

Figure 3. After this gentleman kindly consented to let me make this portrait of him, I set my point-and-shoot camera on its Portrait mode and fired away. As you can see, the quality of the resulting image is more than adequate.

SHOOT IN RAW

Working in the RAW format provides a great success insurance policy for street shooters—or, for that matter, any other photographer. Things can, and often do, get very messy when you're street shooting. Scenes change. People move in and out of your range. Light intensity and colors can shift wildly.

When you're working in such a dynamic environment, it's all too easy to make mistakes such as using the wrong white balance, shutter speed, or f-stop settings. And that's where RAW files can save the day. Because of the wide dynamic range of the information they contain, they provide great flexibility in dealing with such problems later during postproduction.

MASTER YOUR GEAR

Street shooting is, by its very nature, fast and unforgiving. If you're going to be successful at it, you must be able to work quickly. And doing that means mastering your camera. Practice different ways of shooting with it. Experiment with its preprogrammed "modes," some of which—such as the "Portrait" setting I used in making Figure 3—can be very useful.

Learn the different ways of focusing. Try using different exposures. Master your flash's capabilities, especially how to control its output. Learn how to "bounce" it. These, and any other techniques you master, will all improve your street (and other) shooting. They'll also make it more fun.

TRAVEL LIGHT

Photo gear can be heavy. Lots of it can be very heavy. The key to not feeling like some sort of overworked pack animal by the end of the day is to take everything you need but nothing more. That, of course, is often far easier said than done.

Obviously, the gear you'll need will vary wildly depending on where you are, how long you'll be there, and how you'll be shooting. At a bare minimum, in addition to two cameras (one small pocket model and one DSLR fitted with a mid-range zoom) and an off-camera flash, I always carry extra memory cards and batteries along with some kind of lens cleaner, a GPS-enabled phone, a tiny flashlight, and a small, inconspicuous bag into which I can stuff everything. From these bare essentials the list of "must-haves" can grow and grow.

Along with these items, I also carry business cards with my name, phone number, and email address on them. These I give to anybody—such as local officials, security guards, and police officers—who is curious about what I'm up to. I also make it a point of giving my card to anybody whose picture I take. They usually appreciate the courtesy.

AVOID CHANGING LENSES

The street is a dirty, dusty place, and dirt and dust are exactly what you *don't* want on your camera's sensor. The specs and blobs they produce are deadly picture killers. The easiest way to prevent such disasters is to avoid "on-street" lens changes whenever you possibly can. Instead, use a zoom lens that provides the range in focal length you like or carry several bodies, each fitted with a different lens.

It's also smart to use cameras that are equipped with some kind of self-cleaning sensor system. Such gear does a great job of keeping dust damage to a minimum.

Wear light colors. Turn yourself into a reflector. Wear a light-colored jacket, shirt, or T-shirt when you're street shooting. That done, you can use your own body as a reflector whenever you need to bounce a little extra fill light on your subject. You can use your body to reflect whatever ambient light is around or you can point an off-camera flash at yourself and fire away. Either technique works surprisingly well.

LOOK BEFORE YOU SHOOT

Much to your delight, you stumble on some great place to shoot. There, before your eyes, are lots of fascinating people doing all sorts of fascinating things. You are, in other words, in a portrait maker's paradise. So you grab your camera and start blazing away. *Wrong move!*

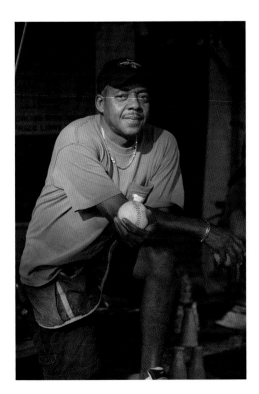

Always stop before you start. Be aware of your surroundings before you put camera to eye. Remember how our parents used to tell us to "always stop, look, and listen" before we crossed the street? Well, exactly the same basic common sense caution applies to street shooting. Quiz yourself about where you are. Ask yourself such questions as: What's good about this location? Where are the best vantage points? Are there any obviously "must-have" portraits? What about backgrounds?

And then there's the matter of light—that all-important picture maker or picture breaker. What is the light like? From where is it coming? Is it natural or artificial? What color is it? How intense? What will it look like later?

Besides such artistic considerations, it's also important to be alert to the "vibe" around you—to the mood and temper of the place. Do the locals appear relaxed? Do people seem upset by your arrival or are they smiling at you? Is there anybody who seems to be following you or watching you just a little too intently for comfort? Are there any police officers around? Depending on what part of the world you are in, that can be either a very good or a very bad thing.

Figure 1. Good light is critical to good portraits. The trouble is that you never know when or where you'll find it. I turned the corner at a county fair and found this gentleman highlighted by the dappled rays from a late afternoon sun. Moments later clouds moved in and the opportunity for a great ambient-light street portrait was gone.

Along with checking where you will be shooting when you first get there, a bit of up-front research often pays off handsomely. If, for example, you're planning to shoot away from home, find out what kind of weather you can expect. Permits are another issue you should investigate. For example, do you need one to use a tripod (this is very common) or flash?

It's also important to check on the local customs. In some cultures, for example, street shooters are welcome. In others, they're not tolerated. In some areas, women are strictly off-limits to photographers, yet in others they're only too glad (usually for a fee) to pose for you. So check things out before you go if you want them to go smoothly while you're there. Fortunately, that's not too hard to do. Web sites, magazines, and guidebooks can all provide you with a wealth of useful information on just about anywhere.

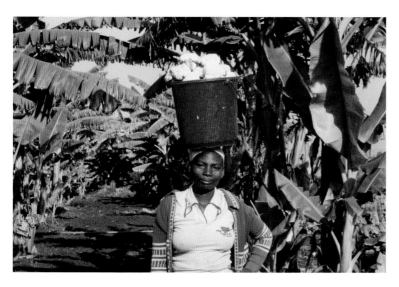

Figure 5. Talking nicely can and often does pay off when you're trying to photograph strangers. At first, this farmer in Kenya did not want her picture taken. After a few minutes of friendly conversation, however, she changed her mind and graciously allowed me to shoot this environmental portrait.

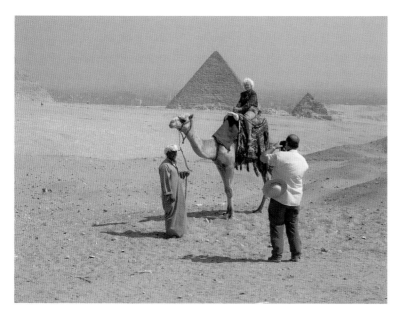

Figure 6. In major tourist areas, local residents will usually expect you to pay for the privilege of taking their pictures. If you don't, you may end up in a nasty situation.

BE NICE

When it comes to street shooting, you'll get a lot more with honey than you will with vinegar. Most people don't mind your taking their picture—if you ask them first. They may, and no doubt frequently do, think that you're nuts, but more often than not they will work with you. On the other hand, many folks get more than just a little irate when they catch you being sneaky about things and "stealing" their picture on the sly. That's why, whenever possible, it's a good idea to get your subject's permission before making their portraits.

It's also helpful to have an answer ready for the rich-in-suspicion question that will so often meet your request: "Why do you want to do that? Why do you want to take my picture?" My standard reply is, "Well, faces have always interested me. I collect them just like some people collect stamps, and you have an interesting one." Generally, this reply puts the minds of all but the most suspicious of my would-be subjects enough at ease for them to let me make their portraits.

I also make it a point to show my subjects their pictures once I've taken them. This is a small courtesy to them, but it's one they always seem to appreciate. Finally, I always give anybody I shoot my card. It has my name and email address on it, and I tell them that if they contact me, I'll send them a copy of their picture. Again, it's a small courtesy, but it helps in a big way toward building goodwill.

DON'T PAY

Depending on where you are and with whom you're dealing, you may be pressured to pay for the privilege of taking their picture. To do so can be a very big mistake. As one experienced shooter warned me years ago, "Once money hits the street, everybody wants some." That

can result in exactly what you don't want—a potentially nasty crowd scene. It's worth noting, however, that in many of the world's most famous tourist "hot spots" you will have to deviate from this strict "no-pay" approach. There you will usually find locals who make their living by posing for photographers.

Figure 7. Most of the time, I prefer to pose my subjects away from the center of their pictures. Such "off-center" compositions are, to my eye, usually far more dynamic than centered ones.

Figure 8. Filling the frame with your subject's face can produce a powerful image, as evident in this up close and personal portrait I made of my friend Josh.

In such locations, you can end up in some very serious trouble if you don't pay. However, don't be afraid to bargain for a good price. It's expected of you. Finally, be sure to agree on the fee you will be charged *before* you start pressing your shutter release or you may well find yourself in the middle of a serious argument when you're through.

BE WARY OF "BULL'S-EYE" COMPOSITIONS

Generally speaking, I'm of the opinion that most of the so-called "rules" governing what is and what is not "good" portrait composition are for the birds. That being said, however, I do think that although it's true that there are situations in which centered—or, as it's often called, "bull's-eye" positioning—produces beautiful portraits, many or even most look far more dynamic and interesting if their subjects are not positioned squarely in the middle of the picture.

See for yourself. Experiment by positioning your subjects in different parts of your portraits and then decide which arrangement you prefer. If you can't make up your mind while shooting (which is the case often when I'm shooting), don't worry. Shoot using several different compositions and then decide which are your keepers later.

GET CLOSE

The closer the better is more often than not true when it comes to portrait shooting. Once folks have agreed to let you take their pictures, it's togetherness time. It's time to move in close and personal. If for some reason you can't do that physically, don't fret. Just tighten in on your subject with a zoom lens. As a longtime street shooter once put it, to me, "Fill the frame and you're halfway there." I think he was right in most cases. Most portraits do look their best—as is the case with Josh's in Figure 8—when there's a whole lot of their subject showing in them.

However, the "close" look is not the only look. That's why once I'm through taking my tight shots I step back, or pull back on my zoom, and take some more pictures. This second group, because of its wider field of view, will show more of my subjects' surroundings and their relationship to it. Not only can such environmental portraits be eye-catching, but they also tend to tell a bigger story about people and the lives they live.

TAME THAT FLASH!

A flash should kiss, not maul, portraits. I like to shoot with nothing but available light whenever that's possible. It produces a sense of authenticity, mood, and feeling that's hard to beat. But as much as I like to work that way, there are those

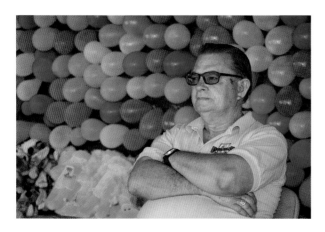

Figure 9. I used an off-camera flash set at a very low intensity to brighten up this portrait of a carnival worker in his booth. More light would have blown out, or seriously overexposed, the lighter-toned areas, giving the image an unpleasant and artificial "definitely shot with a flash" look.

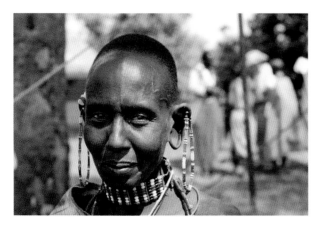

Figure 10. Generally speaking, I think that most portraits, such as this one of a charming Maasai woman I met in Kenya, look better when their subjects are visually separated from their backgrounds. In this case, I used a shallow depth of field to achieve the degree of separation I wanted.

times when it's so dark that I have no option but to use a flash. In such situations, success usually depends on two things:

• Adding as little light as possible to the scene

• Using an off-camera flash

Too much flash tends to blow out the highlights in portraits and gives their subjects a harsh "deer in the headlights" look. And unless you just happen to be after that particular look, it's the last thing you want. So use the flash compensation adjustments on your camera or flash to keep the amount of light you're adding to the scene as small as possible.

A flash set at any level of brightness can produce harsh, unwanted shadows. That's especially true when the person you're shooting is close to a wall of some kind. Fortunately, however, the solution to this problem is simple. Just hold (or use a bracket to hold) your flash where it won't produce offensive shadows. Often, this means getting it up above your head. Doing this has the effect of "forcing down" any shadows your flash produces behind your subjects where they're not visible to your camera.

SEPARATE YOUR SUBJECTS FROM THEIR BACKGROUNDS

I generally like to shoot street portraits in which there is at least some degree of visual separation, or "distance," between my subjects and the backgrounds against which I have posed them. To do this, I try to position my subjects a minimum of several feet in front of their backgrounds.

In addition, I usually keep my depth of field shallow, as in Figure 10. This in turn throws the background against which my subjects are positioned out of focus, thus producing the visual separation I'm after in most of my portrait shooting.

The physics involved in controlling depth of field is complex. However, the following three things you can do to reduce it—and thus blur your backgrounds—are not:

• **Use a wide aperture.** Shooting at $f/2.8$ or $f/4$ produces a much shallower depth of field than shooting at $f/16$ or $f/22$, for example.

• **Move in close.** The closer you are to your subjects, the shallower the depth of field will be in your pictures.

• **Use a long focal length.** The longer the focal length you select, the more restricted the depth of field will be. Because of this, I usually shoot using a 100mm or longer lens.

Shooting in the Portrait Mode

Many of today's point-and-shoot cameras are built with short-focal-length wide-angle lenses that don't stop down to any lower aperture than $f/4$ or so. The great depth of focus that such lenses produce is wonderful for most general photography. You press the shutter release and you know that just about everything in the resulting picture will be in sharp focus.

Most of the time, that's exactly what's wanted. However, it's not so great on those portrait-making occasions when you're after some visual separation—when you want to throw your subject's background well out of focus.

There is, however, a simple workaround that can help with this problem:

- If it has one, set your camera to use its Portrait mode. That will cause it to select the widest aperture available.

- Move in close to your subject. When I'm using my point-and-shoot camera for portraits, I stay within three or four feet of my subjects.

Follow these suggestions and you'll soon find yourself shooting great-looking portraits with even the simplest of point-and-shoot cameras.

EXPOSE FOR THE FACE—FOCUS ON THE EYES

The face is the most important part of nearly all portraits. That's why it's so important to expose it properly. With that in mind, I usually set my camera to use center-weighted metering and then read the light on my subject's face. This approach almost always produces good exposures.

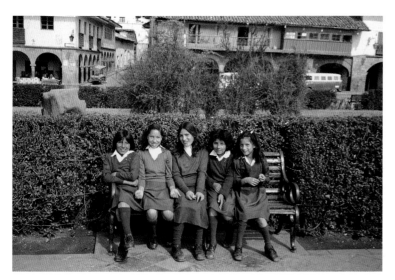

Figure 11. When shooting a group, such as these schoolgirls in Peru, there's a good chance that somebody will blink, move, or do something else to spoil the shot. The best insurance against such disasters is to take several pictures. Chances are good that at least one will be just what you want.

In addition, I believe that most portraits look better if at least one of the subject's eyes is in sharp focus. That's why, in almost all cases, I focus carefully on my subject's eyes.

SHOOT LOTS OF PICTURES

Portrait subjects the world over have the extremely annoying habit of blinking, turning, or twitching at exactly the wrong moment in the portrait-making process. Their expressions can also change in a flash. It's not too hard to deal with these potentially picture-killing annoyances in a relaxed studio setting when you have all the time you need to get things right. On the street, however, where you often have but moments in which to grab your picture, the dynamics are very different.

The best way I've found to deal with this issue is to take lots of pictures. I don't make just one picture and then say, "Thank you." Instead, I take several shots, one right after the other. Chances are good that at least one will turn out well.

Many of today's cameras can help with this "shoot and then shoot again" approach. They have built-in "burst" modes. These cameras can be set to take a

predetermined number of rapid-fire exposures every time you press the shutter release.

If, however, your camera doesn't have a burst mode, don't worry. Set your camera to its "continual" exposure mode (or whatever it's called on your camera) and hold the shutter release down until you've made five or six exposures. With a bit of luck, at least some of them will turn out well.

In addition, I also frequently take several shots, each with a different exposure. Such exposure "bracketing" is especially helpful when I'm not sure which one will produce the particular look I'm after at that moment.

CHECK YOUR SHOTS

It would be great if we, and the equipment we use, always got everything right—great if our focus was always tack-sharp and our exposure always dead-on. However, as we all so painfully know, that's not the case. Electronic systems hiccup, we misjudge where to focus, the light changes at the wrong moment, and so it goes. And that's why it's so important to check our pictures as we shoot them.

I've had the good fortune to observe some fabulous photographers doing their thing, and I've noticed that most share a key trait: they're careful. They check their work while they are shooting. They shoot and then look at the resulting images (and often their histograms) on their camera's LCD or attached computer screen. If they like what they see, they move on to the next shot. If not, they make any needed adjustments and then reshoot the pictures they've just shot until they're satisfied with them.

This "feedback loop" way of shooting may seem to be both overly complicated and a lot of extra work. Once you start using it, however, this watchful way of shooting soon becomes second nature—a second nature that, over the years, can save what otherwise would have been many lost pictures. (For more information on histograms, please see page 154.)

SHOOT STEADY

Camera movement is a double-edged sword. Sometimes—as was the case when we made Nigel's portrait in spread 21—we want camera movement, because it adds a blurry look that we want for our picture. At other times, it's a ruinous picture killer. It all depends on what we're after when we're shooting. Generally speaking, however, I think that most of the time camera movement—and the picture blurring it causes—is a bad thing that all too often condemns otherwise worthy portraits to the trashcan.

Unfortunately, however, rarely if ever is it practical to drag a tripod (or even a monopod) around when street shooting. They are heavy, are clumsy, get in the way, limit mobility, and attract attention—all considerations that go against using them amid the hustle and bustle of the street. And that's why it's so important to master the fine art of handholding your camera as steadily as possible.

Bracing against a wall, lamppost, or any other convenient support can help to reduce camera shake. So can holding your camera close to your chest and squeezing its shutter release smoothly. It's also helpful not to take your camera away from you face until you've completely lifted your finger from its shutter

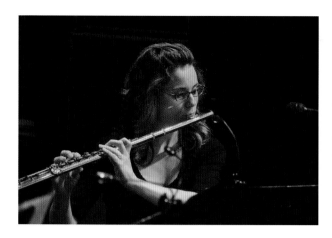

Figure 12. Shooting with high ISO settings allows one to work in very low light situations, such as a concert performance, without having to use a flash. Unfortunately, it can also produce pronounced digital noise.

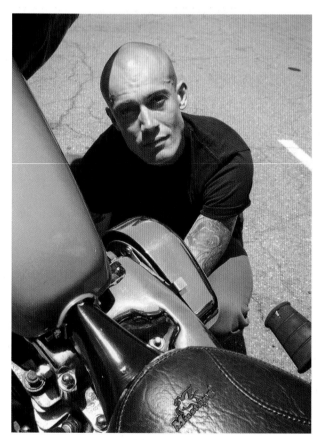

Figure 13. Always shooting from eye level guarantees that you will miss some potentially interesting shoot portraits, such as this one of a rider working on his bike. Purposely varying how you shoot is one of the best ways of keeping your work fresh and interesting.

release. All these are little things. Practiced together, however, they can and add up to noticeably sharper images.

Along with these techniques, you can also increase your chances of getting acceptably sharp images, especially in dim light, by increasing the ISO at which you are shooting. The plus side of doing this is that you will then be able to use faster shutter speeds. The negative is that as your ISO increases, so also does the amount of image-degrading "noise" your pictures may show (Figure 12). Fortunately, many of today's cameras produce far less noise at higher ISOs than those in use only a few years ago.

All of these techniques will help you shoot with less camera movement and the resulting picture blurring. If, however, you're truly serious about shooting the best images you can, make it a point to always use cameras and/or lenses that are equipped with some sort of optical image stabilization, or as it is sometimes called, "vibration reduction" system. Marvelously effective, such gear is one of the very best protections against blurred pictures available.

VARY YOUR VISION

Don't always shoot the same way. Instead, experiment. You never know when a "different" shot is going to turn out to be your best shot. You never know when a different way of looking at a portrait opportunity is going to be the best way of looking at it. So go for variations.

Try different poses. Vary your lighting. Move around. Shoot from different angles. Take both verticals and horizontals. Try shooting both from above and below your subjects. Try the same shot with and without flash. All this may seem like a lot of extra work—which it is. Chances are, however, that sooner or later you'll end up with some portraits that'll make you very glad you invested it.

STAY READY

Life is sweet. You've had a fabulous day of shooting, and you're headed home with a memory card packed full of great pictures—pictures that you're sure stand a good chance of winning that big contest you're planning to enter. You stuff your gear into your bag, zip it up tight, and head for the nearest bus stop. And then it explodes; the scene of a lifetime—right in front of you. And where's your camera? It's nicely zipped up in your bag where you can't possibly get to it in time.

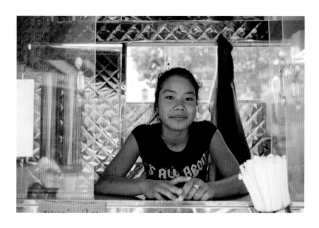

Figure 14. As I rounded a busy street corner, this charming young lady looked out at me from her chrome-plated kiosk and smiled ever so faintly. Fortunately, my camera was with me and the result is this vaguely enigmatic street portrait.

That happened to me, and from that awful day on I've never walked the street without some kind of camera (usually one of the many small advanced point-and-shoot models available today) stashed in an easily reached pocket.

WATCH YOUR BACK

Because the cameras we use are worth a good deal of money, we photographers are and always will be prime targets for criminals. There is, of course, no way that any of us can completely "crime-proof" ourselves. Simple, commonsense precautions can, however, greatly reduce the chance of falling victim to some street thug.

For example, don't advertise. Avoid using gear that calls attention to you. This includes such things as obviously expensive professional cameras, photo vests, tripods, gear bags, and camera straps with the name of some high-end camera blazed across them. Keeping cash and credit cards out of your pockets and in a security pouch is also a good idea. I prefer the kind that hangs around my neck. Be careful with camera bags. I always carry a scruffy, nondescript one that I tether to my belt with a thin but strong cord that I don't unhook until I'm safely home.

BAD WEATHER CAN MEAN GOOD PORTRAITS

Shooting in rain, snow, and other such dreadful conditions can be a real pain. However, it's pain that can produce great street portraits. Bad weather stresses people, and that stress shows in their faces. The result can be some very telling portraits. Plastic bags can help keep your gear dry, as can a broad-brimmed hat. You can also buy protective "raincoats" for many popular cameras.

BACK UP PROMPTLY

Today's digital cameras and memory cards are technological marvels. They can accomplish photographic miracles we couldn't even imagine a few years ago. The sad truth is, however, that they can also go terribly wrong—and, in the process, destroy countless hours of your hard work in the blink of an eye.

And what does this mean for us photographers? It means we're total idiots if we don't back up our picture files as soon as we possibly can. There are, luckily, many ways of making these all-important backups. Everything from storing images online, downloading them to a computer, and then burning a disk or loading them onto one of the many dedicated image "safes" now available can do the job. In addition, some of today's cameras have slots to house two memory cards, one of which can be set to automatically mirror the other while shooting.

While making backups, the prudent path is to make at least two copies. This may sound like overkill, but it's overkill that's saved many a photographer, including this one, from disaster on more than one occasion.

GETTING READY:
A GUIDE TO PREPRODUCTION

GETTING READY:
A GUIDE TO PREPRODUCTION

There are no rules for good photographs, there are only good photographs.

—ANSEL ADAMS

"Be prepared." Any Boy Scout will be glad to tell you this—and to explain why it's so important if you intend to live a prosperous and productive life. And to some extent, he will be right.

Being prepared can be and frequently is a very good thing—especially if you want to be a portrait photographer and not lose your sanity at the same time. Finding yourself, for example, in the middle of a location shoot that's costing you a small fortune to stage and is far from anything that can be remotely considered civilization and running out of batteries is definitely not the kind of experience that helps to keep one totally glued together.

So with that in mind, let us give the Scouts their due and agree that the better prepared we are, the less hassle we will have to endure. And that brings us to the question, "What does the word 'prepared' mean?" Well, the truth is that there's no one answer.

Obviously, being prepared for a simple portrait shoot in one's studio is quite different from being prepared for a portrait-making jaunt into the more remote reaches of some distant land. That being said, both situations share certain common threads and involve many commonsense steps and precautions. Those are what we'll cover in the rest of this section.

THE FOUR "W" QUESTIONS

Generally speaking, getting ready for a portrait shoot involves "what, who, when, and where"—the four "W" questions that are at the heart of so many of the preparations we make in life. Once you can answer them, you're pretty much good to go.

What?

The answers to two very different "what" questions are at the heart of preparing for any portrait session. The first is "What do I want from this portrait?" The second is "What gear do I need to shoot it?"

What do I (or my client) want from this portrait?

This is among the first questions I ask myself when I'm getting ready for a shoot. The answers, and those to similar questions, help me form that all-important mental image of the portrait I'm going to shoot well before I get started.

If, for example, the portrait that I'm about to shoot is to be part of an advertising campaign or serve to illustrate a magazine article, it's critical that I understand exactly what my client's

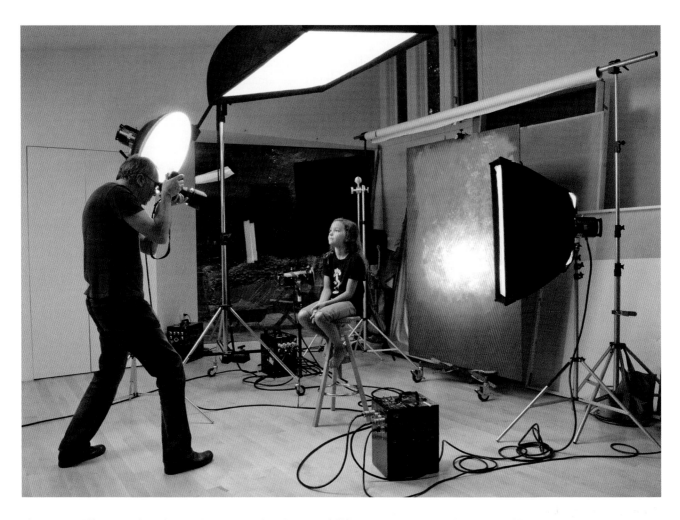

Figure 1. Different styles of portraits can require the use of different gear. Frequently, it's possible to rent equipment you don't own.

needs and expectations are. Or if I'm shooting a portrait that somebody wants to use on their holiday cards or to send along with a job application, I need to understand their sensitivities—particularly what they do and do not like about the way they look.

The key in either of these cases is to ask lots of questions and to listen carefully to the answers given. Doing this will provide the information you need to shoot portraits that do what you want them to.

What gear do I need?

Here we're talking about things—the things needed to shoot a given portrait, to be exact. These include such items as wardrobes, props, backdrops, cameras and lenses, lights and stands, batteries, memory devices, laptops, cases, grip equipment, permits, first aid kits, and all the other gear that's used in portrait making.

Many times, you will already have everything you need on hand for the shoot you're planning. In other instances, you may not. If that's the case, you may be able to rent everything you need. This is especially true if you're working in or near a large metropolitan area. If not, you may be able to arrange for the rental items you need to be shipped to you. In either case, be sure to allow enough time for everything you need to be delivered and for you to test it.

In addition, when you are using anything but the simplest setups it's a good idea to leave yourself enough time to put together and fully test the setup you're planning to use. I always test the pose and lighting I have in mind for an upcoming portrait shoot well beforehand. It's amazing how many times I discover that my original vision for the image doesn't quite work, because it doesn't quite produce the look I'm after.

Location shooting introduces added problems to the gear selection process. Some things to keep in mind if you're going to be shooting away from home are:

- If it can break, it will. Take backup for all critical gear.

- Make sure that everything arrives well before your shoot is scheduled to begin.

- Watch the weather. If you're planning to shoot outside, even a slight change can mean a big difference in how you're going to have to do things.

- Permits and licenses are often required, and they can take a long time to get. Apply well in advance of your shoot.

- Security counts. Do whatever you have to do to make sure nothing is stolen and make sure that your insurance will cover any loss.

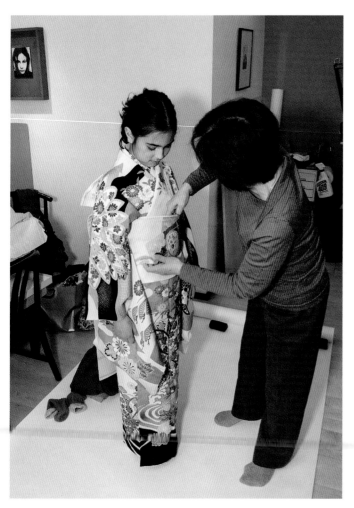

Figure 2. We used a professional kimono dresser to help style this shoot.

Generally speaking, the closer your location is to home, the easier it is to follow these guidelines. If you are forced to work in some distant location, be sure that the project budget is large enough to cover such things as preshoot visits, document procurement, delays, and shipping services.

Who and When?

Whom do I need for this shoot and when do I need them? Because these two questions are so intimately related, it's helpful to think of them together. Sometimes the answers are simple and sometimes they're not. Sometimes the only people involved are you and your subject. On other occasions, however, lots of assistants, of one kind or the other, may be a part of your shoot, some of whom are responsible for getting different tasks done at different times.

For example, it's common to involve both hair and makeup and wardrobe stylists in the sort of high-end portrait shoots made for advertising or magazine covers or articles. Food and floral stylists may also be involved. Professional models are also frequently used in such shoots, along with photo assistants who help with the actual picture taking.

Prior to a complex shoot, you may also employ such experts as set builders, prop makers, backdrop artists, guides, location scouts, caterers, drivers, and security personnel. And managing even a few extra people can be a lot of extra trouble. So leave yourself plenty of time for taking care of the

"human" side of things. In my experience, most of the problems involved with it come from misunderstandings. With that in mind, make it a point to:

- Provide everybody involved with your shoot with written instructions that include precise instructions on where they are to be and when they are to be there. Include instructions on how to get there and provide a map and/or GPS locaters if the location is hard to find. Also include your, or a trusted assistant's, cell and land line phone numbers.

- Call or email everybody involved prior to the shoot and confirm any arrangements you made with them.

- Build plenty of "slush" time into every schedule. Unforeseen problems have a nasty habit of cropping up in even the most carefully planned shoot.

Where?

Where will you be working? Your answer will have a huge impact on your preparations. Shooting in your studio is one thing. Working in a relatively close location is another. Going abroad to work in some place you've never visited is about as complex as portrait shooting gets.

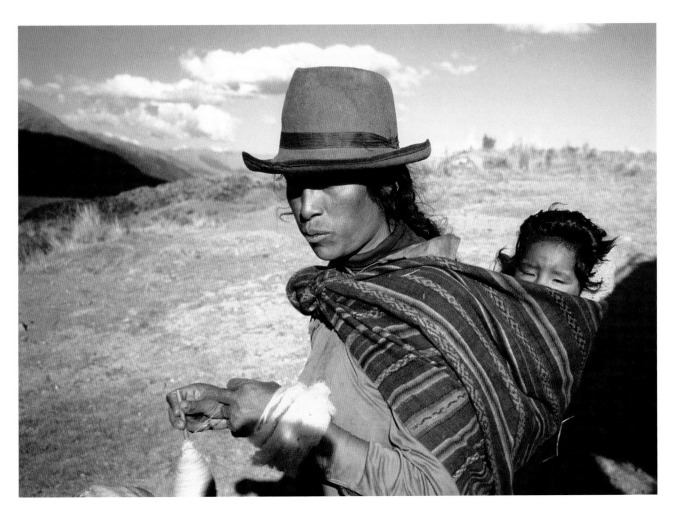

Figure 3. Shooting in remote locations can present some interesting challenges. The better prepared you are, the better you'll cope with them.

If you're working in your studio, one of the most important "Where" preparations is to make sure that everybody involved knows how to get there. I was once held up for over an hour because the hair stylist had trouble finding the studio we were using. Perhaps the simplest way to avoid such a problem is, as I suggested earlier, to email a map and "how to get there" instructions along with a contact phone number to everybody involved well before your shoot.

Location shooting can be—and, unfortunately, usually is—more complex than studio work. One of the keys to surviving location shooting is to scout anywhere you are thinking about using before you commit to it. Look around carefully. Ask yourself questions such as these: What are the best vantage points? What are its potential problems? What's the ambient light like at different times of the day? Will I need a generator or battery-powered lights? How's parking? Is there room to work without getting in people's way? Does the area look safe or do I need to hire security guards? Are there restrooms available? Will I need any permits? How about places to eat? These are the kinds of questions that you need to answer before deciding to use any shooting location.

Sometimes it may not be practical for you to scout locations yourself. If that's the case, consider hiring someone to scout it for you. Fortunately, in many locations professional location scouts are readily available.

In addition, a web search will produce numerous hits on location scouting services. Some, such as the California-based Plan-It Locations, Inc., provide web-based archives that include pictures of literally thousands of different potential shooting locations. Others are small—often one-person—agencies that specialize in a particular city or area. In addition, many national, state, and local governments support media and tourism offices that can be of help. Guidebooks and magazines can also help in finding good locations in which to shoot.

MODIFYING
LIGHT

MODIFYING LIGHT

I'm always mentally photographing everything as practice.

—Minor White

Many things go into the making of good portraits. Interesting subjects, appealing poses, exciting locations, suitable points of view, backgrounds, lens, and depths of field are just some of the factors that portrait photographers—be they beginners or seasoned professionals—must consider before putting finger to shutter release.

And then there is light—the great portrait maker, the great portrait breaker. Get everything else right but get your lighting wrong and your portrait dies. Get the light right and it lives. Or, to put it differently: if the light isn't right, the portrait isn't right. It's that simple. And that's how this section fits into the art of portraiture. In it we'll discuss some of the tools that we have found most useful in modifying—or as it's sometimes called, "controlling"—the light we use in portrait making.

Before going any farther, however, a few words of encouragement for those of you who are serious about getting into portrait shooting but for whom the financing of such a desire may be a problem. Please don't lose any sleep over the fact that at this time in your life you can't afford all the various gear, gadgets, and gizmos we talk about in this section. One of the fabulous things about portrait shooting is that you can produce wonderful images using nothing but the absolute simplest of gear. Take, for example, the portrait of Max, shown earlier on spread 4.

Steve shot this picture using nothing more than an ordinary table lamp that served as his main light and a piece of white foam board that reflected a bit of shadow-lightening fill light into the scene.

And consider my friend Yayah's portrait on page 69. It's a nice example of a simple street portrait, and I took it with nothing more than an inexpensive point-and-shoot camera, using its built-in flash.

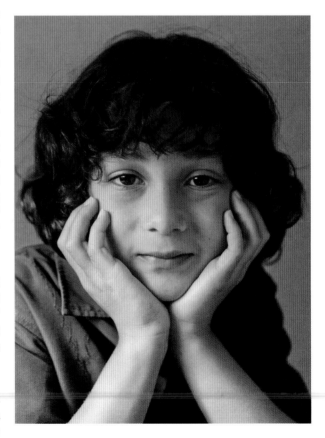

Figure 1. Steve made this professional-looking portrait using nothing but a table lamp and a reflector card.

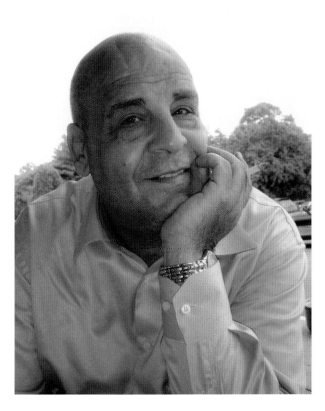

Figure 2. I shot this street portrait of my friend Yayah with nothing more than a point-and-shoot camera and its built-in flash.

Both of these portraits turned out well. And both demonstrate that old truism, "It's what you do with what you've got that counts." Having said that, let's now move on to the business of modifying light, and some of the various tools we use to do it.

My coauthor Steve and I work at opposite ends of the portrait world. Most of what Steve shoots comes to life within a controlled setting, whether it be a studio or on location. In contrast, just about every portrait I shoot is a quick grab from the street. Obviously, that contrast means that we often work very differently. However, when it comes to the all-critical task of manipulating the lighting we want for our portraits, we both use nearly identical tools. The only real difference between them is that those Steve uses in his studio are bigger, heavier, and more powerful than the versions I stuff into my pockets on my way out the door for a busy day of street shooting.

In subsequent pages, we'll describe the most important of the tools we both rely on to manipulate the light with which we are shooting. For clarity's sake, we've divided them into the following six groups:

- Diffusers

- Reflectors

- Spots

- Light blockers

- Ring lights

- Filters

Generally speaking, diffusers soften light; reflectors change its direction while also softening it; spots focus light; and light blockers block it. Ring lights are used to produce shadowless, frontal lighting, and filters restrict the wavelength of the light passing through a camera's lens. Although their effects are often very different, each of these manipulations can have a major influence on the look of any portrait.

DIFFUSERS

When it comes to modifying light, diffusers—in all their different forms—are one of the most important tools available. The reason is simple. People who are illuminated by a "soft," diffused light look a lot different from those lit by a "hard," undiffused source. Look, for example, at the pictures of Nigel in Figure 3. We lit the picture on the left with an undiffused flash. The resulting harsh, sharp-edged light and shadows produced a contrasty portrait of him.

We then shot Nigel's picture again. This time, however, we lit him with a large soft box rather than the flash head and reflector combination we used earlier. The result, shown on the right, is a far "softer," less contrasty, and very different-looking portrait.

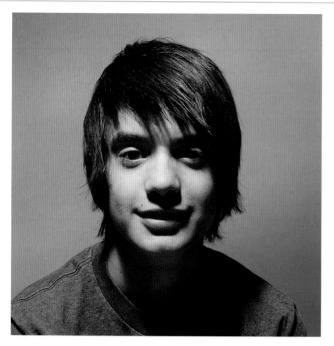
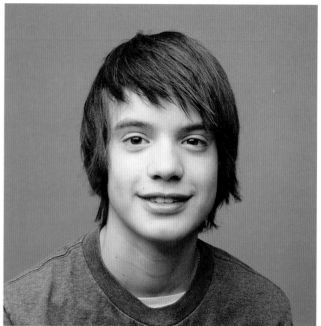

Figure 3. Notice how different these two portraits are. We took them both at the same time using the same camera and lens. The only difference is that we used a "hard," undiffused light when we shot the one on the left and a "soft," diffused light when we made the picture on the right.

And just why is it that this happened? Why is it that one of these portraits looks "hard" while the other looked so much "softer"? Well, the answer involves an important principle of optical science. And that is—all things being equal—the **larger** a light source is, the **softer** the illumination it produces. The reverse is also true. Generally speaking, the **smaller** the light source, the **harder** the light it produces.

Practically speaking, when we use a **large** light source to photograph someone, the resulting portrait will have **soft** shadows that exhibit few if any crisp, sharply defined, edges. When, on the other hand, we use a **small** light source, the resulting shadows will have far **harder**, **clearly defined** edges.

Or, to state this in another way, we can say that in most cases small "hard" light sources produce "hard" contrasty-looking pictures and large "soft" light sources produce "soft"-looking ones. And that is why diffusers are so essential to portrait and other photographers. In their many forms, they are the all-important tools that help us to modify light in ways that control one of the most important aspects of our images—their contrast, or the "hardness" or "softness" of their look.

In the following pages, we will discuss the diffusers that we've found to be most useful over the years. These include **soft boxes**, **shoot-through umbrellas**, **diffusion panels**, **portable diffusers**, and the **attachable diffusers** that are available for both portable and built-in flashes.

Soft Boxes

Visit just about any professional photographer's studio and there's a good chance you'll see one or more soft boxes there. As shown in Figure 4, you can buy soft boxes in different shapes and sizes. Some are made with rigid frames while others fold, making them easy to carry and store.

Figure 4. Soft boxes are available in many different shapes and sizes. In addition to these examples, made for studio use, you can also buy small soft boxes that attach to portable flashes.

Figure 5. Shoot-through umbrellas are useful diffusers. However, the light that escapes from their backs can produce unwanted spill.

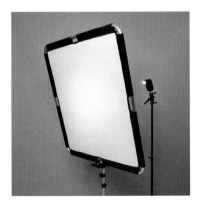

Figure 6. This diffusion panel is typical of the many different ones available. It's also a simple and inexpensive matter to build a similar one.

Regardless of what size or kind they are, all soft boxes are fundamentally the same. They're all boxes that are lined with some sort of reflective material and fitted with a translucent front panel. In addition, they all have fittings to hold one or more lights (usually a flash head of some kind) inside them. The result is that the apparent size of the light source a soft box contains is increased from that of a relatively small flash head (or heads) to that of the box's far larger, translucent front panel.

Soft boxes are extremely useful tools and one of the most important light modifiers used. The soft, often pleasing light they produce is ideal for many kinds of portraiture. Think, for example, of just about any flattering "glamor" magazine cover you've seen lately and the chances are good that it was shot using one or more soft boxes.

Shoot-Through Umbrellas

These umbrellas are another very popular and relatively inexpensive way of diffusing, and thus softening, light. In many ways shoot-through umbrellas act like soft boxes without backs.

One important difference, however, is that, because shoot-through umbrellas do not have backs, a considerable amount of light escapes from the rear of them. In many cases, this makes no difference. Sometimes, however, this spill creates unwanted fill light for which you should be prepared. In addition to spilling light, shoot-through umbrellas are also less efficient than soft boxes and the light from them is less directional.

Diffusion Panels

Diffusion panels—or as they are sometimes called, diffusion screens—are another commonly used light modifier. Figure 6 shows a commercially made panel that's being used with a small portable flash. We also frequently use such panels with large studio flash heads.

Such panels consist of a rigid frame of some sort to which a sheet of translucent diffusion material is attached. Panels such as the one shown have the added virtue of being easy to take apart and thus are simple to store or move to another location. Available in different sizes and styles, some makers also supply reflective and opaque coverings for their panels.

It's also easy enough to make a diffusion panel out of wood or plastic (PVC) pipe and cover it with one of the many diffusing materials available from suppliers such as Rosco Laboratories.

The degree of softness that diffusion panels (or, for that matter, any other diffuser) produce is, at least to some degree, adjustable. The key to making such adjustments is the location of your light source. The farther you place it from your diffusion screen, the softer the light falling on your subject will be.

Conversely, the closer you place your light source to a diffusion screen, the less it will soften the light it gives off. Needless to say, the degree of adjustability possible will vary both with your light source and the nature of the diffusion material you're using.

A Word of Caution

Diffusion panels can be a big help when shooting portraits, or anything else, for that matter. However, at this point, a word of caution is due. Be *extremely* careful whenever you use diffusion screens with any kind of tungsten or other hot light.

There have been too many incidents, some of them fatal, in which hot lights have caused carelessly used diffusion materials such as tracing paper or curtains to catch fire. With that in mind, it's critical to check any diffusing material you plan to use with hot lights to make absolutely sure it can't catch fire.

In addition, always keep a fully charged fire extinguisher around when you're shooting. The unfortunate truth is, you never know when you are going to need it.

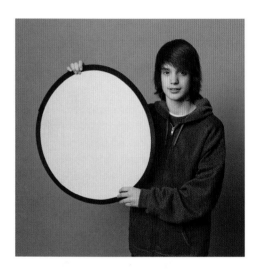

Figure 7. Small, lightweight, collapsible diffusers, such as this commonly used model, are great for location shooting. Some of these diffusers are also supplied with reflective coverings. This makes them a handy and relatively inexpensive "multi-use" modifier.

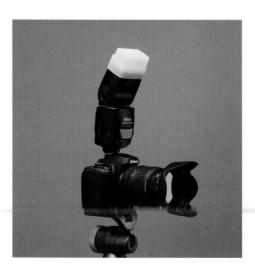

Figure 8. Small, easily carried diffusers, such as this one, can be real portrait enhancers.

Portable Diffusers

Many kinds of portable diffusers are available. These come in different sizes and styles. Some (Figure 7) collapse and fold to a much smaller size than when they are open. That makes them easy to store and to carry around with you. In addition, because such portable units don't weigh much, they're ideal for use with lightweight stands and portable flashes.

As was the case with studio panels, some collapsible diffusers are also supplied with reflective coverings, making them both useful and a definite "best buy."

Attachable Diffusers

Many journalists, street shooters, travel photographers, and other enthusiasts use portable flash units. In addition, because today's portable, off-camera flashes are both highly sophisticated and relatively inexpensive, several photographers I know have used them to rig basic, but very effective, portable "studio" lighting setups.

Because of the increasing popularity of portable flashes, many different attachable—or, as they are sometimes called, "snap-on"—diffusers are now available for them. Figure 8 shows one I often use. Called the Omni-Bounce® and made by STO-FEN, it's easy to use, pack, and carry around. It's also relatively inconspicuous or "normal" looking. This can be a very good thing when you're working in places where you don't want to draw too much attention to yourself.

Another attachable diffuser I like is the Lightsphere® from Gary Fong. This dome-shaped unit does a great job of spreading evenly diffused light around a room.

When rotated so that its "top" faces forward, the Lightsphere also provides useful fill light, as long as I'm not more than four or five feet from my subject. My only objection to this diffuser is that its size and shape make it somewhat difficult for me to carry around.

Sometimes, when I'm either shooting outside or in rooms with ceilings that are too high or too dark to bounce my flash off effectively, I use

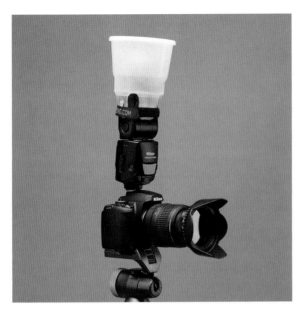

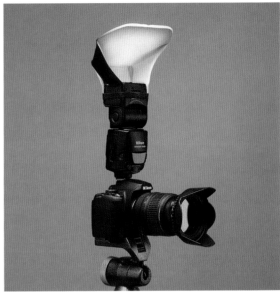

Figure 9. The Lightsphere fills a room with a nice, evenly diffused light. It also works well outside when shooting at short ranges.

Figure 10. The Pocket Bouncer is an attachable reflector that produces a nicely diffused light.

foldable and thus easily portable flash reflectors, or "bounces," such as the LumiQuest® Pocket Bouncer (Figure 10).

We talk about reflectors later in this section. However, since the only reason I ever use a Pocket Bouncer is to diffuse my flash, I've opted to introduce it to you here. Quick and easy to attach, this small reflector does a good job of softening the quality of the light my portable flashes produce and in spreading it across a wider area.

Getting a Grip

So far, I've introduced some of the most helpful of the devices we use to modify, or control, the light with which we are shooting. In the following pages, we'll present more. Together, they are a mixed bag, but they all have something in common. To do their job, they all—in one way or the other—have to be held in front of the light they are to modify. And that's where "grips," or clamps, come in. They do the holding.

Between us, Steve and I own many different grips. The following ones are representative of those we use with our portable flashes. Figure 11 shows two we use frequently.

The grip shown at the top of the picture is designed to screw on to a light stand. In addition to a flash, it can also be used to hold a small to medium-sized umbrella in place. The other grip shown is a type of clamp. In addition to stands, we've used it to hold on to everything from tabletops to doors and fences.

The grip I'm holding in Figure 12 is a high-end example of those made to lift flashes above the camera to which they are attached. Such grips are popular with wedding photographers and photojournalists because they help to reduce red eye and eliminate distracting shadows behind their subjects.

The grips shown here are representative of the many available. The right choice for you depends upon the sort of portrait shooting you do. They're a good investment. Not only will they make your shooting easier, they'll also help you to make the kinds of pictures you want to.

Figure 11. The two grips shown here holding portable flashes are typical of the many that are made for attaching lightweight gear, such as portable flashes, to different kinds of supports.

Figure 12. Flash brackets, such as this rotating one, help prevent red eye and unwanted shadows by holding a flash above the camera to which it's attached.

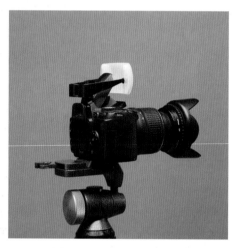

Figure 13. The Puffer is one of the small diffusers now available for built-in pop-up flashes.

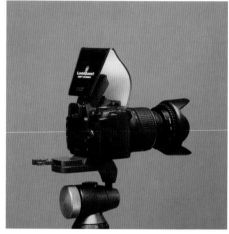

Figure 14. I have had good luck using Soft Screen diffusers with built-in flash. One particularly nice feature of them is that they fold up and thus are easy to carry in a pocket or small camera bag.

Up to now, all of the attachable diffusers we've mentioned are made to work with portable, off-camera flashes. Fortunately, however, models are now available for the pop-up flashes that are built into so many of today's DSLRs.

In most cases, the light that these little flashes produce is challenging—to say the very least. Actually, in most cases I've seen, it's pretty awful. However, using one of the small diffusers that are now available, such as the Puffer® (Figure 13) from Gary Fong can help. These mini diffusers go a long way toward making the light given off by pop-up flashes far more useful.

Another useful diffuser for pop-up flashes is the Soft Screen from LumiQuest (Figure 14). Inexpensive, and available for many cameras, it does a good job

of softening shadows and reducing the hot spots that pop-up flashes so often produce. Because it's thin and folds up nicely, it's also easy to store in a camera bag or stuff into a pocket.

I have, however, at times had a bit of trouble attaching my "Soft Screens" to some of my cameras. On occasion, especially on a windy day, this has caused the front of the screen to come loose at inopportune moments. Although that's not a catastrophe, it can be a nuisance—especially if you are in the middle of taking somebody's picture. So if you want to use a Soft Screen, be sure that it's firmly attached before you begin shooting.

Be Warned: Diffusers Are Light Eaters

Before moving on, a few words on "light eating" are in order. All diffusers are light eaters. Some are far more voracious than others, but the use of any of them reduces, often dramatically, the intensity of the light falling onto your subject.

In most studio situations, such a diffusion-caused reduction is of little importance. Studio strobes are powerful beasts. They are capable of producing large amounts of light. However, if you are diffusing the light from a small portable flash, the light reduction caused by any diffuser may present you with a serious challenge. In such situations, the only practical remedies are to increase your ISO (and thus increase the risk of getting nasty noise in your pictures), move closer to your subject, or a combination of both.

REFLECTORS

Reflectors change the direction that light rays shine. That's simple enough. It's also very helpful. Take, for example, that indispensable helper upon which all portrait makers must from time to time depend—fill light. Reflectors are often the easiest way to provide it.

Reflectors can also help with a picture's color. Both silver and gold surfaces are provided for many professionally made reflectors. These provide us with a choice between warm or cool reflected light. It's also a simple matter to make a reflector that will produce just about any colored bounce light that we could want by painting a piece of art board, wood, or canvas in the desired shade.

You can also use reflectors to diffuse, or soften, a light source. For example, bounce a flash off a nearby wall, ceiling, photographic umbrella, or "bounce" card and the resulting image will show softer shadows and subtler highlights than if you had shot it straight on with your flash.

Just about anything can serve as a reflector. I've used everything from the side of a truck to the dirt underfoot—from a piece of foam board to a white T-shirt. You can also select from many different professionally made reflectors. Among the most popular of these are the so-called **standard** models, **"beauty dish" reflectors**, **reflector panels**, and photographic **umbrellas**. We'll discuss them all in the following pages.

Standard Reflectors

Flash and continuous, or hot light, heads are designed to accept a wide variety of "standard" reflectors. Usually made of metal, these vary greatly in size, shape and reflective quality. Some, for example, are deep and brightly polished. Such

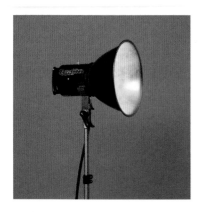

Figure 15. This 12-inch-diameter silver reflector is typical of the standard units that are usually supplied with studio flash and "hot" lights.

Figure 16. We frequently use this Softlight beauty dish reflector because it produces a concentrated core light that falls off with evenly feathered edges.

Figure 17. Shown fitted with a gold reflective covering, this portable TriGrip reflector/diffuser combination is typical of the many multipurpose models available today.

"headlight" reflectors are commonly used to produce intense, highly directional beams.

Other reflectors are manufactured with various shapes, sizes, finishes, and focusing capabilities. The practical result of this diversity is that there is a standard reflector available for use in just about any lighting situation.

At least in the beginning, perhaps the most important factor to consider when deciding on which reflector to use is size. If you want a reflector that will project light across a large area, use a large one. Conversely, if you want it to illuminate a relatively small area, use a small reflector. And keep in mind that you can always increase the effective size of any reflector that you are using. All you have to do is shine it through a diffuser of some kind.

"Beauty Dish" Reflectors

A favorite among glamor and fashion shooters, many portrait photographers (ourselves included) regularly use this style of reflector. A specialized version of the previously discussed standard reflectors, this style comes in several different makes and models.

Needless to say, each manufacture is only too happy to assure you that their product is the very best one you can buy. Figure 16 shows one we use often. It's a 22-inch Softlight made by the Mola company.

Extremely efficient, this reflector combines a specially formulated shape and surface coating. In addition, it makes use of both internal and external diffusers. The result is a relatively soft, but focused or concentrated core light that falls off with attractive, evenly feathered edges. The look this produces falls somewhere between that produced by an ordinary standard reflector of the same size and that created by a soft box.

Reflector Panels

Reflector panels are among the portrait maker's most useful tools. They are also one of the simplest. Not only are reflectors useful for directing light to where you want it, but, as we mentioned earlier, because they are larger than the light sources shining on them, they produce a soft light that's very useful in some styles of portrait making.

Reflector panels can be made out of just about anything. We often used reflectors made from sheets of white foam board when shooting the portraits for this book. In cases for which we wanted a more specular rendition, we used reflectors that had bright, highly reflective metallic coatings.

We also regularly use collapsible, and thus easily portable, reflectors such as this TriGrip® from Lastolite (Figure 17). Several companies make similar portable models, which are useful in both field and studio.

The most useful of these reflectors are sturdily made, light, and easily collapsible. In addition, they're are supplied with both translucent diffusion and opaque black removable covering as well as several different colored reflective ones. Obviously, such multipurpose products give by far the biggest bang for your hard-earned bucks.

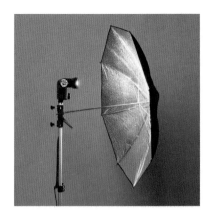

Figure 18. Umbrellas, such as this small, silver-lined one, are lightweight and easy enough to carry to be ideal partners for off-camera flashes. Together, they make a great on-location portrait-shooting combination.

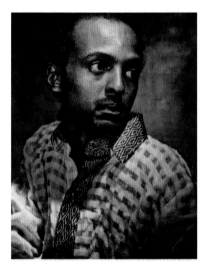

Figure 19. We shot this portrait of Yonus with relatively hard, high-contrast lighting because we felt it would help to bring out his tense, "coiled-spring" mood.

Umbrellas

Umbrellas such as the one in Figure 18 are another extremely useful and popular type of reflector. As is the case with other reflectors, umbrellas provide an effective way of softening a light source as well as changing its direction.

Relatively inexpensive, easy to set up, and available in many sizes, umbrellas can be attached to either small portable flashes or used with powerful studio strobes.

Reflective umbrellas are made with an opaque outer covering and a reflective inner lining. The most common colors for them are soft white, satin white, silver, and gold. In addition, as mentioned earlier in this section, so-called shoot-through umbrellas are also available. These work in much the same way as other types of diffusers do.

SPOTS

Many photographers with whom I talk tend to think—especially if they are new at the game—that the words "portrait" and "soft, diffused light" always go hand in hand. They believe, in other words, that soft light is "good" portrait light and that hard light is "bad" portrait light. To some small extent they are correct. Soft light can be, and often is, very flattering. Many people do look very attractive when their picture is taken using it.

There are, however, plenty of other great portrait looks. Take, for example, Figure 19, Yonus on spread 42. He's definitely not a delicate kind of a guy—definitely not the sort we would shoot with softly diffused light. Instead, we felt an edgy and hard, high-contrast approach was the way to go. It was, in other words, the lighting that would best bring out the tense, on-edge side of Yonus's nature we wanted to emphasize in this portrait.

Or look at Figure 20, showing Lelia. It demonstrates another way in which spots can be helpful. In this case, we wanted a nicely defined, circular area of bright light on the backdrop behind Lelia. We were able to get that by aiming a small grid spot at the backdrop. It produced exactly the bright halo of light we wanted to around Lelia's head and made it pop out from the rest of the portrait.

Now that you've seen some of the ways in which spots can help you produce the sort of look or style you want for your portraits, let's define what they are. Basically, spots are lights that allow you to focus, or constrain, their rays to a particular part of a scene. In other words, instead of spreading light rays around the way diffusers do, spots make them more directional. Some of the different spots we commonly use when shooting portraits are **Fresnels, grids**, and **optical spots**.

Fresnels

Fresnels (Figure 21) are spotlights that contain specialized condensing lenses. These gather the light rays from a source and bring them together into a concentrated beam.

The most useful types of Fresnels are those that can be focused. They can be used as everything from broad-beamed floodlights to intense, narrowly focused

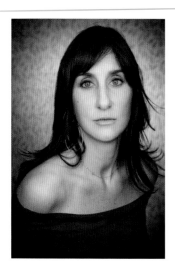

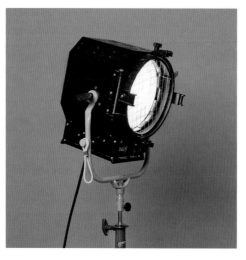

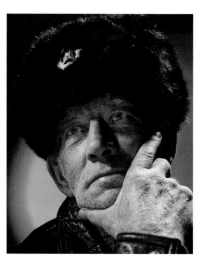

Figure 20. We used a grid spot to project the circle of bright light you see on the backdrop behind Lelia.

Figure 21. Fresnel spots, such as this focusable model, can serve as everything from wide-beamed floods to sharply focused spotlights.

Figure 22. By using a narrowly focused beam from a powerful Fresnel spot, we were able to produce the hard-edged, retro movie poster look we wanted for Lynn's portrait.

Figure 23. Grids limit the spread of light rays. Because of this, they are useful for concentrating light on a specific part of a scene.

Figure 24. Because optical spots contain lenses much like those used in slide projectors, they can project bright areas of light where you want it in a scene.

spots. Such focusable lights are more expensive than fixed-focus models. However, their versatility makes them well worth their higher cost.

We used a Fresnel as our main, or key, light when we shot this portrait (Figure 22) of our friend Lynn. To get the crisp, hard-edged look we thought best for him, we focused our Fresnel so that it produced a narrow beam. This, in turn, helped to produce the crisply defined tonal separation we were after for this portrait.

Grids

Grids, or as they are sometimes called, "honeycombs," are screens with honeycomb-shaped openings. They attach to the front of lights and constrain, or limit, the spread of their rays, thus concentrating them on a specific part of a scene. The extent of this concentration depends on the size of the openings in the grid used. The smaller the openings, the greater the concentration will be.

The light pattern grids produce is characterized by a bright central area that's surrounded by soft, feathered edges. These edges then gradually fall away into increasingly darker tones.

Optical Spots

Very specialized optical spots (Figure 24), like grids, attach to the front of light sources. They contain lenses much like those found in photographic projectors.

This design allows the light they give off to be carefully focused. Thus, depending how you focus them, you can use optical stops to produce bright areas of light with either soft or sharp and clearly defined edges. You can also use them to project patterns or graphic shapes called "cookies" onto your subjects or their backgrounds.

Figure 25. Both flags, such as the large black one in this picture, and the barn doors in front of it, shape the light falling on something or partially block it. They are among the most widely used light modifiers.

Figure 26. Notice in this picture how the ring light surrounds the camera's lens.

Figure 27. Shot with a ring light, this portrait shows the unique circular catch lights that are characteristic of portraits made with such lighting.

LIGHT BLOCKERS

Light blockers do exactly what their name implies. They block light from going where you don't want it to go. The two blockers we use most often when shooting portraits are **flags**—or as they are sometimes called—**gobos**, and **barn doors**. We show both in Figure 25.

Flags (or Gobos)

Photographers often use these terms interchangeably.[1] Both are used to mean anything that's opaque and that's placed between a light source and a subject, background or lens.

We usually use flags to shape the way light falls on something or to block it partially. On occasion, we also use flags to keep light from falling on a lens and causing unwanted flare.

Flags and gobos range in size from small hand-held ones to 4-foot × 8-foot, or even larger, panels. We often make them from foam or art board. Commercially made flags, such as the one in Figure 25, are also available. They're usually made with a thin metal frame and black cloth. Some of the more useful of these units are made with collapsible frames to which an opaque black fabric covering can be attached. In addition, reflective and diffusion coverings are also available for some models.

Barn Doors

These are frames with two or four hinged panels, or "doors." Barn doors attach to the front of lights, and as was the case with flags, they're useful for shaping light and determining where it will and will not fall. Barn doors are relatively inexpensive and are available in different styles and sizes. Useful in many different situations, they are worth every cent you pay for them.

RING LIGHTS

Ring lights are unique, having been originally developed for scientific and forensic use. Their circular shape is unlike any other light source used in portraiture. That's because, unlike other lights, ring lights actually surround the lens with which you are using them.

Ring lights produce an intense, frontal light. This has made them popular among some fashion and glamour photographers. Ring lights also produce unique circular catch lights in a subject's eyes. These are clearly visible in Yougeshwar's portrait on spread 16.

FILTERS OR "GELS"

Many different types of filters—or as they are often called, "gels"—are available. The majority of them are made of dyed acetate or other similar plastics. The more accurate, and thus far more expensive, filters are made of glass and other optically pure and color-stable materials.

[1]In addition to this usage, the term "gobo" is also at times used to mean a thin metal or card pattern that has been cut in such a way that it produces a desired shadow pattern when placed in front of a light.

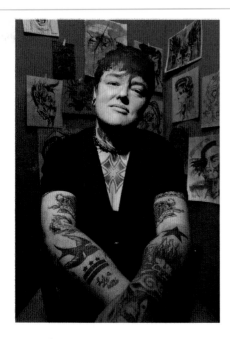

Figure 28. We used two lights to make this portrait taping a blue acetate filter over one of them and an amber-colored one over the other.

Filters help in several ways when shooting portraits. Sometimes, for example, we use **colored** filters to correct the color balance of the lights we are using. Most of the time, however, we use them for purely creative reasons. In addition, when working outside, we frequently use **polarizing** and **neutral density** filters to help us manage both glare and brightness issues.

Color Filters

Color filtering material is supplied in both rolls and sheets and is attached to the front of lights with clamps or tape. We used both blue and amber-colored acetate to create the saturated colors in Figure 28—Ax's portrait on spread 10.

Polarizing Filters

When glare is a consideration, we frequently turn to polarizing filters, or polarizers, to manipulate it in the way we want. We've found them particularly useful when we're shooting outside.[2]

Look at Figure 29. It's a "with and without" comparison of Jade in full sun. Steve shot the image on the left without a polarizer and the one on the right with a polarizer. What a difference there is between the two! Notice how much more saturated the colors are in the polarized image and how reduced the glare is on Jade's skin, hair, and glasses.

Figure 29. The image on the left was taken without using a polarizing filter. The one on the right was shot using one. Notice the difference in color saturation and glare between the two.

[2] Two types of polarizing filters are available for cameras. One is a **linear** polarizer, the other a **circular** polarizer. Circular polarizers are the more expensive of the two. And, unfortunately, they are the only polarizers that should be used with today's digital cameras. Using a linear one with a digital camera is sure to compromise either its light meter or auto focus mechanism, or both.

Neutral Density Filters

These can be your best friends when you're shooting in bright light—such as that burning down on a beach, snow, or desert on a sunny day. By absorbing some of the ambient light evenly through the entire visible spectrum—and thus keeping it from reaching your lens without changing the colors in the scene—neutral density filters are your first line of defense against overexposed, washed-out images.

Neutral density filters are also critical in situations in which you need to use large lens openings in bright light for sharpness or depth-of-field considerations such as blurring backgrounds. In addition, they also make it possible to use slow shutter speeds to produce blurred motion effects, such as water going over falls, in very brightly lit locations. Neutral density filters are available in different densities. I frequently carry a light one, a medium one, and a dark one as part of my kit.

SOME USEFUL SOURCES

On the previous pages, we've discussed the light modifiers that my coauthor Steve and I use most often. Variations of many of them are often available from different sources. The following list is not meant to be all-inclusive. Rather, it contains the names of those companies whose gear we've found to be well made and reliable and who, in addition, have also given us good service over the years.

- For colored filters or gels and diffusion materials, we often turn to products made by:

 - Rosco Laboratories, Stamford, CT (www.rosco.com)

 - THK Photo Products, Inc., Long Beach, CA (www.hoyafilter.com)

 - The Tiffen Company, LLC (www.tiffen.com)

- The Softlight "beauty" dish we use was manufactured by Mola, Inc., Toronto, Canada (www.mola-light.com).

- Various umbrellas, soft boxes, the large studio LitePanel diffusion panel, a small collapsible model, and a wide selection of grips we often use are from Photoflex, Inc., of Watsonville, CA (www.photoflex.com).

- Another well-made and useful line of reflector/diffuser combination units is manufactured by Lastolite Limited, represented in the United States by Bogen Imaging, Ramsey, NJ (www.bogenimaging.us).

- Two small pop-up flash diffusers we have found useful are the Puffer from Gary Fong, Inc., New York, NY (www.garyfonginc.com), and the Soft Screen from the LumiQuest Company, New Braunfels, TX (www.lumiquest.com).

- Well-made flash brackets are available from Custom Brackets of Cleveland, OH (www.custombrackets.com).

AND FINALLY…

A photographic portrait is a picture of someone who knows he's being photographed, and what he does with this knowledge is as much a part of the photograph as what he's wearing or how he looks. He's implicated in what's happening, and he has a certain real power over the result.

—Richard Avedon

"The art and craft of portraiture" is a phase that turns up all the time in books, articles, blogs, and web sites devoted to the making of pictures of people. Though I haven't checked, I wouldn't be at all surprised if either of us hasn't tucked it into this book a couple of times. And just what does it mean? Just what are we implying when we link the words "art" and "craft" to portrait making?

The first thing we have to do to answer that question is to look at what both words mean. Of the two, "craft" is by far the easiest to define. Dictionary definitions vary. However, they all revolve around a core theme. A craft is some activity, or trade—such as weaving or whittling, pottery making or paper hanging—that requires some degree of skill, training, and/or specialized knowledge. Judged by those standards, the making of portraits certainly qualifies as a "craft."

And that brings us to the matter of tools. Think of a craft and you almost automatically think of the tools essential to it. Masons have their hammers and chisels; carpenters their hammers and saws. We photographers have our cameras, lights, and other gear. And as we have shown throughout this book, the tools we use are an important part of the portrait-making process. However, the key point to remember is that they're only a small—a very small—part of it.

Obviously, if you're going to make a photograph, you need a camera of some sort. You may also need some sort of light. Beyond that, the field is wide open. We shot some of the portraits shown on preceding pages using very sophisticated digital gear. We made still others of the portraits at which you have looked with simple, inexpensive point-and-shoot cameras. We used digital cameras for most of the portraits we shot, but we also used film to shoot some of them. This we did using everything from professional 4 \times 5 view cameras and digital equipment to inexpensive plastic "toy" and "instant" film gear.

And just why am I telling you all this? For one reason—to stress what I think is the most important concept in portraiture:

It's what you do with what you've got that counts.

Yes, there's no doubt about it: it's great to know that you've got a bag filled with the newest and niftiest gear hanging from your shoulder. It's fabulous to feel that you have at your command all the gadgets and gizmos that you can ever possibly need for any eventuality. However, the truth is that in portraiture and the many other genres of photography—what's key to success, what's key to making great, rather than just satisfactory images—is what's stuffed between your ears, not in your camera bag.

And that brings me to the word "art"—as in the phrase "the art and craft of portraiture." Art is an amazing thing, and let me say from the get-go that I don't have the slightest idea what the word *really* means. I grew up surrounded by art and artists. My grandmother and mother were both portrait painters; my uncle and father were cultivated critics. I started playing around with pencils, brushes, paints, and cameras when I was a kid. And here I am, more than 60 years later, still doing it. But I still haven't figured out what the word "art" means. I still couldn't write a definition of the word if my life depended on it. I do, however, have a feel for it: a small glimmer, perhaps, of a far wider-ranging concept. To me, for something—be it a photographic portrait by Irving Penn or a Hopi Kachina doll—to be art it must enhance our understanding of our surroundings and/or ourselves.

And just what does that mean for us? What does it do to help us understand what is meant by the "art and craft of portraiture"? Well, for one thing, it means that the "art" side of portraiture is where our brains do their true magic. Some cultures call these mysterious workings of all those little gray cells between our ears "creativity." Still others credit them to the intervention of the supernatural. Who is right? We'll never know. But we all know that when the mysterious force some call "creativity" comes forward to take control of the human consciousness the results have sometimes been staggering.

Finally, what does all of this have to do with you as a maker of portraits? The answer is simple—everything.

The "craft" end of portrait making is relatively straightforward. Today, shooters such as you and I have marvelous gear available to us that routinely takes technically wonderful pictures with little or no input from us other than pressing the shutter release button. Other than that, all the other calculations and settings needed to produce beautiful-looking pictures are generated by fiendishly clever electronic "chips" programmed in some far-away factory to suck huge amounts of data in from the scenes at which we point our cameras, analyze it using incredibly complex mathematical formulas, and then spew out amazingly good digital pictures.

Are they "great" pictures? Amazingly often, the answer is "Yes." This approach can result in lots of them. And if camera owners take the time to learn a little about what their gear can and can't do, and learn a bit about composing their pictures, and if they study what different lighting does and does not produce—their pictures will probably get better and better. To put it another way, their grasp

of the craft of photography will increase, thus increasing the quality of many of their pictures. This, however, may not be the case of any portraits they take.

A portrait can be a strange and taxing type of photograph to make. That's not because they present any particularly difficult technical challenges. Rather, the difficulties are almost always to be found in the human side of things. If you're going to take a good portrait of me, you have to be able to communicate with me. No communications, no portrait. Nice quality "pictures," yes—portraits, no.

Over the past year or so, I have had the opportunity to watch closely as my co-author Steve made many of the portraits in this book. Without exception, his best images don't start to flow until he has established good communications with his subject—when, in other words, he gets "in the zone" with them. It is then, and only then, that he starts making images that capture not only his subject's physical looks, but also the relationship between him and them. It's then, in other words, that Steve makes portraits—not just pictures.

APPENDIX—TOOLS AND TECHNIQUES

The negative is the equivalent of the composer's score, and the print is the performance.

—ANSEL ADAMS

We close with this small compilation of tips and techniques that we've found useful in making the portraits for this book. We hope that you may find one or more of them useful in your own work.

COMPOSITING A COMPLEX GROUP PORTRAIT

Group portraits involving more than just a few subjects can be a nerve-wracking experience to make. It's not unusual, for example, to find that everybody who is supposed to be in the picture can't—for some reason or the other—be at the same place at the same time. In addition, finding the right location for an even moderately large group shot can also be a major headache.

These, and a few others, were the issues I faced when I was asked to produce this (Figure 1) group portrait of the Fuse Ensemble, a contemporary music performance group founded and directed by the composer Gina Biver.

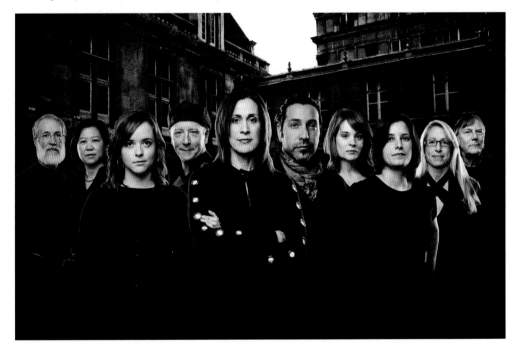

Figure 1. This group portrait was assembled, or composited, from many different individual images. Doing so required much careful planning.

153

My first step was to plan the portrait carefully. I needed to have a clear view in my mind of exactly what I wanted the finished portrait to look like and the steps needed to get there.

Due to scheduling conflicts, I had to shoot each of the group's members individually. And because I wanted to have plenty of choices to work with when I got around to putting the final portrait together, I shot each member in several different and somewhat varied poses (looking left, looking right, looking straight on).

During this process, I used the same lighting for everybody, hoping that when it came time to put all their pictures together, I could produce a final portrait that had a somewhat unreal, out-of-this-world look to it.

In addition, while shooting all the individual portraits, I kept the camera mounted at the same height and angle of view on a sturdy tripod. And because I wanted to keep everybody's head at about the same height, I asked the Ensemble's shorter members to stand on "apple boxes" or small, portable platforms.

For a background (Figure 2), I choose a picture that I had shot in Paris some years ago. After some work on both its color and its texture, it set just the mood I wanted. In addition, it provided a visually interesting background against which to assemble the Ensemble.

Next, I arranged the Ensemble's members. Because I placed each one of their pictures on a separate Photoshop layer, I had the freedom to move them around and size them in any way I liked. In my final arrangement, I placed the most

Figure 2. This old, visually interesting building in Paris had just the "look" I wanted for the Ensemble's portrait.

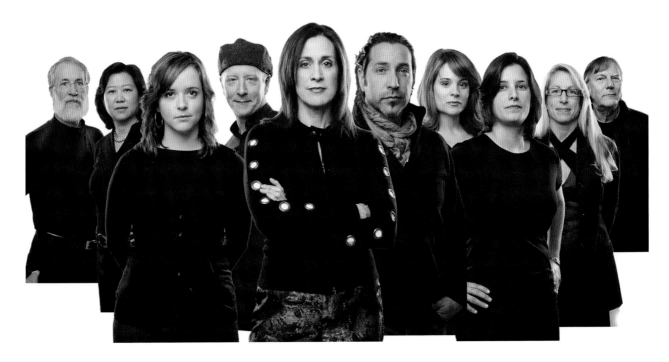

Figure 3. This shows the Ensemble's members as I finally arranged them, but before I superimposed them over the background.

important members at the front of the group and then layered the rest in behind them (Figure 3).

Portraits such as this one take careful planning, careful shooting, and the detailed arrangement of many Photoshop layers. But if you're willing to put in the hours required, the results can well turn out to be worth every minute.

COLOR OR BLACK AND WHITE?

Most of the time, I shoot in color. And most of the time, I like the results. But then there are those other times—when a color image I've so carefully crafted fails me. Sometimes the color is too pallid and my picture looks flat and generally undernourished. Other times, it's too garish and overpowering. But regardless of what's wrong with the image, there's one simple solution that's often successful when trying to rescue it from the dreaded "Delete" key. I convert it to black and white. The result can be amazing. What was moments ago headed for the trash almost miraculously turns into the day's prize.

Take, for example, Figure 4. It's of Shorty, a skilled horse wrangler I met in Arizona. He's a charming, but tough and hardened man—a man more than ready to take on just about any hardship life can throw at him.

Figure 4. We felt this color image did not accurately reflect Shorty's character.

But those qualities don't come through very well when we look at this color portrait of Shorty. The color image is, as you can see, flat and almost completely lacking in any hint of drama, any hint of artistic tension. Put simply, it just doesn't work.

Now look at Figure 5. It's the same portrait of Shorty, but after I converted it to black and white and increased its contrast a bit.

Figure 5. Now the portrait has some punch to it. It's a much more eye-catching and a much more accurate representation of the rough, ready, and very competent Shorty I photographed.

There are many different ways of converting from a color to a black-and-white image. I suggest you experiment with as many of them as you can. The approach that I have found least successful is to simply desaturate all the colors at the same time. True, it's a quick and easy way that ends up with a black-and-white picture. However, to my thinking, the results always leave a good deal to be desired. A much better way of working is to use imaging software that allows you to adjust each individual color channel separately. This way of working will give you far more control over what the resulting image will look like.

In the case of Shorty's portrait, I completely removed all the color from it. There are, however, times when you'll get interesting results by only partially desaturating an image. So experiment, and remember, just because you shoot in color (which I usually do), does not necessarily mean that you have to end up with it.

CHECKING EXPOSURE WITH HISTOGRAMS

Don't get me wrong—I love being able to shoot with digital cameras. The digital world that has now all but taken over photography is a great place to work. Today, I can do things that I could only dream of a few short years ago. That being said, there are some things about working with digital cameras that bother me from time to time.

One problem, for example, that pops up when shooting in anything but the Automatic mode is not being able judge accurately whether a picture I've just taken is properly exposed. This is a rather common problem, and it happens because the LCD panels of many digital cameras frequently do not show us a completely accurate representation of the scene our camera's sensors have just captured. This can happen because of everything from badly adjusted LCDs to being partially blinded by light reflecting off them and into our eyes.

Fortunately, most "prosumer" and all professional digital cameras on the market today have a feature that helps us to deal with this problem. The **histogram** is a graph that you can call up on your camera's LCD that makes it quick and easy to spot over- or underexposed images.

Don't let the long name worry you. Histograms are nothing more than a sort of bar graph that shows how many of your image's pixels where exposed at each brightness level.

The **horizontal** axis of a histogram represents the different gray tones, beginning at black at its far left side and running to white at its right side. The middle tones fall along the middle part of the horizontal axis. A histogram's **vertical** axis shows the number of pixels at each of these brightness intensities. This information can be very useful during postproduction as well as when shooting. For the purpose of this discussion, however, we'll limit ourselves to how to use it when we're shooting—and that, as you'll see, is very simple.

Take, for example, Figure 6. It shows a properly exposed picture of my daughter, Tessa, and the histogram for it. Notice how all the pixels in it are fairly evenly distributed across it from the "dark" or left side of it to the "light" or right side.

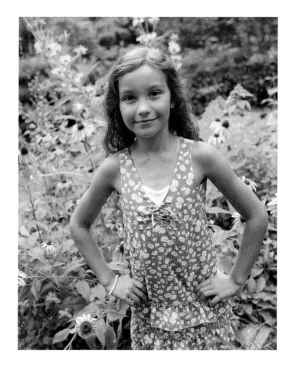

Figure 6. This well-exposed photograph of Tessa produced the histogram shown beside it. Notice how the pixels that make up Tessa's picture are fairly evenly distributed from one side of the graph to the other.

Now look at Figure 7. Notice how most of the pixels shown in the histogram are bunched up on the right, or "light," side of it. That tells us that Tessa's photograph is severely over exposed, which it so obviously is.

Figure 7. Tessa's overexposed picture produced the histogram beside it. Notice that the pixels in it are bunched up on the right side of the histogram.

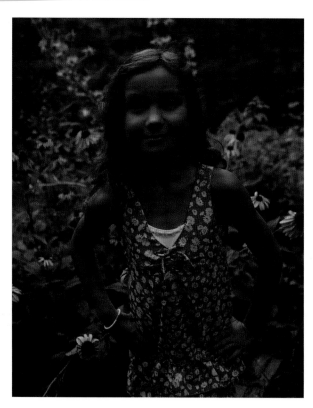

Figure 8. Tessa's underexposed picture produced the histogram beside it. Notice that the pixels shown in it are bunched up on the left side of the histogram.

And finally there's Figure 8. It demonstrates the reverse of what we've just seen. It's seriously underexposed, which has caused many of the pixels in its histogram to bunch up along its left or dark side.

And that's all there is to using histograms to check your exposure. The important thing to remember when looking at them is that there's no such thing a "good" or "bad" histogram. Rather, when it comes to checking exposure, what counts is whether it shows the pixels it represents as bunched up along either of its sides. Bunched-up pixels on the left side mean underexposure. On the right side, they mean overexposure.

Or, to put it another way, if your histogram shows lots of pixels bunched up on the left side, you're going to lose shadow detail. If, on the other hand, it shows most of the pixels against the right side of your histogram, you're going to lose highlight detail. If you don't want either of these things to happen, adjust your exposure and shoot again until your photograph is exposed the way you like.

ABOUT LIGHTING RATIOS

Lighting ratios—they're often misunderstood, and that's unfortunate because, as you are about to see, there's nothing that's really complex about them. If you want to understand what lighting ratios are, all you have to do is to think of one word—"contrast." That's what they are about.

Put simply, lighting ratios are nothing more than a numeric way of expressing how contrasty the light you are using to make a photograph is. They are nothing

more than a measure of how much difference there is between a scene's brightest (highlight) and its darkest tones (shadows).

Take, for example, Figure 9. It's a very "flat" portrait of my assistant, Mike. That's to say that there's almost no difference between the lightest and the darkest tones on his face. From that, we know that the main and fill lights I used were equally bright. If we were to translate that into "ratio speak," we would say that I made this portrait using a 1:1 lighting ratio.

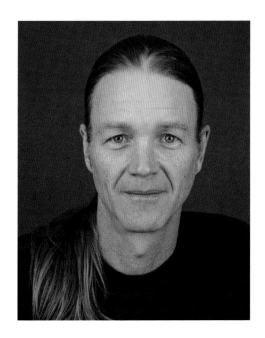

Now let's move on to Figure 10. Notice how Mike's face shows considerably more contrast in its lighting. This time there is a noticeable difference between this image's lightest (left side) and darkest (right side) tones. That tells us that there was a considerable difference between the intensity, or brightness, of the main and the fill light that I used in making it.

In fact, I did change my lighting when I made Figure 10. This time, instead of using main and fill lights of equal intensity, I boosted the brightness of my main light by two stops. This made the brightness of my main light four times as bright as my fill light. Shifting, once again, into "ratio speak," we can say that I shot Figure 10 using a 4:1 lighting ratio.

So far, I've explained what lighting ratios are. That's certainly a useful thing to know. But an equally important question is, "Of what importance to me are they in making my portraits?" The answers to that can vary. If you like to be very precise, and if you have a good light meter, you can control the lighting ratios you use in your portrait making with very great precision. Some photographers I know and respect highly like to work that way.

Figure 9. I used a 1:1 lighting ratio when I shot this picture of Mike. Notice how "flat" it is. That's because the main and the fill light I used to make it were of the same brightness.

Personally, I generally prefer to take more of an "eyeball," or instinctive, approach to lighting. I tend to like portraits that are a bit on the contrasty side. To achieve them, I move my lights around until they produce the look I want on my subjects. When I'm there, I shoot. As our friend, widely respected photographer and author Fil Hunter, has said, "Get the main light right, then fill in as much as you like—actually works pretty well."

Finally, let me inject a bit of very simple math into this discussion. If you want to find your way around in the wonderful world of lighting ratios, all you have to do is to divide or multiply by a factor of 2. It's that simple.

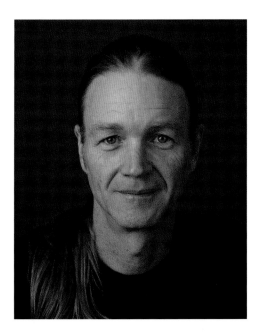

For example, if you want to know the ratio for a portrait you made in which there is a three-stop difference between your main and your fill light, simply multiply 3 by 2. The answer is 6. Thus you have a 6:1 ratio.

Figure 10. This time I used a 4:1 lighting ratio to shoot Mike. That means the main light I used to shoot this image was four times as bright as my fill light.

If, on the other hand, you would like to know how many stops difference a 5:1 ratio represents, the process is equally simple. Just divide 5 by 2. The result is 2½. That means there's a 2½ stop difference.

INDEX

A

Abstract portrait, 90–91
Adams, Ansel, 8
Aesthetic portrait, 88–89
Ambient-light portrait
 evening street portrait, 108–109
 fashion-style portrait, 29
 framed, 80–81
 instant camera portrait, 107
 portable strobe street shot, 52–53
 with reflected light, 94–95
 relationship street shot, 38–39
 with three-light set-up, 86–87
 with two-portable strobe, 22–23
 vignetting, 42–43
Aperture
 ambient-light portrait, 23, 109
 close and wide portrait, 63
 depth of field control, 121
 fashion-style portrait, 29
 minimalist approach, 59
 natural-light look, 35, 85
 single beauty-dish portrait, 97
 three-light/ambient-light portrait, 87
 two-light portrait, 19
 window-light portrait, 51
Apple box, 33, 101
Armstrong, Neil A., 14
Attachable diffusers, 138–141

B

Backdrops
 composite portrait, 33
 four-light portrait, 47
 hard-edged mainly dark portrait, 41
 natural-light portrait, 79
 one-light Rembrandt-style portrait, 27
 one light on white, 57
 preproduction gear, 129
 and spots, 143
 three-light natural bright look, 35
 three-light portrait, 55, 67, 77, 101, 105
 top-lit one-light portrait, 93
Backgrounds
 ambient vignette, 43
 backlit one-light portrait, 111
 blurring with filters, 147
 close and wide portrait, 63
 early portrait examples, 8, 14
 full-sun natural-light portrait, 31
 group portrait composite, 154, 155
 high-key mixed-light portrait, 65
 natural-light B&W portrait, 99
 and optical spots, 144
 ring light portrait, 49
 separation from subject, 121, 122
 silhouette portrait, 75
 single beauty-dish portrait, 97
 single-light portrait, 25
 street shooting preparation, 118
 three-light/ambient-light portrait, 87
 two-color gelled lights portrait, 37
 two-light portrait, 19, 61
 window-light portrait, 51
Back-up files, 125
Back-up gear, 130
Bank light, 61
Barn doors, 145
Batteries, 117
Beauty dish reflectors
 characteristics, 142
 companies providing, 147
 example, 142
 single portrait, 96–97
Ben-Yusuf, Zaida, 3
Black velvet backdrop, 41, 93
Black & white portraits
 vs. color, 155–156
 informal natural-light portrait, 98–99
 natural-light, richly textured, 84–85
 three-light portrait, 66–67
Blue acetate filter, 146
Bounce card, 111, *see also* Reflectors
Burst modes, 122
Business cards, 117
Butterfly lighting, 93

C

Catch lights
 composite portrait, 33
 four-light portrait, 21, 47
 hyperrealistic three-light portrait, 77
 portable-strobe/ambient-light
 street portrait, 53
 ring light portrait, 49, 145
 three-light portrait, 67, 105
 two-light portrait, 61
Center-weighted metering, 122
Child photography, 102–103
Circular polarizing filters, 146
Close and wide portrait, 62–63, 102–103

Color filters
 advice on use, 37
 companies providing, 147
 four-light portrait, 21
 as light modifiers, 146
 two-color gelled lights portrait, 36–37
Color portraits, *vs.* B&W, 155–156
Composite portrait, 32–33, 83
Composition
 close and wide portrait, 103
 full-sun natural-light portrait, 31
 group portraits, 153–155
 informal natural-light B&W portrait, 99
 in street shooting, 120
Confrontational look, 18–19
Continual exposure mode, 123
Contrast–lighting ratio relationship,
 158, *see also* High-contrast look
"Craftsman with his tools" portrait, 56–57
Curtis, Edward S., 3

D

Daguerreotype, 7
Dark portrait, 40–41
Depth of field
 close and wide portrait, 63
 controlling factors, 121
 natural light look, 35, 85
Diana F+ camera, 89
Diffusers
 ambient-light portrait, 39
 attachable, 138–141
 companies providing, 147
 diffused *vs.* nondiffused light, 136
 as light eaters, 141
 natural-light portrait, 79
 overview, 135–141
 portable, 138
 shoot-through umbrellas, 137
 single-light portrait, 25
 soft boxes, *see* Soft boxes
 two-portable-strobe/ambient-light
 portrait, 23
Diffusion panels, 137, 138
Digital single-lens reflex (DSLR)
 attachable diffusers, 140
 street shooting gear, 117
Dragged-shutter look, 23
DSLR, *see* Digital single-lens reflex (DSLR)

E

Environmental portrait
 early example, 10
 high-key mixed-light, 64–65
 three-light with ambient-light portrait, 86–87
Equipment preparation
 during preproduction, 129–130
 for street shooting, 117

Exposures
 bracketing, 122
 checking with histograms, 156–158
 minimalist approach, 59
Eyes, as focus in street shots, 122

F

Family portrait, 70–71
Fashion-style portrait, 28–29
Fenton, Roger, 9
Filters
 color, 146
 as light modifiers, 145–147
 neutral-density, 147
 polarizing, 146
Flags
 hard-edged mainly dark portrait, 41
 as light blockers, 145
 one-light formal portrait, 27
Flash brackets
 ambient-light street portrait, 53
 companies providing, 147
 example, 140
 street shooting, 121
Flashes
 ambient-light portrait, 39, 53
 backlit street portrait, 68–69
 composite portrait, 33
 four-light portrait, 47
 mixed-light portrait, 29
 natural light portrait, 35
 one light on white, 57
 street shooting, 117, 120–121, 135
 two-color gelled lights portrait, 37
 two-light portrait, 19, 45
Focal length
 close and wide portrait, 63
 depth of field control, 121
 natural-light look, 35
Formal portrait, 26–27
Four-light set-up
 movie poster-style portrait, 46–47
 retro portrait, 20–21
Fowx, Edgar Guy, 5
Fresnels
 four-light portrait, 47
 as light modifiers, 143–144
Fujifilm Instax 200 instant camera, 107
Fuse Ensemble group portrait, 153, 155

G

Gardner, Alexander, 4
Gels
 companies providing, 147
 as light modifiers, 145–147
 retro four-light portrait, 21
 two-color gelled lights
 portrait, 36–37

Gilbert, Sam, 11
Glass plate negative, 5
Gobos, *see* Flags
Graphic portrait, 82–83
Grid spots
 example, 144
 four-light set-up, 47
 as light modifiers, 144
 three-light/ambient-light set-up, 87
 three-light set-up, 67, 101
 two-color gelled light set-up, 37
Grips
 companies providing, 147
 for light modifiers, 139, 140
Group portraits
 composite portrait, 32–33
 composition, 153–155
Gum bichromate process, 3

H

Halo portrait, 104–105
Hard-edged portrait, 40–41
Hartsook, Fred, 9
High-contrast look
 via diffusers, 135
 four-light movie poster-style, 47
 hard-edged mainly dark portrait, 41
 self-portrait, 113
 via small hard lights, 136
 via spots, 143
 two-light confrontational look, 19
High-key look
 backlit one-light portrait, 111
 mixed-light portrait, 64–65
 three-light/bright/natural look, 35
Hine, Lewis Wickes, 10
Histograms
 double-checking shots, 123
 for exposure check, 156–158
Hollywood look, 7, 9
Holz, George, v, xii, xiii, xviii
Honeycombs, *see* Grid spots
Hyperrealistic portrait, 33, 76–77

I

Identity, via portraits, xxiii
Image editing software
 abstract portrait, 91
 single beauty-dish portrait, 97
Instant camera portrait, 106–107
ISO
 ambient-light evening street
 portrait, 109
 diffusers as light eaters, 141
 minimalist approach, 59
 single-light portrait, 25
 during street shooting, 124
 three-light/ambient-light portrait, 87

 two-portable-strobe/ambient-light portrait, 23
 window-light portrait, 51

J

Johnston, Frances Benjamin, 6

K

Kander, Nadav, v, vi, v, xviii
Key light
 four-light portrait, 21, 47, 144
 three-light/ambient-light environmental portrait, 87
 three-light B&W portrait, 67
 three-light portrait, 101
 two-portable-strobe/ambient-light portrait, 23

L

Law enforcement portraitures, 6
Lee, Russell, 6
Lenses
 close and wide technique, 103, 120
 Diana F+ camera, 89
 halo portrait, 105
 image stabilization, 124
 neutral-density filters, 147
 point-and-shoot cameras, 122
 preproduction gear, 129
 and ring lights, 135, 145
 street shooting, 118
 subject–background separation, 121
 two-light confrontational look, 19
 two-portable-strobe/ambient-light portrait, 23
Light blockers, *see* Barn doors; Flags
Light eaters
 black velvet as, 41
 diffusers as, 141
Lighting ratios, 158–159
Lighting set-ups, *see also* Portrait creation
 ambient-light portrait, 52–53, 80–81, 108–109
 ambient/reflected-light portrait, 94–95
 ambient vignetting, 42–43
 backlit one-light portrait, 110–111
 backlit portrait with on-camera flash, 68–69
 close and wide portrait, 62–63, 102–103
 composite portrait, 32–33
 four-light portrait, 20–21, 46–47
 full-sun natural-light portrait, 30–31
 graphic portrait, 82–83
 hard-edged mainly dark portrait, 40–41
 high-key mixed-light portrait, 64–65
 hyperrealistic three-light portrait, 76–77
 instant camera portrait, 106–107
 low-fidelity aesthetic portrait, 88–89
 minimalist approach, 58–59
 mixed-light portrait, 28–29
 natural-light portrait, 34–35, 78–79, 84–85, 98–99
 one-light portrait, 26–27, 70–71
 one light on white, 56–57
 ring light portrait, 48–49

self-portrait, 112–113
silhouette portrait, 74–75
single beauty-dish portrait, 96–97
single-light portrait, 24–25
social commentary portrait, 72–73
street shot, 38–39
three-light/ambient-light portrait, 86–87
three-light portrait, 54–55, 66–67,
 100–101, 104–105
top-lit one-light portrait, 92–93
two-color gelled lights portrait, 36–37
two-light portrait, 18–19, 44–45, 60–61
two-portable-strobe portrait, 22–23
window-light portrait, 50–51
Light modification devices
attachable diffusers, 138–141
barn doors, 145
basic considerations, 134
beauty dish reflectors, 142
color filters, 146
companies providing, 147
diffused *vs.* nondiffused light, 136
diffusers, 135–141
diffusers as light eaters, 141
diffusion panels, 137, 138
filters, 145–147
flags, 145
Fresnels, 143–144
grid spots, 144
light blockers, 145
modifier grips, 139, 140
neutral-density filters, 147
optical spots, 144
polarizing filters, 146
portable diffusers, 138
reflector panels, 142
reflectors, 141–143
ring lights, 145
shoot-through umbrellas, 137
soft boxes, 136–137
spots, 143–144
standard reflectors, 141–142
umbrellas, 143
Lightsphere®, 138, 139
Lincoln's cracked-glass portrait, 4
Linear polarizing filters, 146
Location shooting
ambient-light evening street portrait, 109
mixed-light fashion-style portrait, 29
preproduction considerations, 130, 131–132
Low-fidelity aesthetic portrait, 88–89
LumiQuest® Pocket Bouncer, 139
Lyon, Danny, 4

M

Main light, *see* Key light
Matzene, Count Jens, 7
Memory cards, 117
Miller, Sandro, v, x, xi, xviii

Minimalist portrait, 58–59
Movie-poster look, 46–47, 109, 144

N

Natural-light portrait, *see also*
 Ambient-light portrait
with full sun, 30–31
informal B&W, 98–99
outdoor studio example, 78–79
richly textured B&W, 84–85
three-light, bright, 34–35
Neutral density filters, 147
News pictures, 5
Nonrealistic portraiture, 83

O

Omni-Bounce®, 138
One-light set-up
backlit, 110–111
family portrait, 70–71
Rembrandt-style portrait, 26–27
top-lit, 92–93
Optical spots
four-light set-up, 47
as light modifiers, 144
Outdoor studio portrait, 78–79

P

Parks, Gordon, 9
Partridge, Rondal, 10
"People pictures,", 12, 31
"Person in power" portrait, early example, 7
Personnel, during preproduction, 130–131
Point-and-shoot cameras
backlit street portrait with on-camera flash, 69
close and wide portrait, 62–63
Portrait mode, 122
social commentary portrait, 73
street shooting, 117, 135
Poised-look portrait, 60–61
Polarizing filters, 146
Pop-up flash diffusers, 147
Portable diffusers, 138
Portable flashes, 23
Portrait creation, *see also* Lighting set-ups
abstract portrait (Harry), 90–91
ambient/reflected-light portrait (Andy), 94–95
backlit one-light portrait (BJ), 110–111
bright natural-light look (Tessa), 34–35
B&W portrait (Carolyn), 66–67
B&W portrait (Shorty), 84–85
"child in sun" ambient vignetting, 42–43
close and wide portrait (Captain Jay), 62–63
close and wide portrait (Hayden), 102–103
composite portrait (New Standard), 32–33
confrontational look (Doug), 18–19
environmental portrait (Dennis), 64–65
environmental portrait (Mike), 86–87

evening street portrait (Mark), 108–109
family portrait (Flemmings), 70–71
fashion-style portrait (Jade), 28–29
"father & son relationship" street shot, 38–39
formal Rembrandt-style portrait (Scott), 26–27
framed portrait (Gary), 80–81
graphic portrait (Gleason), 82–83
halo portrait (Lelia), 104–105
hard-edged mainly dark portrait (Paul), 40–41
hyperrealistic portrait (Nigel), 76–77
informal B&W portrait (Sam), 98–99
instant camera portrait (Pop), 106–107
low-fidelity aesthetic portrait (Suzi), 88–89
minimalist example (Nigel), 58–59
movie-poster-style portrait (Lynn), 46–47
natural-light portrait (Larry), 30–31
one light on white (Mark), 56–57
outdoor studio portrait (Paul), 78–79
poised look (Laura), 60–61
portable-strobe street portrait (Derek), 52–53
profile portrait (Alexis), 54–55
relaxed portrait (Pratima), 44–45
retro portrait (Li'l Dutch), 20–21
ring light portrait (Yougeshwar), 48–49
self-portrait (Steven Biver), 112–113
silhouette portrait (BJ), 74–75
simple portrait (Max), 24–25
single beauty-dish portrait (Delilah), 96–97
social commentary portrait (Kirin), 72–73
street portrait (Yahya), 68–69
three-light portrait (Yonus), 100–101
top-lit one-light portrait (Matteo), 92–93
two-color gelled lights portrait (Ax), 36–37
two-portable-strobe portrait (Tom), 22–23
window-light portrait (Edith), 50–51
Portrait examples, early
 Abraham Lincoln (Gardner), 4
 American Gothic (Parks), 9
 Baby in Best Clothes, 11
 Boe Brothers, 8
 Bull Chief (Curtis), 3
 Cannibal Tom, 4
 Charles Dalmorès, 7
 Chicano Teenager in El Paso's Second Ward
 (Lyon), 4
 Coronet Wilkin, 11th Hussars (Fenton), 9
 Couple on an Outing, 12
 Edwin Aldrin, Jr., 14
 Ella Fitzgerald (Van Vechten), 14
 Fargo and Doris Caudill, Homesteaders (Lee), 6
 Gen. U. S. Grant (Fowx), 5
 George Kimbrue, 11
 Guitar Player, 12
 Harry Houdini in Chains, 13
 Henry Ford (Hartsook), 9
 Jack Guth and His Steer, 10
 John D. Crimmins Standing in Front of Fish, 3
 King Farouk of Egypt and His Family, 7
 Laura Bullion, Outlaw, 6

 Martin Luther King Press Conference
 (Trikosko), 5
 Miss DuBoise Ferguson, 13
 The Monti Family, 5
 On the Freights (Partridge), 10
 Pilot Wm. C. Hopson, U.S. Mail Service, 13
 A Pioneer Family By Their Wagon, 12
 Portrait of Miss K (Ben-Yusuf), 3
 Post-Mortem Portrait of an Baby, 8
 Sgt. Alexander Kelly, 14
 Spinners in a Cotton Mill (Hine), 10
 Starving Inmate of Camp Gusen, Austria
 (Gilbert), 11
 Tom Kobayashi (Adams), 8
 Urias A. McGill (Washington), 7
 Wu Ting-Fang, Chinese Minister
 (Johnston), 6
Portrait gallery
 Christina Ricci (Kander), vii
 Cuban Mona Lisa on Bus (Miller), xi
 Dasha (Tenneson), viii
 Head Guru (Stirton), xv
 Helen Mirren (Winters), xvii
 Jack Nicholson (Holz), xiii
 Larissa (Tenneson), ix
 Leonardo DiCaprio (Winters), xvi
 Madonna (Holz), xii
 Singing Man (Miller), x
 Sofia Loren (Kander), vi
 Young Aids Orphan (Stirton), xiv
Portrait mode
 backlit street portrait, 69
 close and wide portrait, 63
 example, 117
 mastering gear, 117
 social commentary portrait, 73
 for subject–background
 separation, 122
Portraiture basics
 as art and craft, 149
 color *vs.* B&W, 155–156
 exposure check, 156–158
 format options, 51
 group portraits, 153–155
 lighting ratios, 158–159
 portrait definition, xxiii–xxiv
Preproduction
 equipment considerations, 129–130
 location shooting, 131–132
 overview, 128
 personnel, 130–131
 portrait expectation, 128–129
"Pretty-girl" pictures, 13
Profile portrait, 54–55
Proximity, depth of field control, 121
Publicity
 early portrait example, 13
 portraits as, xxiii
Puffer® diffuser, 140, 147

R

RAW format, 39, 117
Red-eye, 53, 139, 140
Reflected light portrait, 94–95
Reflector panels
 as light modifiers, 142
 one-light portrait, 27
Reflectors
 ambient-light portrait, 39
 ambient/reflected-light portrait, 95
 backlit one-light portrait, 111
 beauty dish reflectors, 142
 characteristics, 95
 clothing as, 118
 composite portrait, 33
 full-sun natural-light portrait, 31
 overview, 141–143
 single-light portrait, 25
 standard, 141–142
 two-color gelled lights portrait, 37
 two-light portrait, 19
 umbrellas, 137, 143
Relationship street portrait, 38–39
Relaxed portrait, 44–45
Rembrandt-style portrait, 26–27
Representation, photography as, xxiv
Retro look, 20–21, 47
Ring lights
 example portrait, 48–49
 as light modifiers, 145
 retro four-light portrait, 21

S

Scouting services, 132
Self-cleaning sensor system, 118
Self-portrait creation, 112–113
Shoot-through umbrellas, 57, 137
Silhouette portrait, 74–75
Simple portrait, 24–25
Snapshot portrait, 3
Social commentary portrait, 72–73
Social reform
 early portrait example, 10
 portraiture for, xxiii
Soft boxes
 backlit one-light portrait, 111
 companies providing, 147
 hard-edged mainly dark portrait, 41
 high-key mixed-light environmental
 portrait, 66
 hyperrealistic three-light portrait, 77
 as light modifiers, 136–137
 natural light look, 35
 one-light set-up, 27, 71
 ring light portrait, 49
 silhouette portrait, 75
 three-light set-up, 55, 67, 87

 top-lit one-light portrait, 93
 two-light set-up, 45, 61
Softlight beauty dish
 characteristics, 142
 companies providing, 147
 example, 142
 single portrait, 96–97
Soft Screen diffusers, 140, 147
Software, *see* Image editing software
Spots
 Fresnels, 143–144
 grid, *see* Grid spots
 as light modifiers, 143–144
 optical spots, 144
Status portraits, 5
Stereographic cards, 4
Stirton, Brent, v, xiv, xv, xviii
Street shooting
 ambient-light, with portable strobe, 52–53
 ambient-light evening street portrait, 108–109
 ambient vignetting, 43
 assessing surroundings, 118–119
 backlit, with on-camera flash, 68–69
 carrying a camera, 116, 117
 composition, 120
 courtesy during, 119
 crime awareness, 125
 double-checking shots, 123
 filling the frame, 120
 flashes, 120–121
 focus on eyes, 122
 gear, 117
 lens changes, 118
 lighting, 135
 mastering gear, 117
 multiple shots, 122–123
 overview, 116
 paying subjects, 119–120
 photo back-ups, 125
 RAW format, 117
 readiness during, 124–125
 relationship portrait, 38–39
 shot variation, 124
 steadying shots, 123–124
 subject–background separation, 121, 122
 weather, 125
Strip lights
 composite portrait, 33
 four-light set-up, 21
 high-key mixed-light set-up, 65
 three-light set-up, 77, 101, 105
 two-light set-up, 61

T

Tenneson, Joyce, v, viii, ix, xviii
Texture
 group portrait composite, 154
 hard-edged mainly dark portrait, 41

minimalist portrait, 59
natural-light B&W portrait, 84–85, 99
one-light family portrait, 71
one light one white portrait, 57
one-light Rembrandt-style portrait, 27
self-portrait, 113
three-light B&W portrait, 67
Three-light set-up
ambient-light environmental portrait, 86–87
for bright natural look, 34–35
B&W portrait, 66–67
example portrait, 100–101
halo portrait, 104–105
hyperrealistic portrait, 76–77
profile portrait, 54–55
Tintypes, 11
TriGrip® reflector, 142
Trikosko, Marion S., 5
Two-light set-ups
confrontational look, 18–19
poised-look portrait, 60–61
relaxed portrait, 44–45

U

Umbrellas
companies providing, 147
mixed-light fashion-style portrait, 29
natural light look, 35
as reflectors, 143
shoot-through, 137
three-light profile portrait, 55

V

Van Vechten, Carl, 14

W

Washington, Augustus, 7
Weather factors, 125
Wet collodion, 5, 9
Window-light portrait, 50–51
Winters, Dan, v, xvi, xvii, xviii